PHOTOGRAPHIC
LIGHTING
IN PRACTICE

PHOTOGRAPHIC LIGHTING IN PRACTICE

John Evans

DAVID & CHARLES
Newton Abbot London

An Element technical publication
Conceived, designed and edited by
Paul Petzold Limited, London

First published in 1984
Second impression 1984

British Library Cataloguing in Publication Data
Evans, John
 Photographic lighting in practice
 1. Photography—Lighting
 I. Title
 778.7′2 TR590

 ISBN 0-7153-8406-6

Designer Roger Kohn
Illustrator Janos Marffy

Typeset by ABM Typographics Limited, Hull
and printed in Great Britain
by Butler & Tanner Ltd, Frome
for David & Charles (Publishers) Limited
Brunel House Newton Abbot Devon

CONTENTS

1 VISION, LIGHT AND PHOTOGRAPHY

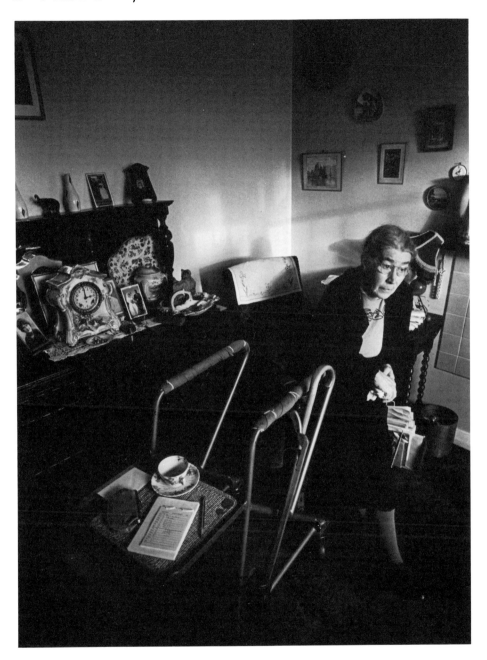

For the majority of people, vision is the most important of the five senses. So it is hardly surprising that photography enjoys such tremendous popularity, both as a hobby and a profession.

But how many of those who gain such pleasure from seeing and recording what they observe manage to successfully bridge the gap between vision and photography? Because, make no mis-

1 Shooting by ambient or existing light allows you to work unobtrusively. Sometimes your subjects may not even be aware that they are being photographed. In reportage photography this technique preserves atmosphere and

permits you to capture natural poses and expressions. But natural light is not always suitable for other types of photography which demand a greater degree of reliability and control.

take, although there are many parallels between eye and camera, there are even more differences.

By far the most important of these is the fact that the eye is not simply an organic analogue of the camera. It is an 'outer part' of the brain, so its information is subjected to intelligent interpretation, memory, preferences and a cultural heritage. Furthermore, the process of human vision has evolved to cope with an enormous range of brightness levels and to concentrate on fine details but, at the same time, to be aware of peripheral objects.

In addition to this capability human beings see a moving image in colour, three dimensions and in relationship to other sensory stimulae – usually sounds and smells. There is a wide gulf between perceived reality and its two dimensional, time-frozen reflection – the photograph.

It is hardly surprising therefore, that the production of a successful picture from even the most apparently attractive subject matter is not always as easy as it may seem.

Concentrated seeing

The first stage in improving your photography is to learn to look in a more concentrated way: to see objects as a whole *and* as a series of interdependent aspects – size, shape, colour, texture – then to move on and consider how objects and their surroundings relate to one another and how a more complex group of objects can, together, create an arresting image. You can also substitute 'person' for 'object', although the successful portrait is a product of human relationships as well as of a heightened sense of visual awareness.

The second stage is easier – learning photographic technique.

Technique is simply the skilful handling of equipment and materials. It is not an end in itself, but the means to that end – an image which clearly expresses what you set out to achieve. Many aspects contribute to the overall concept of technique, such as camera handling, exposure, processing and, perhaps the most vital consideration of all, lighting.

Controlling the light

There is a well respected school of thought which advances the notion that you should only take photographs by natural or ambient artificial light. Supporters of this principle tend to be reportage photographers concerned with capturing aspects of human behaviour which would be distorted if the photographer's presence were to be clearly signalled by bright or flashing lights. Do not be confused or misled by this outlook. It is a perfectly valid and well considered approach for one important area of photography – but you cannot apply it to every conceivable usage of the photographic process.

A more liberal attitude to adopt is that of *learning* from ambient light. Develop the idea of concentrated seeing a little further by observing the way natural light varies in quality, direction and intensity. As you develop parallel technical skills, you can apply your observations by recreating these lighting effects in controlled studio conditions.

Learning about the scientific properties and behaviour of light does not necessarily make you a better photographer. On the other hand it does give you a precise language which it is helpful to understand when it comes to controlling light and exposing film. Many of the products you need to use have technical specifications expressed in scientific language.

The behaviour of light: an outline

Light travels at immense speed in a wave-like movement along a straight axis. What you perceive as white light is really a mixture of many different colours. A scientific way to describe colour is to specify its wavelength: the distance between peaks of the wave motion. Visible light can vary in wavelength between 400nm and 700nm (the unit nm is a nanometre, or one millionth of a millimetre). Beyond the range of visible light are other forms of radiation. Though invisible, some of these, such as ultra-violet and infra-red rays, can be used in photography. Further beyond these lie both shorter and longer wavelengths – X-rays, radio waves and others. Taken together, this whole band of energy is known as the electromagnetic spectrum.

The human eye accepts any reasonable mixture of visible wavelengths as white light. Consequently colours appear similar whether viewed outside, or indoors with artificial lighting. A colour film does not exhibit this flexibility and has to be designed to work in light with a particular combination of wavelengths – either daylight or electric 'tungsten' illumination. The cocktail of wavelengths which goes to make up these different types of white light is identified by the colour temperature.

2 First attempts at controlled lighting usually involve the use of on-camera flash. This unsophisticated approach gives sharp, well exposed pictures as long as each part of the subject is at roughly equal range from the camera. The dark underexposed background is a typical characteristic which has been exploited in this shot to suppress domestic clutter. However, the lighting quality is crude, obviously artificial and cannot be properly evaluated during the brief flash duration.

As light travels in its wave motion it is thought to 'vibrate' in all planes, at right angles to the line of travel. Light which behaves thus is described as unpolarised. By using a pola screen (polarising filter) you can remove some of these planes of wave movement and cause the light to become polarised. You may imagine a pola screen as acting like a grid of parallel slots allowing to pass through only those planes of polarised light which align exactly with the slots. If you then introduce a second pola screen and rotate it to a position where the 'grids' are at right angles to those in the first, the light is completely extinguished. Light is often partly polarised when it is reflected from a non-metallic surface so a pola screen allows you a measure of control over such reflections.

Brightness

The intensity of light reaching a subject from a small (theoretically a point) source is inversely proportional to the square of the distance between the light and the illuminated surface. This so-called 'inverse square law' when translated into practice means that if you double the distance of a light the brightness drops, not to $\frac{1}{2}$ but to $\frac{1}{4}$ of its original intensity; at three times the original distance it falls to $\frac{1}{9}$. What at first seems like an academic point in fact largely accounts for why your first flash pictures showed featureless over-exposed foregrounds and equally featureless but solid black backgrounds. A little scientific background knowledge could help you avoid this and other more complex problems.

3 By removing the flash gun from the camera, bouncing it into a white umbrella and adding a low power electric 'modelling lamp' you can achieve a more natural light quality combined with a controllable intensity and direction. The continuous light from the modelling lamp simulates the output of the flash so that you can pre-judge its effect. With simple arrangements using basic equipment such as this you can combine much of the appeal of ambient light with the convenience of controlled lighting.

2 LIGHT SOURCES

The ideal lighting unit is safe, efficient, consistent, compact and portable. It also has a long life, is inexpensive to purchase and operate, permits you to judge the exact effect of the light and has sufficient output to provide appropriate exposures.

In practice, no one source exactly matches this ideal description. Fortunately each type of lighting equipment offers a different mixture of characteristics, so you can always match the source to the kind of photograph you want to shoot. Broadly speaking, lighting for photographic purposes can be broken down into two forms – tungsten and flash.

Tungsten light sources

Tungsten lighting is commonly referred to as electric or sometimes incandescent light, and is familiar as the normal type of lighting used in most homes.

Light is generated by passing an electric current through a fine wire filament inside a glass envelope. The gas inside the lamp is inert (not chemically active) so that the wire does not oxidise. Even though the current raises the temperature of the wire to white heat it does not melt because it is made from a metal which has an extremely high melting point, tungsten – hence the name for this light source. The wire does, however, evaporate, gradually blackening the inside of the glass. Eventually it develops weak spots and breaks, ending the life of the lamp.

The light produced by a tungsten source differs considerably from daylight. If you were to analyse it in terms of its component colours (its spectrum) you would find a higher proportion of red and yellow wavelengths. Not all tungsten lamps emit light of the same quality. These differences are important, especially for photography in colour, so an exact description of colour quality is used – *colour temperature* (see page 35). For accurate results you must match the colour temperature of the light to the colour balance of the film, using filters where necessary. In addition, all other sources such as daylight and fluorescent tubes, should be excluded from the picture. With black-and-white film the question of colour temperature is usually unimportant so you can freely mix different light sources.

The amount of light produced by a lamp is largely dependent on the power consumption, rated in *watts* (W). Converting electricity into light in this way is an inefficient process. As little as 10 per cent of the electrical energy finally emerges as light: the remainder is converted into infra-red and heat radiation.

The usual source of electricity is an AC supply, though accumulators and batteries are sometimes used.

Types of lamp

Apart from lamps intended for domestic or industrial lighting which might also sometimes be used for photography, there are several types designed specifically for photographic, movie or video applications. They vary widely in size, power, colour temperature, life, angle of illumination and fitting. Several types of fitting are employed – bayonet cap (BC), Edison screw (ES), giant Edison screw (GES), bi-post and pre-focus bayonet are all common.

Domestic lamps range in power from about 15W to 250W with a variety of designs including tubular shapes and some which have built-in reflectors to concentrate the light over a relatively narrow area. The glass envelopes may be clear and colourless, 'frosted' or 'opal', and are occasionally tinted. Colour temperature of the higher wattages (75–250W) is in the range of 2800–3000K. Average lamp life is 1000 hours and the huge volume of manufacture and sales ensures a low purchase price. Fittings are BC and ES.

Photofloods are more powerful lamps made in two sizes – number 1 which is 275W and number 2, a 500W lamp. Both are effectively 'over-run' which means that when connected to a standard AC supply they produce roughly three times more light than a conventional lamp of the same wattage. Colour temperature is consequently higher at 3400K, but average lamp life is drastically reduced to 2 hours and 10 hours repectively although it can vary from these nominal figures very considerably. Photofloods are somewhat more expensive than domestic lamps but still cheap enough to be considered as disposable items. Fittings are BC and ES.

Photographic lamps. These are usually 500W and 1000W lamps with a colour temperature of 3200K and a life of approximately 100 hours. Tungsten-balanced colour film is designed to be used with

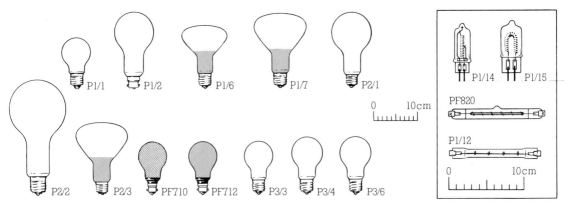

2.1 Lamps: relative sizes and performance

	Lamp reference	Watts	Volts	Cap	Film rating K	Average Life hours	Nominal Light output
Photoflood	P1/1	275	240/250	B22d/E27	3400	3	8000 lm
Photoflood	P1/2	500	240	B22d/E27	3400	6	15000 lm
Photoflood	P1/6	375	240	E27	3400	4	1300*
Photoflood	P1/7	500	240	E27	3400	6	8000*
Photopearl	P2/1	500	240	E27	3200	100	11000 lm
Photopearl	P2/2	1000	240	E40	3200	100	23000 lm
Photopearl	P2/3	500	240	E27	3200	100	3000*
Tungsten halogen	P1/12	1000	240/250	R7s	3400	10	34000 lm
Tungsten halogen	P1/14	650	240/250	G6.35	3400	15	20000 lm
Tungsten halogen	P1/15	1000	240/250	G6.35	3400	15	33000 lm
Tungsten halogen	PF820	1000	240/250	R7s	3400	6	32000 lm
Darkroom	PF710	—	240/250	B22d	—	—	—
Darkroom	PF712	—	240/250	B22d	—	—	—
Photocrescenta	P3/3	75	240	B22d/E27	3200	100	1150 lm
Photocrescenta	P3/4	150	240	B22d/E27	3200	100	2700 lm
Photocrescenta	P3/6	250	240	B22d/E27	3400	3	7200 lm

*Light output in centre beam candles

this type of illumination. The lamps are considerably more expensive than photofloods but the much greater life more than offsets the higher initial cost. Fitting is usually ES or GES.

Spotlight and projector lamps. For normal work, lamps rated at 2000W are quite common, while in large studios, individual lamps of 5000W and 10000W may be found. At this level of power consumption the wattage is normally quoted in kilo-Watts (1 kiloWatt, kW = 1000W). Cost is relatively high and with the more powerful lamps can equal the price of a medium quality camera lens. Colour temperature is 3200K with a lamp life of 100 hours. In a spotlight the orientation of the lamp is critical as the filament must align with the mirror and lens; asymmetrical flanges on a BC fitting ensure that the lamp fits only in one direction. Lamps of very high power consumption (2000W and greater) often have massive bi-post fittings comprising two metal pegs which are secured in a socket by retaining screws.

Tungsten-halogen lamps. Lamps of this type are also known as quartz halogen, quartz iodine or simply halogen lamps. They operate on the same basic principle as a normal tungsten lamp but incorporate two improvements – a compact envelope made from a heat resistant material (originally, only quartz was used), and an atmos-

phere containing a halogen, such as iodine or bromine vapour. By including the halogen a reaction is set up inside the lamp which prolongs the life of the filament and prevents blackening of the envelope.

Tungsten-halogen lamps have a higher efficiency than normal lamps. They are often tubular in shape with long linear filaments: power consumption is usually within the range of 50–2000W. Colour temperature is normally 3200K, although it can be as high as 3600K. Lamp life with 3200K sources can be as great as 2000 hours, but the cost of these lamps is somewhat higher than the equivalent tungsten types. Fittings include special ceramic caps, conventional GES, bi-post and miniature two-pin capless contacts.

With all tungsten halogen lamps you must avoid touching the quartz envelope with bare hands – acidic perspiration etches the surface, causing weak spots which are likely to fracture.

Fluorescent lamps. These are not tungsten lamps but are sufficiently common to be considered together with them. The light is produced by an electrical discharge flowing through low pressure mercury vapour. A large amount of invisible ultra-violet (UV) radiation is produced which then causes a coating inside the lamp to fluoresce. The fluorescence converts the UV rays into a mixture

11

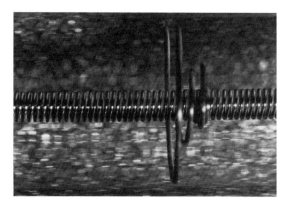

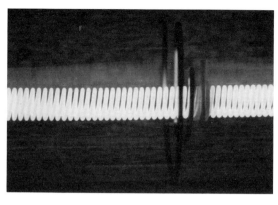

4 The filament of a 1000W tungsten-halogen lamp shown here about 7x life-size. The metal spiral near the centre of the picture supports the filament in the centre of its narrow (13mm, ½in) quartz envelope.

5 As electricity passes through the filament it glows white hot.

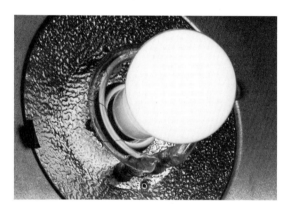

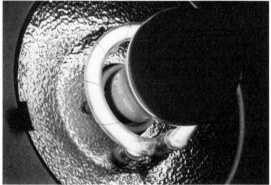

6 In a flash unit the flash tube and modelling lamp are placed close together so that their light distribution is similar. The modelling lamp in this unit is a 275W photoflood.

7 As the flash fires, its intense light output overwhelms that from the modelling lamp. Provided that you choose the normal synchronising shutter speed, light from the modelling lamp contributes nothing to the exposure.

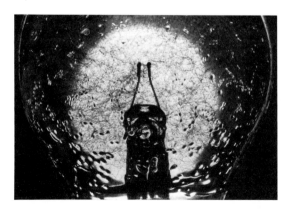

8 A large professional flashbulb closely resembles an ordinary domestic lamp. The two short wires carried on the central glass support are coated with the priming paste that initiates the burning process.

of visible wavelengths.

Fluorescent lamps are usually made in the form of long tubes with a power rating of about 10W per 30cm (1 ft) length: 20–80W tubes are common. Long tubes (up to 125W) arranged in banked rows are used for lighting large interiors such as factories, offices and arenas. Vapour discharge/ fluorescence is a much more efficient process than generating light with a tungsten filament: a 20W fluorescent tube produces as much light as a 60W tungsten lamp.

The colour of the light depends on the type of coating used and several varieties are manufac-tured, eg. 'warm white', 'cool white', 'daylight'. Strictly speaking a colour temperature cannot be applied to fluorescent tubes, though for practical photographic purposes most can be regarded as having a light quality similar to daylight. For

accurate colour on transparency film, filtration is needed (see page 35). With an AC supply fluorescent tubes flicker according to the alternating nature of the electricity (50–60Hz). Use an exposure time of 1/30 sec or longer to avoid underexposure, or uneven exposure with focal plane shutters.

Performance variations: tungsten lamps

Light output and colour temperature change according to variations in electrical supply. Lamp life is also highly dependent on operating conditions.

As the supply voltage is increased, light output and colour temperature both rise, but lamp life is seriously diminished. With reductions in voltage the opposite occurs. These performance variations are exploited to control lamp brightness and colour temperature, and to prolong life.

The simplest application of such a control is the series/parallel circuit, whereby two or more lamps are connected together with a circuit which can be switched from a series to a parallel arrangement. When running in series the lamps consume less electrical current, produce a much lower light output and have a greatly reduced colour temperature. Switching them to a parallel connection restores their normal characteristics. A more controllable alternative is offered by the dimmer unit. This provides infinitely variable adjustment of lamp brightness, from a minimum value up to full power. Professional equipment using a stepped transformer offers a similar degree of control in the form of a series of fixed adjustments.

Prolonging lamp life

Your tungsten lamps will last longer if you follow some or all of these operating procedures:

1 Switch on the lamps using a series/parallel circuit, or a dimmer set to give minimum brightness.
2 Maintain lighting on reduced power until just before exposure.
3 Try to avoid moving the lamp while it is switched on. If you do need to move it, do so as gently as possible.
4 Avoid switching lamps on and off frequently. If you do need to 'extinguish' a lamp to judge a lighting effect, holding an opaque card in front is just as effective.
5 If your lighting equipment has ventilation holes, ensure these are not blocked.

6 Locate the lamp at an angle which is within the range recommended by the manufacturers. Spotlight and projector lamps should only be inclined a few degrees from their intended 'burning angle'.
7 Follow any recommended operating times.
8 Handle and transport equipment so as to minimise impact and vibration.

Despite these precautions lamps do inevitably burn out, so you should always carry spares.

Electrical requirements

The lamps you choose must be suitable for your AC supply. The important specification to check is the voltage (V): it must match the supply. Lamps always have this data stamped on the envelope or cap, eg. *240V* 500W, or *110V* 500W. When lamps and AC supply are different you can use a transformer.

The number of lamps which can be safely operated from an AC supply depends on the total wattage and the amount of electrical current which can be taken: current is measured in amperes or amps (a). Use the following method to calculate how many amps your lighting needs:

1 Add together the wattage ratings of every lamp.
2 Use the formula:

$$a = \frac{W}{V}$$

3 Check to see if your AC supply can provide that number of amps. For example: imagine that you wanted to use three 500W lamps. With a 240V supply, the current needed is

$$\frac{3 \times 500}{240} = \frac{1500}{240} = 6.25 \text{ amps}$$

When your supply is 110V the same total wattage requires

$$\frac{1500}{110} = 14 \text{ amps}$$

You can use a modified version of the formula to determine the maximum amount of power that a given supply can provide. It is:

$$W = V \times a$$

With a 13 amp supply rated at 240V you can operate lamps with a total wattage of 240 x 13 = 3120W.

Using a 30 amp supply at 110V a nearly similar wattage of 110 x 30 = 3300W can be used.

Safety precautions

Only attempt wiring and circuit modification if you are thoroughly familiar with all the principles, safety procedures and colour codes associated with an AC supply. Electricity can kill: if you are not absolutely certain about any aspect of handling or operation, seek qualified professional advice.

Equipment must be double insulated or earthed, and protected by a suitable fuse. Where the equipment itself (or a plug) is fitted with a fuse, its rating should be equal to the number of amps the lamp requires *plus* one or two amps. For example a 240V, 500W lamp needs a 3a fuse, a 240V, 1000W lamp uses a 5a fuse and so on. Do not use a fuse of higher value (lower resistance) than necessary as this diminishes its vital role as a 'safety valve'.

Power cables should match the current likely to be flowing through them. If the conducting wire inside the cable is too thin it may act like the lamp filament and start to heat up! Ask your supplier to recommend suitable cable for the lamps you are planning to use. All cables should be uncoiled before use and positioned where they cannot be tripped over.

Since up to 90 per cent of the electrical energy emerges as heat, a lamp constitutes a fire hazard and must be treated as such:

1 Do not leave a lamp unattended.
2 Do not place it near any combustible materials.
3 Disconnect after use.

In addition, you may find that some subjects are damaged or disturbed by heat. Leaving lamps running on full power for long periods makes the working environment unpleasantly hot. If any liquids are involved in your photograph take care to avoid hot lamps being splashed and consequently exploding. Running your lights at reduced power while setting up minimises the heat problem.

Flash sources

There are two types of flash in use today – electronic flash (or strobe) and expendable flash – flashbulbs, flashcubes, flashbars and so on. Electronic flash can also be classified in two ways according to its power source. Portable flash *guns*

primarily use batteries or accumulators, larger flash *units* are designed to run on an AC supply.

Electronic flash

Light is produced by a high voltage (300–3000V) discharge of electricity through a glass-tube filled with an inert gas, such as xenon. The burst of light lasts for only a fraction of a second – the flash duration – so you cannot clearly see its effect. When operated under recommended conditions, flash tubes have a long working life – 10,000 flashes before replacement is a modest performance. Tubes may be straight in form, horse-shoe shaped or bent into circles, spirals or grids.

Light output is controlled by the energy of the discharge, measured in Watt-seconds (Ws) or Joules (J). All but the smallest flash guns have some means of achieving a fractional output. In practice, the Joule rating is of little significance due to variations in the efficiency of different circuits. Consequently other more practical means are employed to indicate light output. A unit may have its output indicated in Beam Candle Power Seconds (BCPS), Effective Candle Power Seconds (ECPS) or by reference to a Guide Number (GN).

The colour of the light is very similar to daylight and is given an effective colour temperature of 5500–6000K. This value is constant even when equipment is operated at reduced output. If necessary, flash and daylight can be used together for both black-and-white and colour photography.

Because of the brief flash duration, little heat is given off, though the output is rich in infra-red rays. Electronic flash is a remarkably consistent source of light, with little variation in intensity occurring from one flash to the next – 2 per cent variation is typical for an AC powered unit.

The period between flashes is called the *recycling time*. When the equipment is ready to fire, this is usually indicated by a small neon light – the 'ready light'. With most equipment the ready light is illuminated slightly before the flash gun or unit is fully capable of delivering a consistent output, so before firing it is advisable to wait for a second or two after the ready light comes on. Recycling time varies according to the individual characteristics of the equipment, the power output and the condition of the batteries or accumulator. It can be as short as a fraction of a second but when recycling time exceeds 20–30 sec. you should either renew the batteries, recharge the

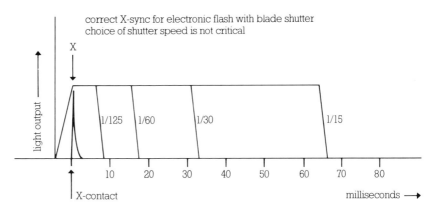

2.2 X-sync with a blade shutter and electronic flash. This is the correct combination. With this type of shutter any speed can be set, but check the flash duration of an AC unit before selecting 1/250 or 1/500 sec. Changes in shutter speed have no effect on exposure when ambient light levels are low.

accumulator or anticipate a repair. Some equipment uses an acoustic signal in addition to the ready light.

Synchronisation

The flash must 'fire' only when the camera shutter is fully open. To achieve this synchronisation (sync) the flash equipment is linked to the camera via a sync lead and (PC or power cord) socket in the camera body or contacts in the hot shoe. Internal electrical contacts associated with the shutter act as a switch: as soon as the shutter is fully open they close, completing the circuit and firing the flash. This operation is called X-synchronisation: if your camera has any controls or sync sockets identified as M, F, or FP do not use them with electronic flash. Unmarked sockets are usually suitable for X-synchronisation.

With a camera that features a focal plane shutter (virtually all 35mm SLRs) you must use only the correct range of shutter speeds. These may be identified on the dial in a different colour. When only one speed is indicated, or the letter X or a 'lightning' symbol is used, this setting represents the *shortest* shutter speed which permits correct synchronisation – typically 1/60, 1/90, 1/125 sec on 35mm cameras but as long as 1/30 sec with a medium format model. Check your camera instruction book for specific data.

If your camera has a blade (leaf, shutter any shutter speed can be used, although with an AC powered unit you should check the flash duration before using speeds of 1/250 and 1/500 sec.

For some special lighting techniques normal synchronisation is not used and the flash is fired by manual means. The following sequence is employed:

1 Open camera shutter on 'B'.
2 Fire flash.
3 Close shutter.

This procedure is known as the 'open flash' technique. Ambient light has to be very low, or you should incorporate its effect into a combined exposure. Most flash guns and flash units are equipped with open flash buttons which fire the flash independently of the camera and sync lead. For the same purpose you can also shortcircuit a sync lead plug with a small piece of metal eg. a paper clip, or a simple switch arrangement. It is quite safe to do this as the sync lead does not carry the heavy voltage used to generate the actual flash. Only a low trigger voltage (typically 4–30V) runs through the lead to operate a separate circuit within the flash equipment which initiates the discharge.

A sync lead should be made from coaxial, screened cable to avoid the risk of induced voltages causing uncontrolled firing.

Multi-source synchronisation

Two or three flash guns or flash units can be fired in perfect synchronism by linking them together with suitable leads and then connecting one sync lead to the camera. The sync voltages of each flash gun or unit must, however, be identical.

A more flexible approach, which allows you to use any number of units, whether identical or not, is offered by the *slave cell* – a photo cell designed to respond only to a flash of light. One master flash is synchronised with the camera in the normal way while every other unit is equipped with a slave cell, carefully located to detect the output of the synchronised flash as it fires. The cell then fires the flash gun or unit to which it is connected. No significant delay occurs so each flash apparently fires simultaneously.

Slave cells can also be connected to flash equipment via cables to permit this kind of triggering when the location of the slaved flash is such that it cannot receive light directly from the synchronised master flash.

A variation of the slave cell system uses a special infra-red emitting 'trigger' unit and a single slave cell specially designed to respond to infra-red rays. The trigger is connected to your camera in the same way as a small flash gun. One flash unit is equipped with the infra-red slave and the remainder with conventional slaves. Invisible infra-red rays are produced as the shutter is fired. These are detected by the special slave which fires its own flash unit, the others then respond to this and fire via their normal slaves. With a complex studio set up this arrangement makes a sync lead unnecessary and offers a great degree of reliability. In a busy professional studio a trailing sync lead between camera and lights is a constant nuisance and might be tripped over and unplugged at regular intervals.

A small flash gun can be used in the same way: if set to produce a minimum output it is unlikely to interfere with the overall lighting effect.

Flash guns

A flash gun is a portable electronic flash powered by batteries or a rechargeable accumulator – usually the nickel/cadmium (NiCad) type. Larger flash guns can also be operated from an AC power supply for studio applications.

Flash guns vary enormously in their size and output characteristics, ranging from tiny guns no larger nor more expensive than a roll of colour slide film, to heavy duty professional models weighing several kilos and costing as much as a high quality 35mm camera. These large guns have ratings of up to 200J/4000BCPS resulting in a GN of 50 (m) for ISO = 100/21° (ASA 100/21 DIN) or 160 (ft) for ISO = 100/21° (ASA 100/21 DIN) materials. In comparison a pocket-sized flash gun often has a GN as low as 8 (m) for ISO = 100/21° (ASA 100/21 DIN) or 26 (ft) for ISO = 100/21° (ASA 100/21 DIN).

An important refinement, unique to the flash gun, is the facility for automatic exposure, controlled either by a built-in sensor ('computer flash') or by the TTL metering system of a camera. This latter development is 'OTF' flash where the control photocells read light off the film during exposure. Conventional operation with the flash gun firing at full power, or on a pre-determined fractional setting, is referred to as manual flash.

Some automatic flash guns have removable

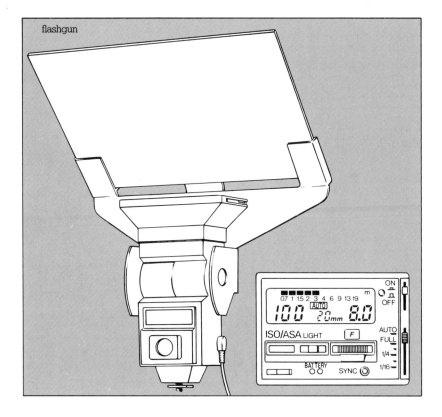

flashgun

2.3 Flashgun showing diffuser fitted to spread the source of light. Back panel contains most controls, ready light, calculator, switch, 'open' flash button, (generalised diagram).

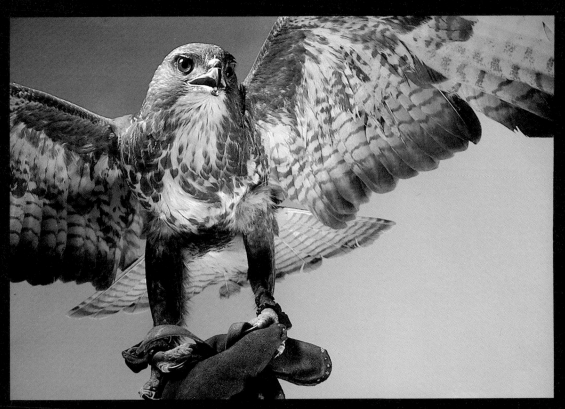

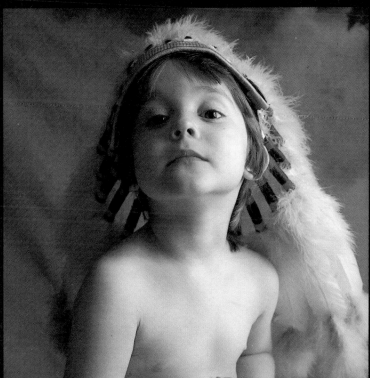

9 A very unusual pet such as this buzzard deserves a dramatic lighting style. Three monobloc flash units were used – a diffused unit from the left, a snoot from below and a background light fitted with a blue filter. The bird was posed on his master's gloved hand and fed with pieces of meat. Exposure on ISO 64/19° (ASA 64/19 DIN) film was f/16.

10 Young children when photographed do not always respond well to careful direction. Your lighting should take this into account by providing a quality which is suitable for a range of poses. In addition, you need sufficient power to allow a small aperture to be chosen – precise focusing is not always possible, so adequate depth of field is needed.

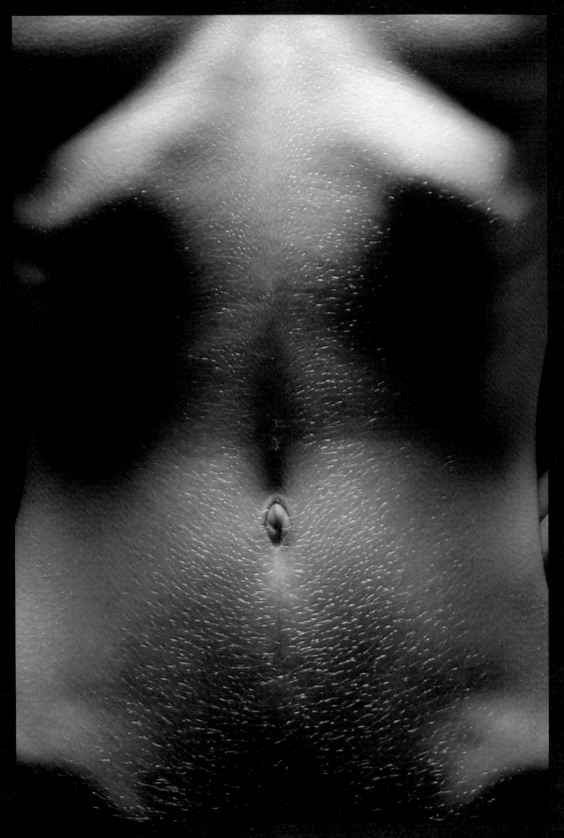

sensors which may be operated via an extension cord. In this way the sensor can always be arranged to face the subject even when the flash gun does not.

Flash duration on full power manual settings is generally in the region of 1/1000 sec although it can be anything between 1/400 sec or 1/2000 sec with some guns. Setting half or quarter power and so on, reduces the duration often in exact proportion to the reduction in light output. Fractional settings of anything down to 1/64 of full power are possible with some guns.

Set to automatic operation, where the circumstances determine the behaviour of the unit, the range of possible flash durations is even greater. Bursts of light with as little as 1/50,000 sec duration may occur with a close range subject needing the minimum light output.

Angles of coverage

Unlike a tungsten lamp and an AC powered flash unit the majority of flash guns are self contained units of lighting equipment whose illumination covers a pre-determined angle. Most flash guns illuminate evenly a rectangular area equivalent to the field of view of a 35mm lens on a 35mm camera. With other film format and lens combinations this pattern of illumination does not always ensure good coverage of the subject area. In particular, pictures taken in 6 x 6cm format often exhibit uneven illumination at the top and/or bottom of the frame.

The angle of coverage can be modified by adding a diffuser to give a wider angle, or a fresnel lens to concentrate the beam. These devices are normally described in terms of their suitability for lenses of certain focal lengths on a 35mm. camera. They may be separate plastic mouldings, slipped into a grooved slot on the gun or built into a permanently attached front assembly which is adjusted to three or four preset positions according to the camera lens in use. Coloured and neutral density filters may be attached via the same grooves.

When fitted to the hot-shoe or a purpose-built bracket on the camera, you should be able to align the beam of light with the subject area. How-

ever, with a hand-held flash gun, or an adjustable bracket, it is advisable to make test exposures to check alignment.

Larger and more expensive flash guns normally have a head adjustable for 'bounced' flash. The flash tube is housed in a reflector which can be angled to point upwards, to the sides, or to the rear. This feature enables you to reflect light from a suitable surface, such as a low white ceiling, while the flash gun remains attached to the camera. A further advantage of this concept is that with an automatic flash gun the sensor still faces the subject and is thus able to read the light reflected from it, irrespective of the direction of the lighting.

Some flash guns feature dual flash tubes which simultaneously provide bounced and direct illumination.

The front-facing flash tube has a smaller output than the bounce head and can be switched off independently from the flash gun as a whole.

Flash units

Flash units generally operate from an AC supply and fall into two categories – smaller monobloc units and larger studio console models. Both types of unit are suitable for studio photography, but the smaller size of the monobloc flash makes it ideal for location work when an AC supply is available. Some monobloc flash units can also be operated directly or indirectly from a 12V car battery, or a portable generator driven by a small motor.

The major differences between the two types of unit lie with the power output and the physical arrangements of electronic components and flash tube/reflector assemblies. With monobloc flash the unit is self-contained – one body houses everything. Many units have built-in slave cells, and most feature interchangeable reflectors. Size and weight vary but dimensions of 15 x 15 x 25cm (6 x 6 x 10in) and weights of 2–6kg (4½–13½lb) are typical for a basic unit without reflector. Costs are similar to the range of 35mm SLR camera prices. Ratings extend from less than 100J up to about 1500J, resulting in figures of 18,000BCPS and, for the most powerful unit, a GN of 100/300 (m/ft) when used with ISO = 100/21° (ASA 100/21 DIN) materials.

You may notice that the most powerful flash *gun* has a higher J rating than the least powerful flash *unit.* Flash duration varies greatly from unit to unit and may range from 1/200 sec to 1/2000 sec. On fractional power settings flash durations do not

11 A single illumination source arranged above, or to one side of, the figure is perfect for revealing form and texture. A flash head fitted with a 50cm (20in) diffuser unit was used, with no fill-in lighting. Exposure on ISO 64/19°(ASA 64/19 DIN) film was *f*/16.

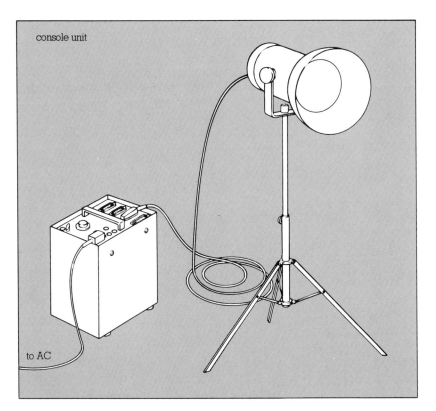

console unit

to AC

2.4 Console flash uses a powerpack into which may be plugged one or more flash heads. Both monobloc and console flash normally operate from an AC supply and can be set to a range of fractional outputs.

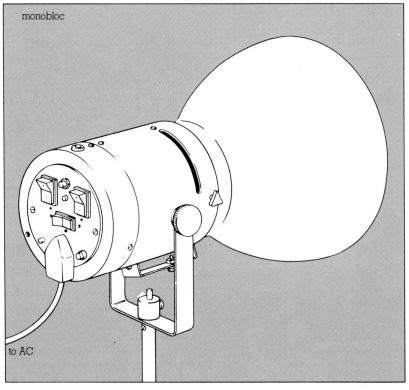

monobloc

to AC

2.5 Monobloc flash units are self-contained, comprising all electronic components, flash tube and modelling lamp.

follow a uniform pattern – with some units duration increases; with others it decreases or remains constant. Before purchasing a flash unit check these characteristics carefully if you are likely to need your flash lighting to 'freeze' movement.

Studio flash consoles have separate power-packs and flash heads. The powerpack or console contains the bulk of the electronic components while the 'head' houses the flash tube, reflector and some electronic parts. Most consoles accept two or more flash heads but power distribution between the heads may be equal or intentionally unequal. Flash heads are often designed to take specially shaped flash tubes made in the form of long strips, grids or rings which fit around a camera lens. Reflectors are interchangeable and a manufacturer who makes monobloc and console units may use the same range of reflectors for both types of equipment.

Consoles vary in size and weight and may be similar in size to a large camera outfit case or resemble an average-sized refrigerator. Costs can be equivalent to that of a high quality 35mm SLR camera or even as much as an expensive car without flash heads being included! Consoles are most frequently rated between 2,000J and 6,000J. Such powerful units are used by studio-based professional photographers under highly controlled conditions, but with a large variety of reflectors and diffusers, many of them specially made. For this reason BCPS and GN recommendations are not normally given, though a GN of 270/890 (m/ft) for ISO 100/21° (ASA 100/21 DIN) is typical for the most powerful units.

Consoles can be set to give fractional power. Combined with selecting the number of heads, this control permits a wide variety of possible outputs through each flash head. Flash duration is similar to the range found with monobloc units.

Modelling lamps

One of the most useful features which all modern flash units share is the built-in *modelling lamp,* also known as a pilot or guide lamp. It is a normal tungsten or tungsten-halogen lamp with a wattage of, usually, between 150–650W. Positioned in the reflector close to the flash tube, the modelling lamp produces enough continuous illumination to simulate the effect of the flash. However, its brightness is not sufficiently great to interfere with or contribute to exposure, so it may be left on at all times when normal synchronisation is used. Provided that the ambient light level is low (less than

normal room lighting) this lamp allows you to easily judge the effect of the most complex lighting arrangement.

When several flash units, with different power outputs, are used together to light a single subject the brightness of the modelling lamps must be proportional to the flash output in each case. Most units have an automatic link between the fractional flash power control and the modelling lamp so the brightness of the modelling lamp dims as the flash output is reduced. In some cases you can override the link and set maximum brightness irrespective of flash output. One manufacturer incorporates an 'extinguishing mode' to the lamp control which causes the modelling lamp to turn off at the moment that the flash fires and to switch on again as soon as the unit has recycled. This feature is most useful when several flash units are being synchronised via slave cells as it gives a very positive indication that each unit has fired. After setting up you can switch the modelling lamps back to continuous illumination.

Supplementary modelling lamps can be used with flash guns and expendable flashbulbs to provide an approximate simulation of the lighting effect.

Expendable flash

Expendable flashbulbs produce light by burning fine aluminium/magnesium or zirconium wire in an atmosphere of oxygen inside a glass envelope. The reaction is started by a priming paste which is itself ignited by a low voltage (3–45V) electrical supply or, in some cases, mechanical action. A simple circuit, incorporating a battery and a capacitor, provides the necessary voltage. A lighting unit designed to fire flashbulbs is also known as a flash gun.

The light output from a flashbulb lasts only a fraction of a second so, as with electronic flash, the lighting effect cannot be assessed beforehand. However, unlike electronic flash, the bulb is used once only and must be changed for each photograph. The purchase price of this type of flash is low but used on a regular basis the running costs are high. Every test shot, and flash fired to estimate exposure, uses up bulbs. In a multi-source lighting arrangement this becomes expensive. It is also quite time consuming to change several bulbs each time a photograph is taken.

To speed up the change, various arrays of small bulbs are connected together to form flashcubes, flashbars and flipflash assemblies containing 4–10

bulbs in a disposable plastic case, complete with integral reflectors.

Larger individual bulbs are made mainly for professional use. Some of these are as big as a household lamp and produce a massive amount of light. Fittings for individual bulbs include miniature BC, ES and capless.

The output of a flashbulb is usually indicated by a guide number (GN). Small bulbs and flashcubes have a GN in the region of 30/100 (m/ft) for ISO = 100/21° (ASA 100/21 DIN) making them directly comparable in power to a medium size electronic flash gun. The larger professional bulbs have GNs up to 160/530 (m/ft) for ISO 100/21° (ASA 100/21 DIN) films making them as powerful as the smaller size of AC powered console flash unit.

There is no means of achieving fractional power, although actual light intensity can be reduced by fitting a neutral density filter or diffusing screen in front of the bulb. When a familiar style of lighting is used, bulbs with different GNs can be chosen to fulfil specific roles.

Bulbs have a plastic coating which prevents the envelope from shattering and, in the case of a blue bulb, converts the colour temperature to match a daylight quality of 5500K. A bulb with a clear coating emits light with a colour temperature between 3800K and 4200K. Clear bulbs have a higher GN than blue bulbs of the same size due to the light-absorbing characteristics of the blue plastic. They are, however, only suitable for black-and-white photography. In many parts of the world clear bulbs are unobtainable through normal retail outlets although they are, in fact, still manufactured.

Flash duration with bulbs depends on the size and type. It is always much longer than electronic flash. A small bulb burns for about 1/30 sec (33 milliseconds) while a large bulb intended for synchronisation with a focal plane shutter has a duration of as much as 1/15 sec (66 milliseconds). The unit of time, one millisecond, is 1/1000 sec.

The light from a bulb is not of equal intensity through the whole duration of the burning time. After the sync circuit is closed and the bulb begins to fire there is a delay of approximately 5 milliseconds (1/200 sec) before any significant amount of light is produced. The intensity then builds to a peak output before fading away.

To use the full output of a flashbulb the shutter speed must be as long, or longer, than the whole flash duration. Normal X-sync is used. However, careful examination of the bulb's burning pattern shows that a high proportion of the light is emitted

during a peak period lasting only a few milliseconds. You could therefore use a much shorter shutter speed provided that you can synchronise the opening of the shutter with the peak illumination. This technique is suitable for small and medium size bulbs identified as MF and M-type.

M-synchronisation

M-sync activates a small delay to the shutter. By using this setting the sync circuit is completed and the bulb begins to burn about 16 milliseconds *before* the shutter is fully open. Only blade shutters allow you to use M-sync and it should never be used with electronic flash. With M-sync any shutter speed can be selected including the usual top speed on a blade shutter of 1/500 sec. Because only a proportion of the total light output is used for the exposure, the GN of any one bulb varies according to the shutter speed. With the shortest shutter speeds as little as 15 per cent of the light is used. The following table gives a typical set of values for a small bulb:

Sync mode	Shutter speed	GN (ISO 100/21°)	f-number at 1.8m/6ft for correct exposure
Open	B	30/100	f/16
X	1/30	30/100	f/16
M	1/60	21/70	f/11
M	1/125	18/60	f/11
M	1/250	14/46	f/8
M	1/500	11/36	f/5.6

GN is quoted in m/ft, f/numbers to the nearest conventional figure.

Very large S-type bulbs (S = slow) should only be fired with X-sync at shutter speeds up to 1/30 sec.

Flashbulbs and focal plane shutters

The exposure given to the film by a focal plane shutter is largely governed by the effective width of the 'slit' between its two blinds as it travels across the picture area. You can think of the film as being exposed one area at a time as the gap between the blinds moves from one side to the other or from top to bottom. Consequently, a normal flashbulb with its distinctive output characteristics produces very uneven exposure. The first and last areas of film to be exposed receive the build-up and fall-off in illumination, while the central section is exposed by the peak intensity.

To avoid this unevenness a special type of flashbulb is made with a relatively even output of light

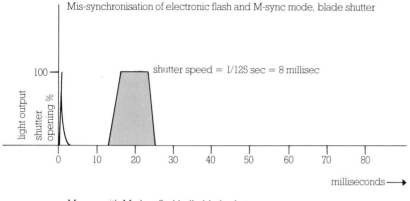

Mis-synchronisation of electronic flash and M-sync mode, blade shutter

shutter speed = 1/125 sec = 8 millisec

100

light output
shutter opening %

0 10 20 30 40 50 60 70 80

milliseconds ⟶

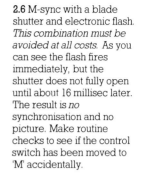

2.6 M-sync with a blade shutter and electronic flash. *This combination must be avoided at all costs.* As you can see the flash fires immediately, but the shutter does not fully open until about 16 millisec later. The result is *no* synchronisation and no picture. Make routine checks to see if the control switch has been moved to 'M' accidentally.

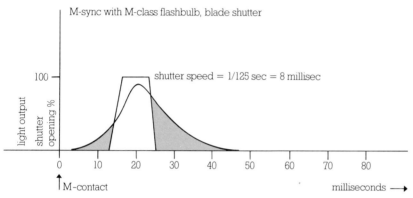

M-sync with M-class flashbulb, blade shutter

shutter speed = 1/125 sec = 8 millisec

100

light output
shutter opening %

0 10 20 30 40 50 60 70 80

⬆ M-contact milliseconds ⟶

2.7 M-sync with a blade shutter and an M-type flashbulb. Because of the output pattern you can use high shutter speeds such as 1/125, 1/250 and 1/500 sec. The M-sync mode delays the operation of the shutter by about 16 millisec, so the opening phase coincides with the peak output of the curve.

over a longer duration than normal. To achieve this, the 'peak output' of the normal bulb is replaced by a 'plateau' – a lengthened period of consistently high light output. These bulbs are identified by the letters FP in their code name or by the manufacturer's classification as a 'focal plane' bulb.

Although the light output is greater, even with these bulbs, there is still a 5 millisecond delay before any light is emitted and a further 10 millisecond delay before the plateau intensity is achieved. To ensure that the shutter does not fire during the build-up period another type of delayed synchronisation is used – FP-sync, normally indicated by a specially identified socket on the camera body. Never plug an electronic flash unit into an FP socket.

It is theoretically possible to use any shutter speed with an FP bulb, but in practice some manufacturers only recommend a limited range of speeds: check with your camera instruction manual for specific data.

Focal plane bulbs are still manufactured, but are not available in all parts of the world. Consult your instruction manual to determine whether any other types of bulb can be used. Some cameras

with focal plane shutters will synchronise at slow shutter speeds – up to 1/30 sec – with commonly available flashbulbs and flashcubes.

Safety spot

All types of flashbulb contain on their inner surface one or more small *blue* spots of cobalt chloride. If air should somehow enter the envelope, water vapour brought with it turns the spot pink. A flash bulb containing moist air is quite likely to explode on firing, so never use a bulb unless the spot is blue.

Safety precautions

Observe the normal safety precautions when handling AC powered equipment and tungsten modelling lamps. Do not attempt to repair flash equipment, even when it is disconnected from the supply, or even if it is a small battery powered flash gun. All flash equipment uses capacitors (condensers) which store electricity for long periods: leave repairs to a professional expert.

Immediately after firing, a flash bulb is usually very hot. Remove it with care and dispose of the expended bulb thoughtfully. In a potentially hazardous environment, seek advice from a safety

expert before undertaking any photographic activities: this is vital if the atmosphere is potentially explosive.

Exposure determination

With a continuous light source, such as daylight or tungsten lighting, an exposure meter or TTL metering system gives an accurate exposure reading under most circumstances (see page 127 for exposure techniques in abnormal conditions). In general, an incident light reading taken with a separate hand meter gives the most consistent results.

Exposures for flash sources involve only the lens aperture and may be determined in a number of ways eg by:

1 Using the automatic sensor or TTL control facility in a flash gun/camera.
2 Reading the flash output directly with a flash meter.
3 Reading modelling lamp output with a continuous light hand meter or TTL system, and relating this to the flash.
4 Calculation from the GN and reading from a calculator dial.

Automatic flash guns provide accurate exposure with an average subject, as long as it is within the maximum distance that can be adequately illuminated. Many guns have a 'check' light that enables you to test if enough flash output is being produced. The flash gun is arranged with the sensor pointing at the subject. You then press the 'open flash' button and wait to see if this light comes on. If it does, you can shoot; if not, select a wider aperture and re-test.

Interfacing flash guns/camera systems can provide a facility for automatic selection of the appropriate shutter speed for correct flash sync and may revert to normal continuous light metering during the recycling period. As with all forms of TTL metering, this arrangement automatically takes account of light loss due to filters or extra lens extension.

Automatic and TTL controlled flash guns can be misled by non 'average' conditions such as dark backgrounds, light backgrounds, backlighting and glaring reflections from background details such as windows, mirrors, gloss paint etc. In all such situations it is safest to work with the manual flash metering method.

Flash meter readings are suitable for work with electronic flash and bulbs although meters designed primarily for use with monobloc units sometimes cannot handle the high light output from large console models. Readings are normally taken using the incident method with a cable link or the 'open flash' button to fire the flash. Some meters can accept a number of flashes sequentially and give a readout of the total exposure effect. As with any hand meter, factors for filters or extra lens extension must be taken into account.

Reading from modelling light Provided that the modelling lamps are of a type designed to give an output proportional to that of the flash itself and all other light is excluded from the scene you can use the following technique:

1 Arrange an average subject and typical lighting.
2 Make an approximate estimate of correct exposure, then shoot a series of pictures on slide film ranging from 3 stops under to 3 stops over the estimated exposure in half-stop increments. Include in each photograph a card bearing the exposure details.
3 Take a hand meter reading of the subject using light from the modelling lamps – make a written note, eg. ½ sec at f/8 with ISO 100/21° (ASA 100/21 DIN) film.
4 Process the film and select the best exposure.
5 Determine which aperture was used.
6 If f/8 gave the best exposure then in future the correct exposure with this equipment is always indicated by the aperture which aligns with a shutter speed of ½ sec. If f/11 gave the best result a speed of 1 sec becomes your reference point. If it was f/5.6 then ¼ sec is the index and so on.

In practice, you must still set the shutter to its normal sync speed. The speed on the meter is merely a reference point or index against which the aperture is read. Once you have found the correct index it can be used for all film speeds.

Guide numbers. The manufacturer of flash equipment provides a guide number (GN) for use with each model produced. This number is the product of the f-number set and the distance from light source to subject measured either in metres (m) or feet (ft). Thus:

$$GN = f\text{-number} \times distance$$

But the GN for any one source is not a fixed value and it will vary according to these factors:

1 Whether distance is in m or ft.
2 Film speed.
3 Reflector/diffuser characteristics or efficiency.
4 Working conditions.
5 Shutter speed/sync mode with M-type flash bulbs.

As GN is used both to describe output and determine exposure, it is most important that the first two factors be clearly stated. You will have noticed that each time a GN is given these variables are defined, eg. GN of 80/260 (m/ft) for ISO 100/21° (ASA 100/21 DIN). When a flash source can be used with a variety of interchangeable reflectors, a single GN with an 'average' general purpose reflector (illumination angle about 60°) is quoted. Alternatively a GN for each reflector may be given.

GN is sometimes based on the assumption that photography is taking place in an average-sized room with light-toned decorations – this is particularly true for small electronic flash guns. Outside, or in large interiors, you may have to allow up to one whole stop more exposure.

In practice, the GN is normally used to find the *f*-number which gives correct exposure when the flash-to-subject distance is known. A variation of the basic formula is applied:

$$f\text{-number} = \frac{GN}{distance}$$

Take this example: you have a GN of 24/80 (m/ft) for ISO 100/21° (ASA 100/21 DIN) the distance is 3m (10ft). The correct aperture is:

$$\frac{24}{3} = f/8, \text{ or } \frac{80}{10} = f/8$$

As you can see, it is vital to have both the GN and the distance measured in the same terms.

The effect of a change in film speed at first appears somewhat strange: changing from ISO 100/21° (ASA 100/21 DIN) to ISO 200/24° (ASA 200/24 DIN) increases a GN of 24/80 to 33/110 and *not* to 48/160 as you might expect. The reason for this becomes obvious if you continue with the same calculation: in this case the correct aperture is:

$$\frac{33}{3} = f/11, \text{ or } \frac{110}{10} = f/11$$

The change from *f*/8 with ISO 100/21° (ASA 100/21 DIN) to an exposure of *f*/11 with ISO 200/24° (ASA 200/24 DIN) film is exactly what you would anticipate.

For the same flash source the GN varies in the following way with other changes in the film speed.

Film speed (ISO)	GN m/ft	Exposure at 3m/10ft	Change in GN
25/15°	12/40	4	÷2
50/18°	18/56	5.6	÷1.4
100/21°	24/80	8	–
200/24°	33/110	11	x 1.4
400/27°	48/160	16	x 2
800/30°	66/220	22	x 2.8
1600/33°	96/320	32	x 4

As you can see, each time the film speed changes by a factor of 2x, the GN alters by a factor of 1.4x, exactly following the progression of the *f*-numbers.

You can also use a GN to find the correct distance when the *f*-number is known. This application is uncommon but a further variation of the basic formula allows you to undertake the calculation:

$$Distance = \frac{GN}{f\text{-number}}$$

Dimensions and terminology
Dimensions and specifications quoted in this chapter are provided to create a general impression of the performance, size and cost of the common light sources. Minimum and maximum values are typical but are likely to change as new products emerge and technological improvements are made.

In the remainder of the book the term 'flash' is used to describe electronic flash; expendable flash is identified separately. Conventional lamps and tungsten-halogen sources are both referred to as 'tungsten'. Where a technique is applicable to any source the term 'light' is used to describe a complete piece of lighting equipment, eg. "move your light away from the camera position . . ."

Imperial equivalents of metric dimensions are rounded off for GN figures.

3 LIGHTING CONTROLS

A naked lamp, flash tube or flashbulb radiates light of a particular colour temperature in almost every direction. For carefully controlled photographic applications you usually have to modify the quality, direction and distribution of the light, and in some instances alter its effective colour temperature.

Quality of light

A small light source (ie. one of small *area*) produces a *hard* lighting effect. This is characterised by dark, sharp-edged shadows, tiny, brilliant specular highlights forming in polished or shiny surfaces and the clear rendition of texture when the source is positioned to one side, above or below the subject – ie away from the camera viewpoint. Colour saturation is high, but the level of illumination declines rapidly with increasing distance, because light from a small source complies quite closely with the inverse square law (page 9).

In practice, you achieve the hardest lighting by using a compact source such as a small tungsten-halogen lamp without a reflector, a flash gun or a naked flashbulb. A spotlight, spotlight projector and slide projector also give hard effects with the added advantage of superior control over the lighting direction. When a naked source is used in a room with a lightly coloured ceiling or walls, reflected light has the effect of lightening or 'filling-in' the shadows.

Soft lighting can be produced with a large-area source. The quality is, in most respects, the opposite of hard lighting: shadows are light and soft-edged, highlights in shiny surfaces are large and texture is relatively subdued. Where large highlights form, the colour becomes desaturated, while intensity is maintained at a more even level as the lamp-to-subject distance is increased. The inverse square law applies here in an approximate way only.

Large area light sources are almost always produced by indirect means – the primary source is reflected from a white or metallised surface, or it

3.1 The shape of a polar curve indicates the lighting effect of a reflector dish or lighting unit. Flat curves mean even lighting over a wide angle: steep curves indicate light output in a narrow beam. A hot-spot is shown by a central peak.

relative light intensity

1 floodlight (general purpose)
2 high performance flash unit reflector dish
3 snoot

The following lighting units are used in the diagrams

naked lamp

floodlight

flash gun plan view

flash gun side view

monobloc + general
purpose reflector dish

monobloc + snoot

monobloc + large
diffuser unit (3ft/1m)

monobloc + small
diffuser unit (20in/50cm)

flag

monobloc + 3ft/1m umbrella –
small 'spillkill' reflector dish
(umbrellas are also used with flashguns)

35mm SLR

6x6cm SLR

6x7cm SLR plan view

6x7cm SLR side view

person

any other subject

reflector board

background

27

is diffused through translucent material. In this respect most soft lighting can be regarded as coming from a *secondary* source. The process of reflection or diffusion effectively expands the light source to the size of the reflector, ceiling, wall, reflector board or panel of diffusing plastic or whatever serves the purpose, but at the price of reduced intensity.

For both hard and soft lighting effects the actual dimensions of the source are not the only consideration – it is the *apparent* or *angular* size of the light which controls the quality. So a small flash gun used at a distance of 3m (10ft) is a hard source. But the same gun, fired from only 10cm (4in) to illuminate a close-up shot for example is, in relation to the subject, quite large in area and consequently provides relatively soft lighting. Similarly, a 1m (3ft) square diffuser is a large source for a small scale still life picture but produces a much harder quality when used to light a factory interior.

Reflector dishes

With the exception of the naked lamp, flash tube or flashbulb, all lighting equipment uses a source in conjunction with a reflector dish or bowl. This arrangement restricts the spread of light and increases the intensity of the useful illumination at the subject plane by re-directing light which would otherwise fall away from the subject and be 'wasted'.

The quality of light which the source plus reflector produces is dependent on a number of factors. Most important of these is the size of the reflector, next its shape, then the nature of the surface and finally whether or not a 'cap' is used. One extreme is represented by the small, deeply dished reflector of up to 25cm (10in) with a polished metal surface – a combination which produces hard lighting. At the other end of the range are large, shallow saucer-shaped or dish reflectors of up to 1m (3ft) with a matt white interior and a 'cap'. These give lighting of a very soft quality. The cap is a metal disc, usually suspended in front of the lamp on wires or a thin rod. It prevents light passing directly from the source (ie, the lamp itself) in this way ensuring that only light reflected from the dish (ie. more diffused light from a wider area) reaches the subject.

A white or metallised umbrella works the same way. Most reflectors are circular dishes, but those for linear filament tungsten-halogen lamps and long flash tubes are often rectangular and shaped like troughs.

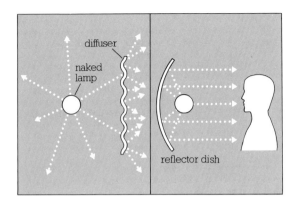

3.2 A diffuser effectively expands the size of the light source. A reflector redirects light towards the subject.

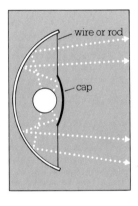

3.3 A large reflector fitted with a cap (shield) gives soft lighting by preventing direct lighting from the lamp.

As well as the quality of light at any one point, reflector characteristics also control the precise spread of light and the pattern of illumination intensity. It is the shape and surface of the reflector which has most influence here. Intensity and angle of illumination are fully described by a reflector's *polar curve*. Diagrammatically, this shows variations in brightness measured at different points on an imaginary semi-circle drawn with the source as its centre. A less thorough specification merely gives the overall angle of illumination without indicating the evenness or otherwise of the brightness pattern. Reflectors which are designed to give a light output with a high intensity central zone, surrounded by a lower level of brightness, are described as having a *hotspot*.

A wide-angle reflector providing even intensity is termed a floodlight.

Spotlights

The spotlight is a further development of the source/reflector combination but with the addition of a condenser lens and a simple focusing mechanism. Most spotlights use a fresnel lens with the familiar ring-patterned surface which helps dissipate heat. By moving the source and reflector away from and towards the lens, you can concentrate the light beam into a small patch or spread it over a wider area. The limits of the focusing movement are often marked 'spot' and 'flood'. The fresnel lens used in a spotlight is not a precision optical device so a sharp image of the light source is never formed.

A spotlight projector does use a conventional lens assembly in the form of an *optical nose*. Such a spotlight may be a complete unit or the 'nose' can be purchased as an accessory and fitted in place of the fresnel lens. By inserting masks and grids into a special slot you can project various patterns, usually to create special effects on the background. Masks and grids must be made from metal or other non-combustible materials. A normal slide projector can be used in the same way.

The hardest lighting is produced by a slide projector, or a spotlight adjusted to the 'flood' position, though none of these quite matches the hard quality of a very small light source.

Spotlights and spotlight projectors are made in the form of tungsten lights and AC powered flash units. A simple alternative which is suitable for some applications is provided by the integral reflector tungsten lamp.

Diffuser units

You can improvise soft lighting by taking any source and then reflecting or diffusing the light. But for regular use when convenience and consistency are important, a reflector with a built-in diffuser is a worthwhile purchase. These are most frequently applied to AC powered flash units and are often designed around a skeleton framework. A diffuser made from translucent plastic or white fabric fits on the front, while the reflector is made up from panels of metallised fabric attached around the sides. A pyramid shape is the most common with the square diffuser occupying its 'base'. For storage and transportation the framework is easily taken apart and the fabric reflector and diffuser panels rolled up or folded. Similar diffuser units are also available in the form of permanent constructions made from fibreglass or thin sheet metal.

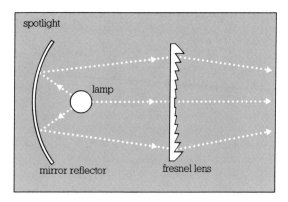

3.4 Spotlight. Light reflected by a curved mirror behind the lamp and from the lamp itself are focused on the subject via a fresnel lens.

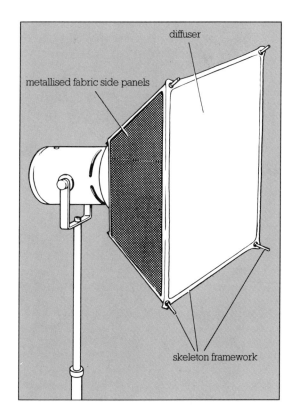

3.5 A diffuser unit provides a very soft, even type of light quality. Normal construction is a pyramid-shaped skeleton framework covered in metallised fabric. The diffusing surface of translucent plastic or white fabric is attached to the front. The unit comes apart for storage and transportation.

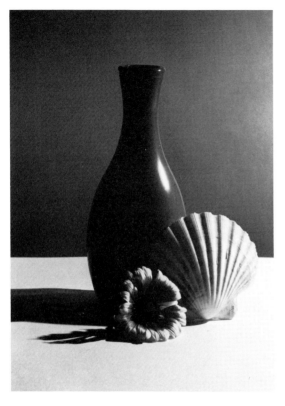 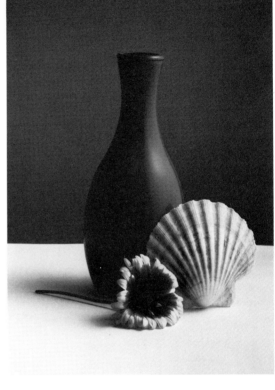

12 A naked 500W lamp produces a very hard light quality. In particular, note the small intense highlight on the vase and the dense, hard-edged shadows. Texture on the shell is clearly visible.

13 With a 60 x 90cm (2 x 3ft) diffuser placed between lamp and subject the light quality becomes soft. Compare the highlights on the vase and the shadows. By varying the distance of the diffuser from the light source you can have precise control over the quality of the light: the closer it is to the subject the softer the lighting.

14 Critical positioning of the light is needed to reveal the maximum texture. Here a naked 500W lamp was arranged at a height which allowed some of its output to graze the surface of the wood.

15 A general purpose reflector gives fairly even illumination over an angle of about 60°.

16 High performance reflectors produce a 45-60° angle of illumination, but with a 20-30° central hot-spot of high intensity.

17 Fitted with a snoot, a narrow-angled beam of light is produced.
15, 16, 17 Interchangeable reflectors fitted to a monobloc flash unit.

18 A 500W spotlight on the 'spot' setting.

19 The same spotlight adjusted to the 'flood' position.

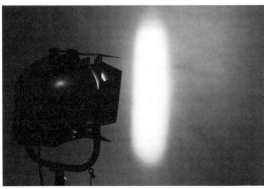

20 With the spotlight set to 'flood' and fitted with barn doors a narrow strip of light is produced.

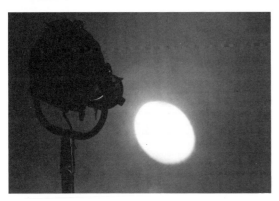

21 A spotlight projector can be used to form a distinct circular patch of light.

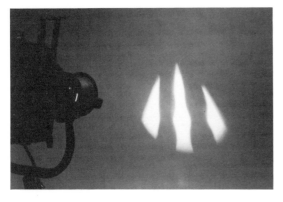

22 By inserting heat resistant objects into the optical nose of the spotlight projector you can project patterns on to the background.

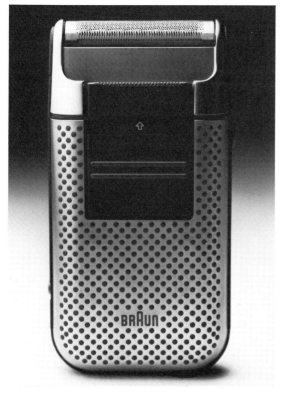

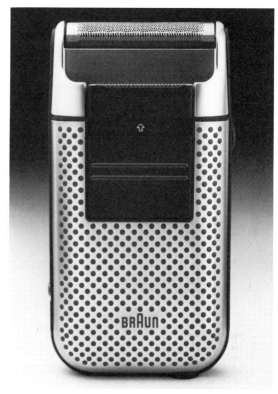

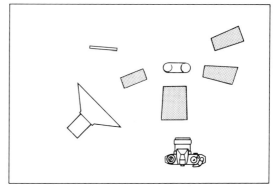

23, 24 Small reflectors made from white card or paper, aluminium foil or metallised plastic can make a significant difference to a lighting arrangement.

23 One diffused light was positioned to the left side. A flag was used to cast a shadow on the background and so produce the graduated effect.

24 By placing four small aluminium foil reflectors around the subject, a much more attractive quality was created. Reflectors were located at the left and right sides, in front of, and to the right rear of the razor to form a series of subtle and distinct highlight reflections.

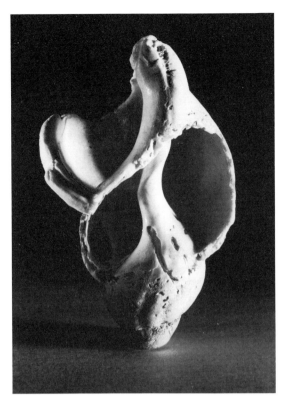

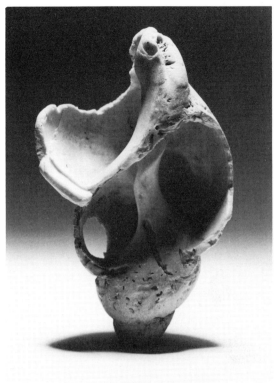

25 A low-level mounting bracket was used to carefully align the height of the source with the table top on which the shell was supported. A small flag was placed on the table to minimise the amount of light falling on the background of white paper.

26 A boom carried the same light above the shell to give overhead lighting. The only difference between these two pictures is the direction of the lighting.

Reflector boards and diffusers

You can exert additional control over your lighting by further reflecting some or all of the light from a neutral surface. White paper and card, expanded polystyrene, aluminium foil, metallised plastic or card and small mirrors are all suitable. Low ceilings and lightly decorated walls also make good reflective surfaces.

A reflector board is used for a number of purposes. You can direct your light exclusively at the surface so that the subject is lit only by reflected light. With a more normal arrangement, where your light points at the subject, place the reflector board to 'intercept' wasted light and bounce it back towards the subject to provide fill-in lighting. Small reflectors, often made from aluminium foil or fragments of broken mirror are used to achieve local lighting effects, especially in still life photography. They are often placed within the subject area, hidden by opaque objects or slipped behind bottles and glasses.

Unfortunately, the word 'reflector' is employed to describe both the lamp reflector dish and the reflector board. Where the specific term is not used you can normally deduce the nature of the reflector from the description of its location and the function it performs.

A separate diffuser can be made by fixing translucent material such as tracing paper, drafting film, white fabric, spun polyester or glass fibre on to a lightweight framework. Alternatively, a sheet of rigid, opal acrylic plastic makes a good diffuser. Held in front of a normal reflector dish, such a diffuser converts any type of lighting quality into a soft source. With a large diffuser – say 1 x 2m (3 x 6ft) – you can place several lights behind it to produce a powerful and even softer quality of illumination.

For colour photography all reflector boards and diffusers should normally have neutral colour characteristics, although some proprietary brands of diffusion material are dyed blue. This

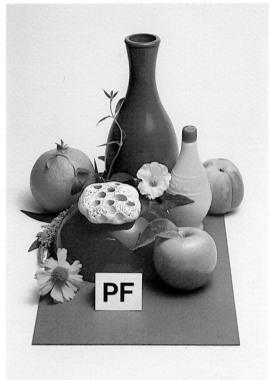

27–31 How unfiltered
daylight-balanced colour
film responds to different
light sources.

27 Electronic flash 5500K
28 Photoflood 3400K

allows you to use daylight-balanced colour film when the light source is tungsten.

Combustible materials like paper and card placed too close to hot light sources represent a considerable fire hazard and should be handled accordingly. Ordinary tracing paper and fabric discolours when exposed to hot lights. Take note of this or your colour photographs could begin to exhibit a colour cast.

Colour quality

The various colour qualities of different light sources are defined by their colour temperature. This is a scientifically derived scale which compares the light from any given source to the light quality produced by a theoretically perfect source (one which, when heated, radiates perfectly according to the laws of physics) – a *black-body* radiator. When the two colour qualities match, the actual temperature to which the black body has to be heated in order to emit light of the same colour is measured and used to define that quality. Strictly speaking colour temperature is only applied to sources which emit a very broad mixture of colours and have a spectrum which is described as 'continuous' – daylight, tungsten, flashbulbs and other materials which burn. Electronic flash tubes are given *effective* colour temperatures. The absolute or Kelvin scale of temperature is used, which has the same size of unit as the centigrade or Celsius scale. But the Kelvin scale begins at absolute zero which is minus 273°C. Consequently a colour temperature of 3200°K could also be expressed as 2927°C, but colour temperatures are more usually expressed in Kelvin units or Kelvins (without the degrees sign) eg: 3200K.

Colour film is manufactured in two basic types – each balanced for exposure in light of a particular colour temperature – either 5500K (daylight, electronic flash, blue flashbulbs), or 3200K (professional photographic lamps).

When it is necessary to use a light source for which the film is not balanced, the colour temperature can be effectively raised or lowered by using an appropriate filter over the light, on the camera lens or both. Filters designed to fit over a light do not have to be made from optical grade materials but they may need to be heat resistant.

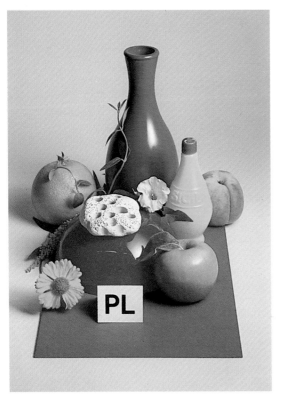

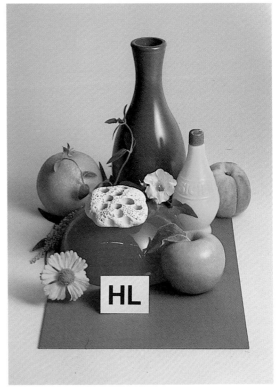

29 Photographic lamp
3200K
30 Domestic lamp, 100W
2800K
31 'White' fluorescent tube

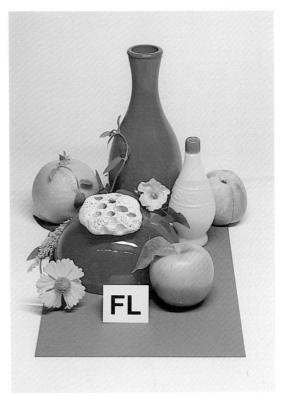

Blue filters raise colour temperature, amber/orange filters lower it.

The following chart lists most common sources, the filtration required for both types of film and the filter factor. In some cases two filters are needed.

Filtration required – Filter factor

Light source – colour temp		For daylight film	Factor	For tungsten film	Factor
Domestic lamp	2800K	80A + 82C	10	82C	1.5
Domestic lamp	3000K	80A + 82A	8	82A	1.25
Photographic lamp	3200K	80A	4	–	–
Photoflood	3400K	80B	3	81A	1.25
Flash	5500K	–	–	85B	1.5

Always try to use a light/film combination where the colour temperature and balance are as close

as possible.

Correct filtration is vital for accurate colour on transparency film but you can shoot on colour negative film without filters and then make the necessary corrections at the printing stage.

Fluorescent tubes are rarely given an effective colour temperature, though most popular types have an output which is similar in colour to daylight. Different emulsions respond in various ways to the same fluorescent tubes. A test carried out with one 'daylight' tube and several types of daylight-balanced transparency film produces slides with colour casts which vary from a slight overall yellow/green to a very strong, vivid green bias. Contact your retailer or manufacturer for specific filter recommendations or conduct your own tests. Where testing is not possible shoot on colour negative film and apply corrective filtration at the printing stage. Colour slides and transparencies for projection or reproduction can be printed from colour negatives.

General purpose filters are made by some manufacturers which are intended to give approximate correction on daylight-balanced film. A CC30M (magenta) filter provides a good starting point for a series of tests. With 'warm white' tubes add cyan filtration in increments of CC10C. For 'daylight' tubes add yellow, again in CC10Y steps. Record all data including the exact name and type of fluorescent tube.

Positioning the lights

You should be able to locate a light anywhere you need it and fix it in a stable but adjustable position. Normal telescopic light stands enable you to place a light between about 1m (3ft) and 3m (10ft) from floor level. Most stands have tripod bases. Larger models feature small wheels so they can be moved smoothly over flat surfaces. Heavy duty stands may be fitted with an internal 'air brake' to cushion the weight of a large light. The angles at which the light can be inclined and turned are controlled by the adjusting bracket or tilting head mechanism – normally a part of the lighting unit itself.

The lighting stand is adequate for the majority of lighting arrangements but for some techniques extra accessories are required. To place a light near the floor you can use a special stand which is a miniature tripod base without the central column. A more flexible alternative is offered by the low level mounting bracket or wing arm. This clamps anywhere on to the main column of a

normal stand.

For overhead lighting you need a *boom* – basically a horizontal arm with the light fitted to one end. An adjustable clamp holds the arm to the top of the stand and allows it to tilt and slide. The arm itself may be telescopic and is always counterweighted or cantilevered to balance the weight of the light. One novel idea for a counterweight is to use a polythene bottle which can be filled with a large volume of water to make up the necessary weight. If you only need an overhead light occasionally, improvise a suitable arrangement with two lighting stands and a sturdy metal tube fixed between them. The light then clamps to the tube.

For location work when weight and bulk have to be kept to a minimum, a spring-tensioned clamp allows you to fix small lights to such things as chair backs, the edge of doors, a fence post and so on. Protect delicate surfaces with a thick pad of folded fabric in the jaws of the clamp. An interest-

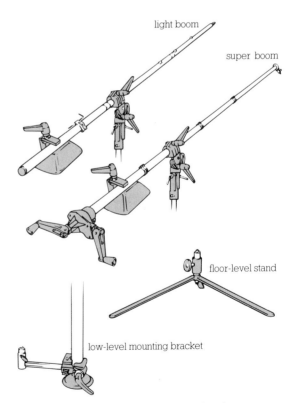

light boom

super boom

floor-level stand

low-level mounting bracket

3.6 Special accessories are needed to position lights at low and high levels. To locate a light close to the floor use a low-level mounting bracket or special floor stand. For overhead lighting the most useful accessory is a boom.

ing range of special brackets is made for flash guns. The more sophisticated of these devices holds the flash gun well above the camera and allows small umbrellas or panels of white card to be used as reflectors.

In the studio there may be heavy duty overhead tracks to support lights which hang down from the ceiling on scissor-action suspension units. Hinged boom-like arms can be bolted to the wall, permitting the light to swing out for use and back again for storage. Both systems are expensive but in a busy studio they help to keep the floor free from stands and cables and so speed up the handling of equipment.

Light distribution

No matter what quality and positioning you choose for your lights you may still need to exert a further control – restricting the distribution. For example, if you want a local area of illumination it does not necessarily follow that the most suitable light is a spotlight – a diffused light is often preferable. But an unmodified source of this type emits light over a wide angle. To limit the spread you need to fit some form of control device.

An improvised arrangement made from black card is often ideal as its performance can be tailored to your specific requirements. A flat sheet of card held near the reflector casts a shadow, so restricting the angle of illumination in one direction. By encircling the light with a long sheet of thin card bent round into a cylindrical shape the angle is limited in all directions.

Fixing card to reflectors is best done by mechanical means, such as a double-ended clip, string or wire. Adhesive compounds or tapes come unstuck by the action of heat. Additions to a basic reflector usually inhibit normal ventilation and often contribute to overheating. Ordinary card also represents a fire hazard when used in combination with tungsten or modelling lamps. In this case try to operate your equipment for short periods and/or on reduced output while setting up.

For regular use it is worthwhile purchasing commercially made versions of these improvised devices. A hinged flap made from metal or plastic which attaches to the reflector is called a *barn door*. Normally these are sold as units comprising two or four flaps. The cylinder, when made in black painted metal, is a *snoot*. An efficiently designed snoot has a conical shape and a ridged interior to control internal reflections and help

produce a narrow beam of light. Barn doors and snoots are used on both floodlights and spotlights.

A sheet of opaque card located at some distance from the light does not have a commercially made equivalent, but is known by a variety of names including *flag, French flag, gobo* or *cutter.*

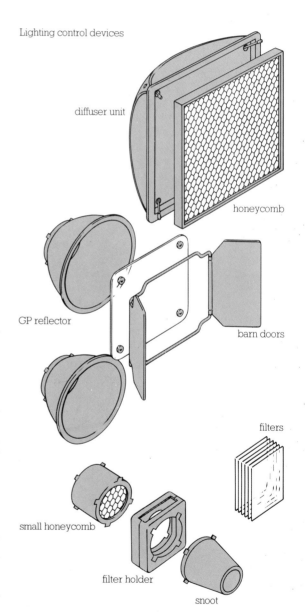

Lighting control devices

diffuser unit

honeycomb

GP reflector

barn doors

filters

small honeycomb

filter holder

snoot

3.7 Lighting control devices. Honeycomb diffusers, filters; barn doors and snoot for shading and concentrating the unfocused light from a general purpose reflector.

It is an excellent plan to routinely place a flag between light and camera to minimise the possibility of lens flare. In this location a flag is also known as a *headscreen*.

Other devices are used with diffused sources to make the light more directional without affecting its soft quality. They work in a similar way to barn doors or a snoot but operate across the whole diffuser surface.

Louvres or *slats* are thin strips of material placed edge-on to the diffuser to act like a series of barn doors. In a situation where little heat is produced, eg. with an AC powered flash unit, elasticated fabric is sometimes used so that individual louvres can be pulled away, or several fixed together to create local lighting effects. Spill rings are short concentric rings, while a honeycomb grid is a further miniaturisation with many hexagonal elements, each one cutting off any light rays which do not emerge at close to 90 degrees from the diffuser.

All of these control accessories have to be used with care if your subject has a polished surface. In this case a clear specular reflection forms which includes details of the louvres, honeycomb and so on. Exactly the same situation arises with a large reflector dish featuring a cap. You may not notice this breaking up of a smooth highlight in the camera viewfinder as the lens is normally set at its widest aperture, causing the reflection to be out of focus. So, apart from scrutinising the subject always check the screen image at the taking aperture.

4 BASIC LIGHTING

An enormous number of factors must be taken into account when choosing lighting equipment, not the least of these being cost.

Professional photographers who undertake a wide variety of assignments own all kinds of tungsten and flash equipment, or they possess a basic outfit and then hire other items for particular jobs. Photographers who specialise in a limited field, eg. studio portraiture, can define their needs very accurately as their subject matter, camera, lens, film emulsion and working conditions vary little from one job to the next.

In arriving at your own selection it is helpful to make an analysis of the type of photographs you intend to take. Firstly, consider the range of subjects then the camera equipment and film requirements and finally the probable working conditions.

The following charts summarise the main characteristics of the major light sources and the practical implications of these features for a range of subjects and locations. Light levels with domestic lamps and fluorescent tubes are likely to be similar, whether you choose to use them as controlled light sources, or find them as part of the ambient lighting fixtures.

Using the chart headed *Applied features* consider, for example, an assignment in which you want to shoot a colour portrait of a young child in your own home, using a hand-held 35mm SLR camera. Ideally, you need a light with the ability to:

1 Freeze subject movement and prevent camera shake.
2 Produce a visible effect.
3 Provide a suitable exposure.
4 Avoid discomfort and heat.
5 Allow a large number of shots to be taken at a modest cost.

Because of the working conditions other features are fairly unimportant – size, weight and the nature of the power supply. Apply all the requirements to the chart and you will discover only a single source which satisfies every one of them – the AC powered flash unit. However if your model is an adult then your choice of lighting, for a formal

Basic characteristics of light sources

Light source	Normal power supply	Colour temp. K	Consistency	Life	Cost		Size Weight	Typical exposure ISO 100/21° (ASA 100/21 DIN) film
					purchase	operation		
Domestic lamp 100W	AC	2800	●●○○○	●●●●○	●●●●●	●●●●○	●●●●●	1 sec f/5.6
Fluorescent tube 40W	AC	Daylight	●●○○○	●●●●○	●●●●○	●●●●●	●●○○	1 sec f/5.6
Photoflood 275W	AC	3400	●●○○○	●○○○○	●●○○○	●●●○○	●●●●●	¼ sec f/5.6
Photographic lamp 500W	AC	3200	●●●○○	●●○○○	●●●○○	●●●○○	●●●●●	¼ sec f/5.6 (1/60 sec f/5.6)
Flash gun GN 30/100	Battery	5500	●●●●●	●●●●●	●●●○○	●●●●○	●●●●●	f/16
Flash unit GN 50/160	AC	5500	●●●●●	●●●●●	○○○○○	●●●●○	●○○○○	f/22
Flashbulb GN 30/100	Battery	5500	●●●●●	○○○○○	●●●○○	○○○○○	●●●●●	f/16

Key: ●●●●● = most favourable
○○○○○ = least favourable

GN is quoted in m/ft for ISO 100/21° film
Typical exposure assumes one light in an average reflector (60 degrees) and a subject distance of 2m (6ft).
With photographic lamps the exposure in brackets (1/60 sec @ f/5.6) is for a spotlight.

approach, extends to take in photoflood and photographic lamps. With a suitable film speed of around ISO 400/27° (ASA 400/27 DIN), and your camera supported on a tripod, an exposure of 1/15 sec at f/5.6 is usually adequate for a standing or sitting pose which allows your model to adopt a stable position.

A further possibility is to use a flash gun or expendable flashbulbs and take an instant-picture test shot to evaluate the lighting effect. This approach works well provided that your model can recreate the exact pose for the exposures on conventional film. Also bear in mind the additional cost, especially when you use flash-bulbs.

Now select a subject of your own and by studying the *Applied features* chart see how you gradually eliminate those light sources which are not suitable. For an undemanding subject such as a simple still life picture or a copy, most types of light can be used, though for optimum results you may sometimes also need a little improvisation to help – and some test exposures. Specific recommendations on lighting equipment, styles and techiques are given in the following chapters covering a wide range of subject areas – portraits, nudes, still life, close-ups and so on.

Lighting style

With the technical problems resolved you can turn your attention to the way in which lights are used to create the lighting style.

The simplest approach to lighting sets out only to show a subject in the clearest possible way. It is a method which is usually, but not always, associated with *objective* photography – pictures that rely for their appeal on the subject matter rather than the photographer's creative interpretation.

To be fully descriptive the lighting has to show the following subject features:

1 Shape.
2 Form – the surface contours.
3 Texture.
4 Colour or tonal qualities.

In order to do this your lighting also has to avoid any possible confusion between subject and background. Shadow quality in particular must be carefully controlled so that the shape is not obscured by a single shadow which falls partly on the subject and partly on the immediate background.

Form and texture are created by control of

Applied features

Light source	Freezing movement	Visible effect	Subject comfort	Freedom from heat	Range of useful exposures	Suitability for –		
						Studio	Indoor ① location	Outdoor ② location
Domestic lamp 100W	○○○○○	●●●●●	●●●●●	●●●○○	●○○○○	●○○○○	○○○○○	○○○○○
Fluorescent tube 40W	○○○○○	●●●●●	●●●●●	●●●●●	●○○○○	○○○○○	○○○○○	○○○○○
Photoflood 275W	●○○○○	●●●●●	○○○○○	○○○○○	●●●○○	●●●○○	●●○○○	○○○○○
Photographic lamp 500W	●○○○○	●●●●●	○○○○○	○○○○○	●●●○○	●●●○○	●●○○○	○○○○○
Flash gun GN 30/100	●●●●●	○○○○○	●●●●○	●●●●●	●●○○○	●●○○○	●●●●○	●●●●●
Flash unit GN 50/160	●●●●○	●●●●○	●●●●○	●●●●○	●●●●○	●●●●●	●●●●○	○○○○○
Flashbulb GN 30/100	●●○○○	○○○○○	●●●●○	●●●●●	●●○○○	●○○○○	●●○○○	●●●●●

Key: ●●●●● = most suitable
　　 ○○○○○ = least suitable

GN is quoted in m/ft for ISO 100/21° film
① Indoor location assumes AC supply
② Outdoor location assumes no AC supply

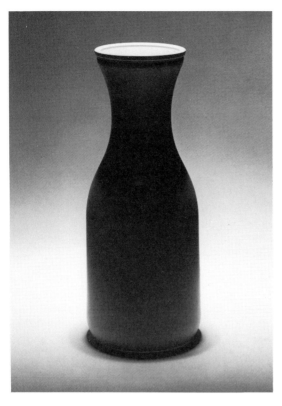

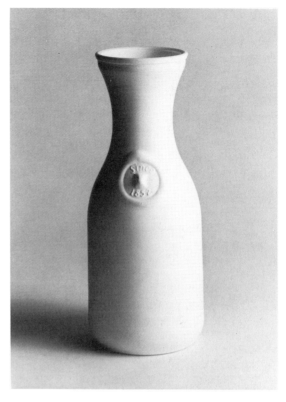

32, 33, 34 Careful control over light quality and direction is important if your picture has to contain clear information.

32 Lighting from the top shows shape quite well, but not form.

33 Soft lighting from one side is ideal for revealing form.

lighting direction and quality. Illumination from a position near to the camera reveals neither; you have to move it so the output strikes the subject from one side, above or below. With this sort of lighting direction, shadows are formed, acting as visual keys by which the general surface contours and smaller scale textural characteristics are judged. Hard lighting produces the most distinctive texture, but may exaggerate form. Soft lighting reveals form in a more natural way, but subdues texture. Choose the quality of light which is most appropriate for your particular subject.

Colour is fully described by referring to *hue* (the name eg. blue, green etc.), *saturation* or purity, and *brightness*. A brilliant deep red for example is said to be highly saturated. Pink is a form of desaturated red. Both colours may be seen or photographed as light or dark, depending on lighting and exposure.

To preserve saturation your lighting should

minimise surface reflections – a hard source is ideal for this purpose. Soft lighting creates large highlights which desaturate colour, though these can be controlled with a pola screen.

For a simple colour photograph you should use a background which is clearly differentiated from the subject itself. You can do this in a number of ways. Consider, for example, a simple objective photograph of a vase which is an average mid-toned blue. The background could be white, black, or a complementary colour of a similar, lighter or darker tone. Complementary colours can be thought of as being 'opposite'.

Colour	Complementary
Blue	Yellow
Green	Magenta (purple)
Red	Cyan (turquoise)

Other 'intermediate' colours can be regarded

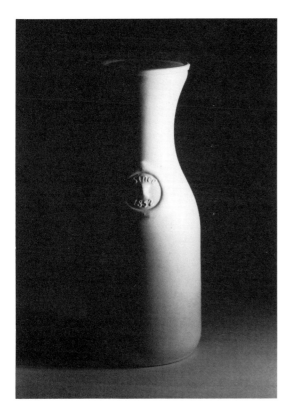

34 But hard lighting tends to exaggerate or disguise both form and shape. Note how the shadow side of the vessel merges with the background.

35 By creating opposing areas of light and dark on subject and background all characteristics of shape, form, texture and tonal quality are clearly shown.

This general principle of tonal interchange between subject and background is applied to all fields of photography in black and white.

as near-complementaries, so a yellow or orange background would make a powerful contrasting colour for the blue vase.

Translating colours into tones for black-and-white photography is not without its pitfalls. It is quite common for the inexperienced photographer to arrange a set-up of coloured subjects on a coloured background which *appears* very pleasing. However, when converted into a range of grey tones the result is often a great disappointment. The problem is simply that you cannot necessarily translate colour contrasts into tonal contrasts. On black-and-white film the blue vase and its yellow background could easily record as identical shades of grey. Bear this in mind when you have full control over your choice of subject and background. Choose tones which provide inherent contrast – light and dark.

A more interesting challenge is to choose a subject and background which are similar in tone,

then use lighting control to introduce tonal contrasts. Imagine now that you had a white vase on a white background. By lighting it from one side you create two distinctly different halves – light and dark. Using barn doors or a flag, control the amount of light reaching the background so that the pattern of light and dark is repeated, but in reverse order. The final print shows light set against dark and *vice versa* to create a simple example of good tonal contrast or tonal interchange. This principle is also applied when a separate background light is used.

When the choice of subject and background colours is beyond your control you can still influence tonal contrasts by using suitable filters. Continuing with the earlier example you could distinguish between the blue vase and its yellow background by using either a blue or yellow filter.

Filters work by transmitting their own colours and absorbing all others. So a blue filter allows

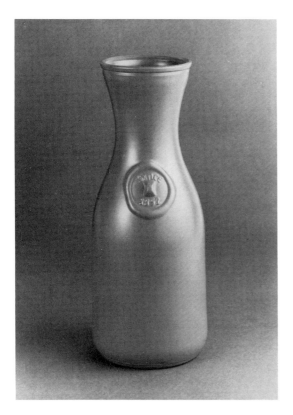
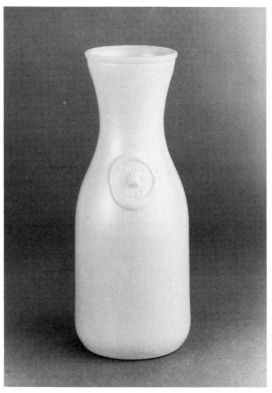

36, 37, 38 Controlling tones in black-and-white with contrast filters.

36 A blue vase on an orange background lit with an even, soft quality of illumination appears to the eye as an attractive combination, with clear separation between subject and background. In an unfiltered black-and-white photograph both areas record as an almost identical shade of grey.

37, 38 In each case, clear tonal separation is created although the tones are, in fact, distorted.

37 By using a deep blue filter (Wratten 47B) the vase is made to appear lighter.

blue light to pass and absorbs yellow light. The result is a light vase seen against a dark background. If you use a yellow filter the picture shows a dark vase on a light background. Neither photograph is a true representation of the original colours, but the technique of filtering to improve contrast is well worth remembering.

The general conclusion to draw from this is to create colour contrasts when shooting in colour and tonal contrasts for black-and-white photography.

Lighting for atmosphere

When accuracy and clarity of information are less important you can concentrate on creating a mood. This is done by carefully selecting the subject, then using controlled lighting to influence:

1 Overall tone.
2 Impression of warmth or coldness.
3 General atmosphere.

The overall tonal qualities are defined largely by the choice of subject and the lighting direction. When lighting comes from the side, above or below, large areas of shadow are formed. Unless these are lightened by a second light or a reflector board they tend to convey an overall dark feel to the picture. If the subject is itself dark the result is termed low-key. This approach suggests mystery, romance, secrecy, menace or depression.

Lighting coming from an angle close to the camera forms the minimum of shadow. Combined with a pale-coloured subject and suitable handling of exposure the result is a high-key picture

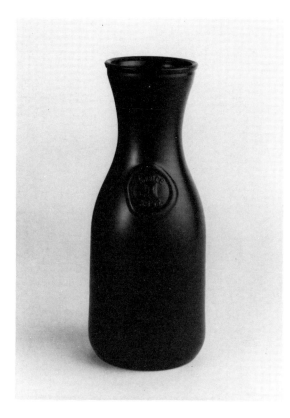

38 With a deep yellow filter
(Wratten 12) the vase
becomes almost black.

various controls. In addition to the tones and colours one further important consideration is the light quality. Hard lighting reinforces the impression of menace, especially when it comes from below, while a soft quality enhances a romantic or tranquil mood.

Fill-in lighting

A single light is suitable for a great many applications. A soft source in particular works well on its own, simulating the effect of light from a window. When more complex lighting is needed, various lights are used for both the subject and the background. Numerous combinations are possible and these are dealt with in the following chapters on specific subject areas. But one additional light is common to most lighting styles – the fill-in.

Eye and film do not respond in the same way to a range of brightness levels within a given scene. You can see detail in both brightly lit areas (highlights) and deep shadows. If you were to take an exposure meter reading from each area and compare them you could find that the brightness range, or lighting ratio, was 300:1 or even greater. But a photograph taken of the same scene does not record detail in both areas. Depending on how much exposure you give, the shadow tends to be correct when the highlight is recorded as a featureless white patch, or conversely the highlight contains detail but the shadow is completely black. A compromise exposure loses detail in both areas.

The fill-in adds light to the shadow to reduce the brightness range, so permitting the film to record what the eye can see. How much fill-in you need depends partly on the type of film. For a black-and-white emulsion a lighting ratio of 8:1 is recommended as a maximum, while for colour materials this is reduced to 3:1.

In a normal lighting arrangement the fill-in lightens the shadows which are deliberately formed by the main subject light. However, you can also use fill-in lighting as the only controlled light in conjunction with ambient sources. The most common example of this technique is a flash gun used to brighten the deep shadows caused by sunshine.

The type of source used for fill-in lighting and its location vary according to the nature of the assignment. A typical arrangement uses a low-power soft source close to the camera but other combinations are possible. Where the main and fill-in lights fulfil totally separate roles their

which tends to imply delicacy, fragility, freshness, innocence or youth.

A photograph with tonal qualities that are part-way between the two extremes is called mid-key and has a neutral atmosphere.

Choice of colour is vital in communicating mood. Warm colours such as yellow, orange or red have associations with heat, sex, energy and power while cold colours such as blue, cyan or purple suggest tranquillity, cleanliness and quality. Select your subject matter carefully to preserve the overall impression of colour. If necessary, you can introduce or reinforce colour by using filters. One filter placed over the lens or on every light gives an overall effect. If you are using two or more lights you can filter some of them only for local colour control.

General atmosphere is created by combining

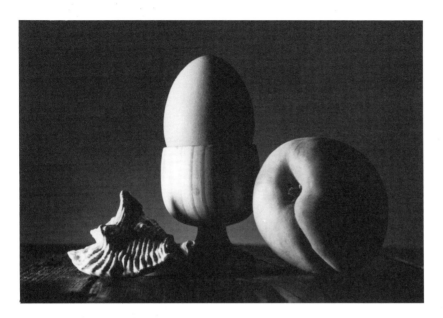

39, 40, 41 Fill-in lighting.

39 No fill-in.

relative powers are easily calculated for a range of effects. In some circumstances fill-in light illuminates the highlight area as well as the shadow. The following table lists the relative power outputs necessary to provide a range of lighting ratios in both situations.

When main and fill-in light illuminate separate areas:

Relative power		Lighting ratio
Main	Fill-in	Highlight : Shadow
1	1/2	2:1
1	1/3	3:1
1	1/4	4:1
1	1/6	6:1
1	1/8	8:1

When fill-in light illuminates highlight and shadow:

Relative power		Lighting ratio
Main	Fill-in	Highlight : Shadow
1	1	2:1
1	1/2	3:1
1	1/3	4:1
1	1/5	6:1
1	1/7	8:1

The figures in this second table look a little strange, but are really quite straightforward. Take the first set as an example. The main and fill-in

lights are equally powerful and at the same subject distance. But the main light only illuminates the highlights while the fill-in reaches all parts of the subject. Consequently the highlight areas receive twice the amount of light reaching the shadow, so creating the 2:1 ratio (1+1:1).

To achieve the reduced output necessary for other lighting ratios use one or more of the following methods:

1 A source with lower power.
2 Fractional power setting.
3 Neutral density filters on the light.
4 Reflection or diffusion.
5 Increase light to subject distance.

In some circumstances a reflector board can be used instead of a separate light source to give a fill-in effect. This is a worthwhile technique as it frees a light which can then be used for another purpose. However, it is only really effective when used in conjunction with certain types of main light style which direct their output partially towards the board. Lighting from the side, top or below lends itself to this technique – a main light near the camera does not. A selection of reflector boards with various surfaces provides a measure of control over how much light is reflected. White and metallised surfaces (both matt and shiny) offer three levels of reflectivity. For subtle effects include one or two neutral grey boards as well.

40 3:1 ratio. Note how much effect the fill-in light has had on the background tone.

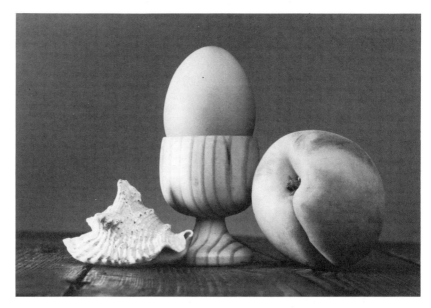

41 6:1 ratio

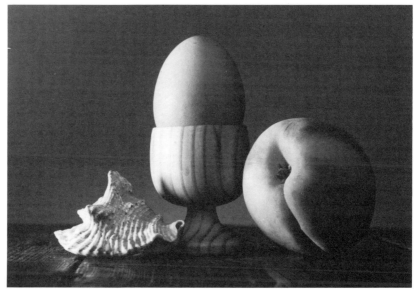

5 STUDIO AND LOCATION OUTFITS

Once you have decided on the type of light source which is best suited to your areas of interest, there remain two important questions – how many lights and how much power?

As a general rule it is better to buy equipment in response to a carefully considered need. To sit down and *imagine* what you might require without the pratical experience of having found that need, is a recipe for wasting money. Bearing this in mind, the best number of lights to begin with is two. One of these generally acts as the main subject light, while the other is employed in a variety of roles, eg. fill-in, background light and so on. In this way you gain experience and learn to identify real, rather than imagined, requirements.

But the number of lights you need cannot be considered in isolation, because number and power are intimately related factors. One of the reasons for this is simply that large, powerful sources are often more expensive than small ones, particularly flash guns and flash units. Consequently, with a given amount of money you have the choice of buying a few powerful lights or more lights with a lower individual and total output.

In making this twin decision you must bring in two further aspects – format and film. Shooting with a 35mm camera on fast film such as ISO 400/27° (ASA 400/27 DIN) or even faster you need far less light than when working on 4 x 5in materials with a slow emulsion speed such as ISO 25/15°– 80/20° (ASA 25/15 DIN) to produce a similar picture. These combinations represent the most common extremes. Power demands for other formats/film speeds are summarised below:

The reason for these various demands lies with the depth of field characteristics of the lenses used on different formats. For a shot where $f/11$ gives adequate sharpness with a 50mm lens on a 35mm format camera, an aperture of $f/32$ is needed to provide equivalent depth of field with a 150mm lens on 4 x 5in format. When an identical film speed is used the large format camera needs 8x the amount of light to provide this exposure.

With a large format camera you can often use camera movements to increase depth of field without closing down the aperture to very high f-numbers, such as $f/32$. A few lenses and bellows units for 35mm and medium format SLRs feature a limited range of camera movements which also provide this most useful control. Used with great care the right combinations of camera movement effectively reduce the amount of light you need. Returning to the earlier example: by applying the correct amount of tilt or swing movement the required depth of field may be achieved at $f/16$ instead of $f/32$. But this effective saving in light output of 75 per cent cannot be relied on in all circumstances. In general the power relationships outlined in the chart hold true.

Basic outfits

Tungsten: a modest outfit of two identical lights provides a good starting point. Photofloods (275W) in general purpose floodlight reflectors, with lamp sockets and AC cables, are both inexpensive and versatile. Once you have experienced their short life span you may care to change to more expensive 500W photographic lamps – they fit the same reflectors.

You also need two light stands, or two clamps, or one of each. An AC extension lead is a useful accessory, especially if fitted with twin-switched sockets. Do not forget to buy spare lamps.

Flash guns: select a pair with a GN of 30/100 (m/ft) for ISO 100/21° (ASA 100/21 DIN). It is tempting to consider one large and one small gun on the principle that the more powerful flash provides the main light, while the smaller gun acts as a supplementary source, lighting the background or filling in the shadows. However, this is not always the case and identical outputs offer the most flexible range of lighting options. Remember, one reason for starting with a basic outfit is to assess its performance and limitations.

Format:	Relative power		
Camera plus standard lens	35mm	Medium (eg. 6 x 6cm)	Large (eg. 4 x 5in)
Film speed			
Slow ISO 25/15° – 80/20°	●●●	●●●●	●●●●●
Medium ISO 100/21° – 200/24°	●●	●●●	●●●●
Fast ISO 400/27° plus	●	●●	●●●

Key: ●●●●● = most power needed
● = least power needed

For studio photography you need light stands or clamps, plus the necessary adaptor shoes to fit flash gun to stand. On location, a purpose-built bracket offers a superior and more controllable on-camera attachment than the hot-shoe fitting. Some brackets take two flash guns. In either situation you require a slave cell or connecting lead and an extension sync lead.

When you have to arrange lighting carefully, clip-on modelling lamps (60–200W) enable you to prejudge the effect of the flash (even if only approximately). Operating the guns on AC power in these circumstances offers the advantages of consistent recycling times and negligible running costs. A flash meter is the ideal means of determining exposure, but can be omitted at this stage. *Monobloc flash units:* choose two units with a GN of 50/160 (m/ft) for ISO 100/21° (ASA 100/21 DIN). In addition, you require two stands, AC cables, a slave cell or lead link and a sync lead.

Most monobloc units are made without integral reflectors and are designed to accept a range of interchangeable dishes – from which you should buy two general purpose reflectors. Monobloc flash units are ideal light sources for location photography when an AC supply is available, in which case an AC extension lead is useful. A flash meter is a highly desirable acquisition unless you intend to use the units only in studio conditions with all the ambient light excluded. In these circumstances a continuous light reading from the modelling lamps gives accurate exposure estimation once you have established the relationship between modelling lamp and flash tube outputs. Remember to buy spare modelling lamps.

Due to their high cost and large size it is unlikely that you would consider a console flash unit as an item of basic equipment.

Roles and reflectors

After a certain amount of experience with your basic outfit, its limitations become clearer – you need more control, more sources and greater power.

The general purpose reflectors and unmodified flash guns give a wide spread of light, which can be softened if necessary by reflection or diffusion, and controlled with the aid of improvised flags. But it is not possible to produce a more intense, narrow beam of light with either the tungsten floodlights or the monobloc flash units and the chosen reflector dishes. A plastic fresnel lens can be fitted to the flash gun to narrow and

intensify its light output, but the effect cannot be seen without an instant-picture test shot.

To give hard and soft effects with minimum light loss you need additional types of light or reflector which offer more distinctive light distribution patterns:

1 Small, polished 'high performance' reflectors and spotlights to give intense, narrow beams of light.
2 Large, matt surfaced dishes with 'caps' to produce soft lighting with a greater intensity of illumination than you can achieve with a reflector board or separate diffuser.
3 Metallised, white and translucent umbrellas to provide soft lighting and a compact portable size for location work.
4 Integral diffuser/reflector unit for soft, high intensity lighting which can be located very close to the subject.

If you use your two basic lights to produce a variety of combinations, such as a main light plus fill-in, main light plus background light, and so on you soon encounter situations where main light, fill-in *and* background lights are required.

The need for more power becomes evident when you change from a 35mm to a medium format camera, use slower film or begin to shoot pictures which require lighting over a larger area, greater available depth of field, or a higher shutter speed.

To cope with these increasing demands you must move on to a more comprehensive outfit.

Extended outfits

The basic outfit of two lights forms a good nucleus for an extended outfit. If you intend to specialise in one or two areas of interest you are usually able to select additional lights knowing exactly which roles they will fulfil.

In this case you can choose their precise power and output characteristics.

Imagine that you have decided to specialise in still life photography, shooting only in studio conditions with AC powered monobloc flash units. Adding a third more powerful flash, equipped with an integral diffuser/reflector unit gives you a soft source with the advantage of high light output. This combination is ideal as a main light for most still life subjects.

But if you retain a wide range of interests your lights have to serve many different roles:

1 Alternative styles of main lighting.
2 Range of fill-in effects.
3 Local lighting, especially on backgrounds.
4 Accent lights, such as rim or hair lights.

Many of these functions cannot be anticipated at the time of purchase. In this event the most flexible approach is to buy additional lights or reflectors which offer a range of different qualities but, nevertheless, have compatible outputs. Generally speaking a hard source and a soft source added to the two basic lights make an excellent outfit.

Tungsten. Add a 500W spotlight and a large reflector dish capable of taking a 500W or 1000W lamp. An alternative is to add two spotlights, producing soft lighting when it is needed by reflecting the output of one spotlight from a white reflector board. For colour photography you must ensure that all lamps have the same colour temperature.

Changing over to photographic or tungsten-halogen lamps is worthwhile at this stage. You need two more stands: clamps are unsuitable for larger lights.

Flash guns. Most guns produce a similar angle of illumination. So, achieving different qualities of light becomes a matter of selecting the appropriate accessories. Plastic fresnel lenses are primarily intended to match illumination angle to the angle of view of the camera lens. But those for telephoto lenses can also be used to create local lighting effects, though the light pattern is often clearly a rectangular shape and not suitable for subtle gradations of brightness. For soft lighting an umbrella is ideal, particularly if the surface is metallised to reflect more light. A second white or translucent umbrella is useful for providing soft, low intensity lighting, such as you may need for fill-in.

If you purchase additional flash guns of the same type all your accessories will fit each gun. You also need another two slave cells, stands or clamps.

Monobloc flash units. Light quality is controlled largely by the choice of interchangeable reflectors. Although special spotlight units are made, many photographers find that a snoot provides a sufficiently similar result to those at a fraction of the price.

By buying another two identical flash units, plus a number of reflectors, your extended outfit offers the most flexible range of lighting options:

Reflector	Major applications
Snoot	Local effects – accents, background lighting.
High performance	Local effects – accents, background lighting.
General purpose	Main light, background light.
Large diameter	Main light.
Umbrella:	
1 Metallised	Main light.
2 White	Main light, fill-in.
3 Translucent	Fill-in.
Diffuser/reflector	Main light, fill-in.

Two more slave cells, stands and AC cables are needed.

Other light sources

Console flash units share many characteristics with the monobloc unit but have a higher output and a larger size and weight. For medium and large format photography where control over depth of field is crucial and slow films are likely to be used, the console flash unit should be considered as a superior alternative. It is a particularly useful source for still life work, where soft lighting from a single source is often all that is needed. Full power through one flash head fitted with a diffuser/reflector provides an adequate exposure in most circumstances.

However console flash does suffer from one important *potential* drawback: all the power stems from a single source – the powerpack. Should any faults occur your whole outfit becomes inoperative. Compare this situation to an outfit of self-contained monobloc units, where the chances of more than one breaking down at the same time are very remote.

Domestic lamps and fluorescent tubes tend not to be considered seriously as light sources which can form the basis of an outfit. You are most likely to encounter them as artificial ambient sources. High power domestic lamps (100–200W) are suitable alternatives to photofloods when a fairly low level of illumination is acceptable and colour temperature is not critical: a simple still life or a copy photograph shot on black-and-white film is a typical application.

Expendable flash can be regarded as obsolescent, though it does provide a remarkably high output which is useful for some location photography. Flash guns for expendable flashbulbs are quite rare and do not offer the variety of features found on electronic guns. The secondhand market is likely to provide more equipment than current suppliers. If you do find flashbulbs suit-

able for some assignments electronic flash accessories such as umbrellas, stands and slave cells can normally be used.

Outfit lists

It is a good plan to make an inventory of all equipment and list any serial numbers. This is particularly recommended for location photography when it is often vital that certain accessories be included. The list also acts as a check for lost or damaged items.

For an outfit of four lights the following is suggested as a general guide.

Item	Number
Lights	x4
Stands	x4
Boom	x1
(Clamps for compact lights)	x4
Floor level stand	x1
Low level mounting bracket	x1
AC cables	x4
Extension AC cables (twin sockets)	x2
Slave cells	x3
Sync lead	x1
Extension sync lead	x1
Reflectors/umbrellas	
Barn doors	x2
Snoot	x1
Supplementary modelling lamps	x4
Exposure meter/flash meter	x1
Reflector boards 60 x 90cm (2 x 3ft)	
white	x3
metallised matt	x2
metallised shiny	x2
Diffusers 60 x 90cm (2 x 3ft)	x2
Filters, ND, 80A, colours	
Black card 30 x 60cm (1 x 2ft)	x5
Double ended clips	x8
Adhesive tapes	
Torch (flashlight)	x1
Book of film data etc	
Notebook, pen	
Rule, 30cm (1ft)	

Spares

Lamps } minimum each wattage	x2
Modelling lamps }	
Slave cell	x1
Sync lead	x1
Batteries/accumulators for flash guns	x2 sets
Batteries for exposure/flash meter	x1

Electrical repair kit

Screwdrivers, small and medium	
slot head	x2
cross head	x2
Fuses	
Fuse wire	
Wire strippers/cutter	x1
Soldering iron	x1
Solder	
Circuit tester	x1

Cases

Robust padded case(s) for lights, meters, lamps. Bag or small cases for other items.

For location work take into account case dimensions and weight in relationship to the journey and mode of transport. Remember that whereas at home you may be able to pack everything into the back of the car in 10 minutes, at your destination you could be faced with a long walk. Where possible, fit cases with shoulder straps and handles – a back-pack enables you to carry the greatest weight with the least fatigue although its contents are, of course, less immediately accessible.

Many other accessories are needed for subject support and treatment – these are detailed in following chapters.

Tracing faults

Lighting equipment which fails to function properly is a source of embarrassment and frustration. On a professional assignment finding faults wastes expensive time and can destroy your concentration. Before starting work or setting out on location always check all your lights, cables, slaves etc. If you do have a breakdown you should follow a logical analysis to find the fault. With AC, work from the master fuseboard to the item of equipment at fault. For a tungsten light:

1 Check the supply.
2 Change the lamp.
3 Check or change the individual equipment fuse.
4 Test the individual socket – connect the other lights.

If the light does not work, the circuit between plug and lamp is faulty and requires repair. Remember that when a lamp does burn out it often blows the fuse so when replacing the lamp expect to have to renew the fuse as well.

For an AC powered monobloc flash unit:

1 Check the supply.
2 Check or change the individual equipment fuse. Note if the modelling lamp works. The most common cause of temporary flash breakdown is the modelling lamp burning out and blowing the fuse.
3 Test the individual socket.
4 Change the cable.

For a battery powered flash gun:

1 Check the battery alignment.
2 Confirm the pressure of the contact.
3 Clean the contacts.
4 Check or replace the batteries.

If the flash gun or unit fires on open flash, but does not fire when connected to the camera, the problem usually lies with the sync lead or its connections. Replace with a spare. If you still cannot fire the flash:

1 Short-circuit the 3mm sync plug with a small piece of metal, paper clip or ball point pen tip. This tests the internal sync circuit and the lead to the flash connection. Assuming the flash fires, continue:
2 Check the lead-to-camera plug, clean and adjust the tension.
3 Some plugs screw apart – open and check the contacts. Assuming that the flash now fires when connected:
4 Confirm the correct synchronisation with the shutter: remove the lens, open the camera, look through the shutter at a blank wall illuminated by flash. You should be able to see the whole format area by the light of the flash.

This procedure checks on each contact in the sync circuit. When the flash fails to fire after stage 3 connect it to another camera. Correct synchronisation here indicates a fault in the sync circuit of the first camera.

42, 43 Testing electronic flash sync with a focal plane shutter. With the lens removed and the flash fired towards a plain wall or reflector board you observe the film plane.

42 Correct sync – the whole format is visible.

43 Incorrect sync – the wrong shutter speed has been set, or the theoretically correct speed is, in fact, too fast.

6 LIGHTING TECHNIQUES: PORTRAITS, PEOPLE AND PETS

People and animals are probably the most important subjects for the majority of photographers. Successful portraits, group shots and nude studies are the result of careful selection, observation and skilful direction of your models, together with the application of the most suitable lighting style. The addition of an indefinable atmosphere created by pose, expression and composition completes the whole mood of the picture.

Lighting, although very important, must be regarded as only one aspect of the process. You should learn to exert complete mastery over your equipment so that choosing the lighting style becomes an enjoyable and intuitive aspect of picture making.

Do not be too ambitious when you start. You will make better pictures at first by adopting a simple, basic approach to lighting, while concentrating on capturing lively or expressive poses. Too many inexperienced photographers concentrate solely on the lighting, producing superb examples of technique which lack the least spark of human interest. Only move on to explore a more experimental approach once you have mastered conventional lighting methods and learnt a little of that most difficult art – directing your model.

For many professional photographers portraiture is a major source of income. Experience gained in shooting portraits and nudes can also be applied to other commercial fields such as weddings, glamour, fashion photography and advertising.

Choosing the light source

The single most important influence in selecting a suitable light source is the approach you take to your subject.

If your pictures are not posed or arranged in any way you are limited to working with ambient light or a flash gun. This technique can produce the best results with a timid or camera-conscious subject, such as a young child. Using flash means that you will only secure a single exposure before your subject is made aware of your presence. For a black-and-white picture where accurate tonal qualities are relatively unimportant, infra-red film allows you to take photographs with a flash source which is virtually invisible to the human eye (see page 147).

A semi-posed approach means that your subject is co-operating and will respond to directions but is otherwise moving and behaving in a normal fashion. You can use this method to record a narrative sequence such as a craftsman at work, capturing significant aspects of his work spontaneously and without unnecessary artificial posing.

Ambient light, tungsten and flash are all suitable sources. You may have to light a fairly large area at an even intensity to ensure that all aspects of the activity are evenly lit. Floodlighting or bounce flash are suitable techniques. When shooting with existing light or low intensity tungsten you need high speed film – ISO 400/27° (ASA 400/27 DIN) or greater – and wide aperture lenses to ensure that you can set a shutter speed fast enough to avoid camera shake and to freeze subject movement – 1/125 sec or 1/250 sec are adequate under most circumstances.

The formal approach is the one you are most likely to adopt for the majority of portrait and nude photographs. Here you direct the subject(s) and control their movements – your instructions must be clear but friendly. The photographer/model relationship is a difficult one to get right – your attitude is of crucial importance. Any feelings of intimidation or hostility that you induce in your model are likely to be evident in the final photograph.

Any light source may be used but studio lighting with tungsten or flash allows the greatest degree of control. Where a certain amount of subject movement is inevitable, eg. when photographing a small child, flash lighting is ideal. Modelling lamps or instant-picture test shots are necessary to judge the effect of the lighting arrangement.

Tungsten allows you to judge the lighting directly, but can cause discomfort to your model. Many people dislike bright lights and react by squinting. The pupils in the eye also contract to a less attractive size. During a long session the build-up of heat can be significant, making the working environment quite unpleasant. Reducing power to bring the illumination down to a more comfortable level solves both problems. However, the lower brightness also requires an increase in exposure generally, so you run the risk of obtaining inadequate depth of field, subject movement or camera shake. For accurate colour

quality you must exclude all daylight when working with tungsten.

Most professional photographers shooting studio-based portraits and other pictures involving people use flash.

Other factors which influence your choice of the appropriate type of lighting equipment include:

1 Whether you have to work at any time other than the hours of daylight.
2 The need for a particular direction, quality or distribution of light.
3 Depth of field requirements and the area you have to light.

The chart below gives a breakdown of major light sources and their suitability for a range of typical subjects. For photography with existing ambient light see Chapter 15.

Lighting style: the basic portrait

A basic approach to formal portraiture uses up to four lights, each serving a distinctly different function – main light, fill-in, background and hair- or rim light.

Lighting style is governed by the number of lights you use, what roles they fulfil, their positions, qualities, relative powers and light distribution characteristics.

Camera viewpoint and pose also exert important influences. The outline that follows describes lighting applied to a head-and-shoulders portrait showing a full face and intended to produce an overall mid-key effect. Your camera should be roughly level with the subject's eyes, though a widely accepted convention suggests that you should shoot from slightly above a woman's eye level, and from just below the eye level of a man. These viewpoints tend to reinforce sexual stereotypes – woman looks up (submissively!), while man gazes down (dominantly!). You may care to make your own judgement on this matter.

Lighting roles

Main light. This defines the basic style by forming the most important areas of highlight and shadow on the face, including catchlights in the eyes. It may be a hard or soft source. With tungsten, either a spotlight or a floodlight may be used. For flash lighting a flash gun or flash unit fitted with a small reflector provides a hard effect, while a softer

Approach to subject

Light source		Unposed		Semi-posed		Formal		Typical exposure and film speed
		Child	Adult	Child	Adult	Child	Adult	
Daylight indoors		●●○○○	●●●○○	●●●○○	●●●●○	●●○○○	●●●○○	1/125 sec f/2.8 ISO 400/27°
Tungsten		●○○○○	●◐○○○	●○○○○	●●○○○	○○○○○	○○○○○	1/60 sec f/2 ISO 400/27°
Fluorescent		○○○○○	●○○○○	○○○○○	●◐○○○	○○○○○	○○○○○	1/30 sec f/2.8 ISO 400/27°
Low power 275W x 4		○○○○○	○○○○○	●●○○○	●●◐○○	●●○○○	●●●○○	1/60 sec f/5.6 ISO 100/21°
High power 500W x3 – 1000W x1		○○○○○	○○○○○	●●●○○	●●●●○	●●○○○	●●●●○	1/125 sec f/8 ISO 100/21°
Flash gun/flashbulb GN 30/100		●○○○○	●○○○○	●●●○○	●●●○○	●●○○○	●●○○○	f/16 ① ISO 100/21°
Flash units x 4 GN 50/160		○○○○○	○○○○○	●●●●●	●●●●●	●●●●●	●●●●●	f/16 ② ISO 100/21°

Key: ●●●●● = most suitable
○○○○○ = least suitable

GN is quoted in m/ft for ISO 100/21° film
① Exposure assumes direct lighting
② Exposure assumes soft main lighting eg. umbrella reflector

quality can be arranged by using a large reflector or an umbrella. You can also achieve soft lighting with any source by diffusing it, or by using reflection from a large white surface, such as a reflector board, wall or ceiling.

The lighting effect is very distinctive with a hard source, as clearly defined shadows are formed on the face, particularly around the eyes and nose. Positioning the light is critical – changes of a few degrees, or the slightest alterations in pose, make a significant difference to the lighting. This characteristic makes a hard source like a spotlight demanding to work with but also an excellent aid to learning. Soft sources, such as umbrella flash, provide a lighting quality which does not change dramatically with minor variations in pose. Such a light source is consequently ideal for subjects such as small children, who may not always maintain a pose and who are unlikely to respond well to precise directions.

In addition to the detailed shadows on the face, the main light also forms a shadow of the subject which falls towards the background. This shadow is clearly defined and dense when you use a hard source but soft-edged and lighter in tone when formed by a large light source. It can be incorporated into your composition but a better plan for your first few portraits is to arrange sufficient space between model and background so that the shadow is cast on the floor, well out of your field of view. The background can then be lit separately.

An alternative name for the main light is the *key* light.

Fill-in light. The sole function of this is to lighten the shadows created by the main source by supplying an overall 'wash' of light which has a lower intensity. A soft source is located close to the camera or near the camera-to-subject axis. This quality and position means that the fill-in light has no distinctive characteristics of its own and does not form a detectable second set of shadows. It can be placed at, above or below your model's eye level.

For tungsten lighting a diffused floodlight is suitable or any compatible source bounced from a reflector board. With flash you can use a diffuser or reflector board in the same way. A translucent white umbrella is a versatile accessory because it can be used either as a diffuser or reflector.

The brightness of the fill-in light needs to be adjusted so that it is approximately one half of the brightness of the main light. As the fill-in light

illuminates both highlights and shadows this arrangement creates a lighting ratio of 3:1 (see page 45). Other ratios are required for more advanced lighting techiques and in order to cope .with certain lighting difficulties.

In some circumstances a reflector board can be used on its own, reflecting light from the main source. You can use this technique when your main light is positioned to produce three-quarter or side lighting. Choose a board with the necessary reflecting characteristics to provide sufficient light intensity.

Background light. as its name indicates, this light illuminates the background. A hard or soft source is used, located at a variety of positions, normally behind the subject plane. The background light is placed high, low or to one side depending on the effect required. You need to control the distribution of light carefully if you want a graduated tone or hot-spot of local intensity. Use barn doors, snoots and flags to modify the spread of light and prevent any unwanted illumination falling on your model. The background light must be placed so that surface glare is avoided. Glare formed in this way desaturates the background colour. Locating the light at an angle of 45 degrees or more to the lens axis usually creates reflections which bounce away from the camera and are not seen.

If surface reflections are unavoidable you can prevent desaturation by fitting your light with a filter of the same colour as the background. Filters can also be used to change the colour or introduce it. For a white background two or more lights are usually required to illuminate the area at an even intensity.

With tungsten lighting spotlights are ideal for local effects, such as producing a bright hot-spot, while floodlights are needed for even and graduated tonal qualities. Using flash, a snoot provides a similar effect to that of a tungsten spotlight – a flash gun or flash unit fitted with a general purpose reflector is suitable for most other styles of lighting.

A spotlight 'projector' is an interesting variation on the basic spotlight design which is particularly effective for background lighting with portraits. It is available in the form of a tungsten light and a studio flash unit. This type of spotlight allows you to project patterns on to the background by inserting masks into the optical 'nose' – a kind of simple projector fitted to the front. An ordinary slide projector can also be used in this way, though the intensity of light reaching the background is likely

to be rather low.

If you want a black background no lighting is needed. However, some light from other sources is certain to reach the background unless you take precautions to prevent it. Even with a background comprising black paper, or matt black paint, a small amount of light is enough to prevent your final picture from exhibiting a true, rich black. Use barn doors and flags to minimise the light intensity at the background plane and keep your model as far away as possible.

In a small room where these controls cannot be properly applied, use black velvet or flock paper as the background material. Alternatively, shoot against an open doorway using the unlit space of the room beyond as your backdrop.

Hair or rim light. This is a light which comes from above and behind the model to form a local highlight on the hair, edge of the face or shoulders. A hard source is normally used, such as a spotlight or a flash unit fitted with a snoot. Take great care in locating a hair or rim light to avoid having light directly enter the camera lens. Should this occur your image will be degraded by flare. To prevent it, position a flag between the light and the camera.

A rim light is used with a dark-toned background, never when the background is white. Try to avoid too much light falling in the ears, and any at all reaching the nose. If your model has a suitable hairstyle (voluminous curls or back-combed) your light can be placed behind her head, directly in line with the camera. This arrangement creates a complete halo of backlighting around the hair – it is particularly effective with blonde female subjects. Look out for parts of the light support assembly, slave cells, cables etc. appearing in the shot.

Two lights, one from each side (but behind) the model can be used to produce a double rim effect. You can also use two lights together to perform the separate functions of a hair and a rim light.

Positioning is quite critical, so small changes in your model's pose can make major differences to the lighting effect. The rim light in particular should only be used with a model who will respond to accurate directions.

Lighting combinations

The four lights can be used in a variety of combinations. When setting up always begin with the main light, adding others only when you clearly identify a need for them. Remember that you can take excellent pictures with only a single light. Never simply switch on all your lights and move them around until the lighting looks right – the chances are that it never will!

Using one light

The main light alone is often all you need. By carefully positioning your model and light, one source can illuminate both subject and background. Soft lighting can be employed without a fill-in, particularly when your lamps are in frontal and three-quarter front placements.

There are three basic positions, each one located at a height slightly above the model's eye level. Watch out for unpleasant shadows forming around the eyes. If these occur reduce the height of the light.

Frontal lighting. Here, the light is placed close to the camera to create the minimum of shadow. This style is sometimes referred to as 'butterfly lighting' because the shadow from the nose formed by a hard source is said to resemble a butterfly. It is a useful method to adopt when the mood to be created by the lighting has to be fairly neutral and the subject not be overwhelmed by photographic technique.

Frontal lighting also has the advantages of suppressing skin texture and forming shadows at the sides of the lower jaw, so making the face appear somewhat thinner. This approach is the basis for most conventional 'glamour' portraiture, and high-key lighting effects. Study photographs of film stars and pictures of models on magazine covers – most are based on frontal lighting.

Three-quarter lighting. Here the light moves round to about 45 degrees from the lens axis. One half of the face is fully lit while the other is in partial shadow with a single inverted triangle of highlight falling on the upper cheek. The shadow from the nose reaches down towards the corner of the mouth. Small rotational movements of the head and slight adjustments to the position of the light have a very marked effect on the shadow quality of the partly lit side. When you use a hard source this change in quality is especially noticeable: for a specific lighting effect your model has to be able to maintain a pose without moving.

Three-quarter lighting is a good basic method which is interesting without being too distinctive, particularly when a soft source is used. Skin texture is shown quite clearly – the more so with a hard source rather than with soft lighting.

44, 45, 46, 47, 48 This sequence shows the effect of a single main light positioned to create the following lighting arrangements:

44 Side lighting (from the left).

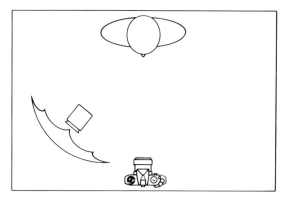

45 Three-quarter lighting (from the left).

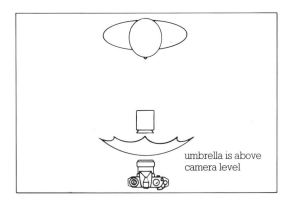

umbrella is above
camera level

46 Frontal lighting.

47 Three-quarter lighting
(from the right).

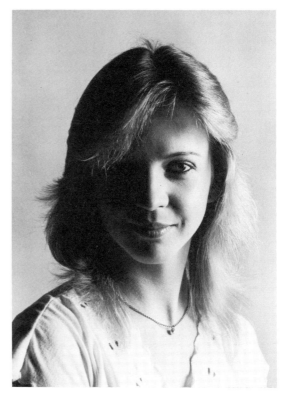

48 Side lighting (from the right). A 275J monobloc flash unit fitted with a 1m (3ft) metallised umbrella was used for all pictures; it was located about 1.5m (5ft) from the subject.

Side lighting. If the light is taken round to roughly 90 degrees from the lens axis it lights one half of the face, leaving the other in complete shadow. The effect is similar whether a hard or a soft source is used. You will often notice an unattractive shadow forming close to the eye, near to the nose. When this appears, bring your light a few degrees back towards the camera. You should be able to reduce the size of this shadow without throwing any unwanted light on to the unlit half of the face.

Side lighting with a hard source gives strong emphasis to skin texture. It is a most distinctive style producing a dramatic and unconventional effect. Use it when you want to create a mood, rather than to simply produce a flattering likeness.

Three-quarter and side lighting can come from the left or right. Changes in lighting direction are made by moving light, model, camera or any combination. This gives rise to an infinite number of subtle variations on the three basic directions.

Using two lights

With two lights at your disposal, three main combinations are possible, assuming that a main light is used each time.

Main light plus fill-in light. This combination allows you to reproduce on film a close representation of the visual lighting effect. A lighting ratio of 3:1 is recommended for colour photography. Higher ratios are possible with black-and-white emulsions or when a more dramatic style is required. One approximate method of judging how much fill-in light you need is to 'squint' at your subject through narrowed eyes. This rather bizarre procedure has the effect of simulating, very roughly, the response of a photographic emulsion. If you can see adequate shadow detail through almost closed eyelids then the film will be able to record it. The most common mistake of inexperienced photographers is to use insufficient fill-in light.

The correct use of fill-in is crucial when you are attempting to produce an accurate likeness and employing a main light to provide three-quarter or side lighting. Both styles result in a large area of shadow on the face. Unless this is adequately lit by fill-in your lighting will be over-dramatic.

The fill-in light usually produces a second catchlight in the eyes, larger but less intense than that created by the main light.

Main light plus background light. The addition of

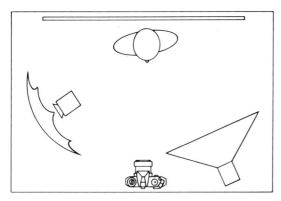

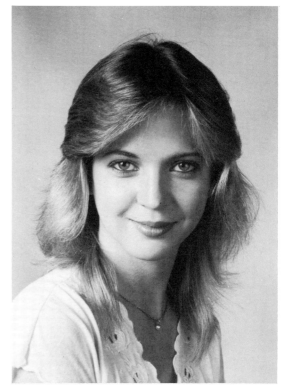

49, 50, 51, 52, 53 Using two lights to produce a range of lighting combinations. In each case, the same basic three-quarter style is used for the main light.

49 Main light plus fill-in. A 1m (3ft) diffuser unit was used close to the camera to provide a 3:1 lighting ratio.

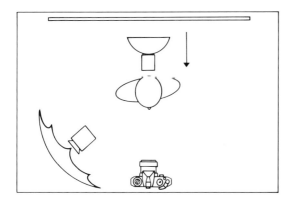

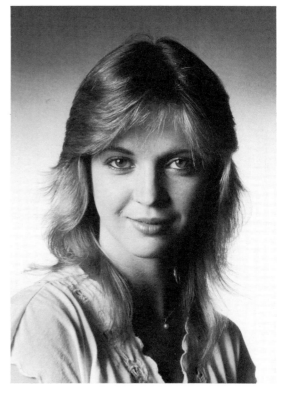

50 Main light plus background light. A general purpose floodlight reflector was fitted to the second flash unit. This was then placed behind the model close to the floor. The gradation in tone was achieved by using a flag attached to a small boom to cast a shadow on the upper part of the background paper.

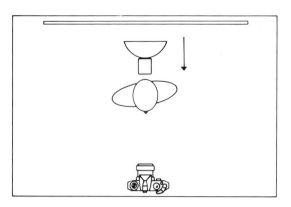

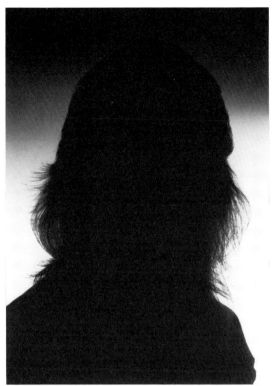

51 The effect of the background light alone.

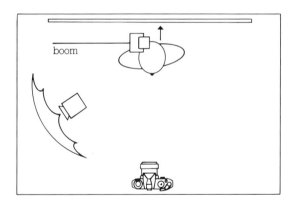

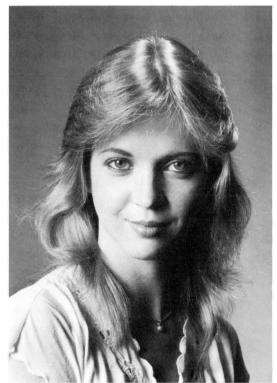

52 Main light plus hair light. Here the second flash unit was fitted to a boom and equipped with a snoot. It was located about 60cm (2ft) above the head of the model.

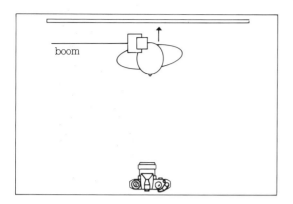

53 Lighting provided by
the hair light alone.

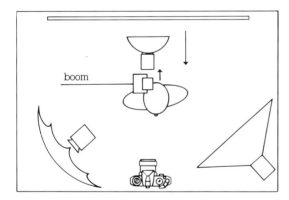

54 Four lights were used
for this picture – three-
quarter main light, fill-in
(3:1), background and hair
light. For pictures **44–54** a
35mm SLR was used fitted
with a 90mm lens. Exposure
was *f*/11 without fill-in and
f/11 + 1/2 with fill-in on ISO
100/21° (ASA 100/21 DIN)
film.

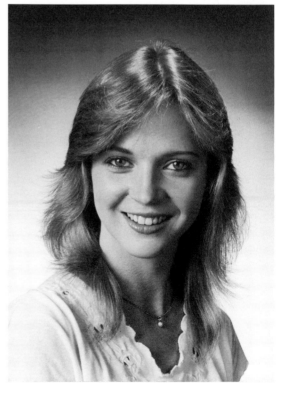

a second light directed specifically on to the background serves to separate the subject from the surroundings. By using a suitable background and lighting style you can emphasise certain aspects of the subject and convey a sense of the three dimensional.

Imagine you were photographing a blonde girl wearing a black dress. If your background was graduated in brightness, from light at the bottom to dark at the top, both hair and dress could be seen clearly against a contrasting tone.

You can use the same idea to create a background suitable for a dramatic, side-lit portrait – a dark area behind the fully lit half of the face, with the shadow side set against a much lighter tone. This principle of tonal interchange between subject and background is a good basic technique to bear in mind, whether you are shooting in black-and-white or with colour film. A hot-spot located behind the head draws attention to the face contained within the lighter area while the darker edges and corners of the picture serve to reinforce the dominance of the central area.

Main light plus hair or rim light. A hair or rim light also has the function of separating your subject from the background. Without specific lighting the background becomes a mid-tone or very dark. The hair or rim light adds a band of light tone which clearly defines the important subject contours of hair, cheeks, neck and shoulders.

With a main light positioned to create three-quarter or side lighting the hair/rim light is often located on the opposite side in order to produce local edge lighting on the shadow half of the face. Do not use too powerful a light for a conventional portrait as the effect then becomes rather theatrical.

Function of light

Number of lights	Main	Fill-in	Back-ground	Hair/rim
2	•	•		
2	•		•	
2	•			•
3	•	•	•	
3	•	•		•
3	•		•	•
3	•		••	
3	•			••
4	•	•	•	•
4	•	•	••	
4	•	•		••
4	•		••	•
4	•		•	••
4	•		•••	
4	•			•••

Using three and four lights

As the number of lights increases, so do your lighting options. With a total of three lights you have *five* combinations, assuming that each one includes a main light, and that a single fill-in light is used or not used. Applying this principle to a set-up with four lights *seven* combinations are possible. The following chart summarises all likely combinations using two, three and four lights.

The purpose of using additional lights is to improve the picture. Do not use them merely because they happen to be available. Build up your lighting arrangement in stages checking carefully to see what each light does individually and if it interferes with the function of another light. There is little point in adding a bright patch of light to the background if this diminishes the effect of a hair or a rim light.

The final result to aim for is a harmonious pattern of light and shade which suits the model without being too ostentatious. A *conventional* portrait is an accurate, perhaps slightly flattering picture of a person, not an exercise in photographic technique.

Power requirements

Choose enough overall power to provide a suitable exposure. Specific data for a range of typical situations is given in the picture captions. The

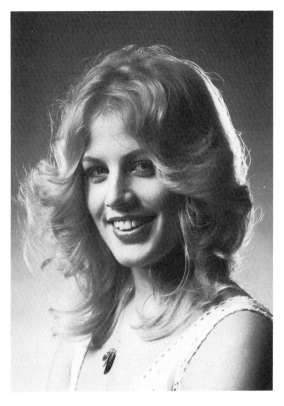 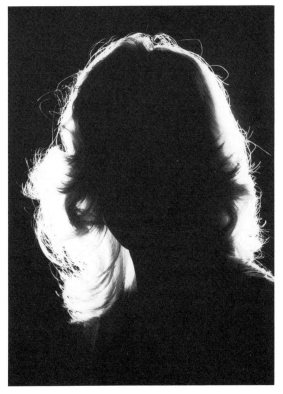

55, 56 With a blonde female subject, try placing the hair light immediately behind her head to create an overall 'halo' of light. Watch out that part of the lighting unit, cable or slave cell does not appear to be growing out of the model's head!

55 Four lights were used, each one operated from a console flash unit. Main light was a 1m (3ft) metallised umbrella. The fill-in ratio of 4:1 was achieved by bouncing light (from a flash head fitted with a general purpose reflector) off a 60 x 90cm (20 x 30in) sheet of white

card. Background lighting was provided by another head equipped with a general-purpose reflector and the hair light was fitted with a snoot. A 6 x 6cm SLR was used, fitted with a 135mm lens. Exposure on ISO 32/16°(ASA 32/16 DIN) film was *f*/11.

56 Lighting with the hair light on its own.

power requirements of the fill-in, background and hair/rim lights, compared to the main light, are highly variable and depend on a number of factors. These include subject tones, the way in which you produce soft fill-in lighting and the size and tonal qualities of your background.

Blonde hair, for example, requires less light than black hair for a given lighting effect. Fill-in light produced by reflection from a white card needs a more powerful source than when diffusion is used. A large white background requires more power than a small dark toned area.

Lights with the same output provide a flexible answer. Flash equipment which can be adjusted to fraction power settings is ideal. Working with

tungsten you can carry a stock of lamps with various wattage ratings, though for colour photography they must all have the same colour temperature. Where each lighting unit has a fixed output it is possible to reduce the intensity of light reaching the subject or background by fitting neutral density filters or applying a suitable diffusion or reflection technique.

Lighting problems
Because of its popularity, portrait photography is the area in which you are most likely to be offered your first paid commission. In common with a professional portrait photographer you often have to deal with a person whom you would not normally

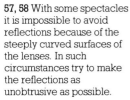**57, 58** With some spectacles it is impossible to avoid reflections because of the steeply curved surfaces of the lenses. In such circumstances try to make the reflections as unobtrusive as possible.

57 A 1m (3ft) metallised umbrella produces very distinctive and unattractive reflections.

58 By replacing the umbrella with a diffuser unit and carefully choosing your viewpoint, less distracting reflections are formed. Watch out for reflections of light stands, tripods and so on.

choose as an ideal model.

Portraits are usually taken, not for the subject's own use, but for the benefit of a third party. A child is photographed so that the grandparents can be sent a picture, an executive needs a portrait for his company's house magazine, and so on. Your client may be viewing the forthcoming experience with all the trepidation associated with a visit to the dentist! You will frequently be faced with a shy, embarrassed person with no natural aptitude for modelling who would much rather be doing something else. In addition, they may have facial features which present particular lighting problems. Such a person is a challenge to your abilities both as a diplomat and as a photographer.

Spectacles. A very common lighting problem is that of trying to avoid reflections in spectacle lenses. You need to use a source which allows you to judge the lighting effect or, alternatively, make instant-picture test shots.

Most reflections can be prevented by using a *small* main light source positioned to form three-quarter or side lighting and located slightly higher than normal. A large source, such as a flash umbrella, is difficult to work with. The exact location of the light depends on the size and strength of the lenses in the spectacles. Large, powerful lenses with steeply curved surfaces reflect from a wide angle and require the light to be located well round to one side. Unfortunately this type of

lighting produces a second problem – shadows on the face, formed by the spectacle frames.

Try to achieve a compromise in which reflection is avoided without creating obvious, unpleasant shadows. In particularly difficult cases you should accept a small amount of reflection at the edge of the lens away from the eyes, rather than produce distracting shadows. You can easily retouch a print to remove minor reflections.

The fill-in light also forms its own reflections. These can be minimised by raising or lowering the source. The large size of a fill-in light makes it more difficult to avoid reflections completely, though the lower brightness means that any which do occur are less intense. Such reflections are often not too unattractive provided that they are at the edges of the lens. They can be reduced in intensity by using a pola screen.

If your subject normally wears spectacles, but has removed them for the photograph, check to see if the frames have left any marks on the nose – your subject may not be able to see these in a mirror with unaided vision! They will usually disappear in a few minutes, aided by some gentle massage. In a bad case a local application of make-up will disguise them. Almost everyone wants to look their best in a photograph. A minor temporary blemish, which can easily be remedied by something as simple as a little make-up, is best mentioned before the session starts. An honest but tactful and friendly word is indicative of a professional attitude. It also saves disappointment or awkward retouching.

Skin blemishes. Extensive facial blemishes which are undisguised by proper make-up can be minimised by using soft frontal lighting. This technique suppresses uneven skin texture but does not improve any areas of discolouration.

With pale skin containing red blemishes use warm-coloured filtration to reduce the contrast. A CC10R filter helps with colour materials, but for black-and-white photography you can fit a deep red filter to make a much more dramatic improvement. The lips are rendered unnaturally pale but this is a small price to pay for the obvious benefit. Where possible, suggest the application of dark lipstick to offset the filtration effect. This technique is also suitable for toning down freckles.

Colour negative film can be shot unfiltered, but the print made deliberately 'off-balance' to produce a warm skin tone.

A local skin blemish, such as a scar, can sometimes be partly hidden by lighting the face in such a way that a shadow is formed in that area. In severe cases use as little fill-in light as possible. A soft focus screen fitted over the camera lens to reduce image sharpness also helps minimise the appearance of poor skin texture.

Facial hair. Suggest to clean shaven men that they shave shortly before the photographic session. If the pictures are taken in the evening your subject has twelve hours' growth on his face unless he does this. To minimise facial hair (other than beards) use soft frontal lighting and expose or print to produce a fairly light skin tone.

Other 'defects' can be considered more as physiological characteristics and you must seriously consider whether or not it is your job to record them honestly, or attempt to reduce their appearance on the final photograph. This judgement can only be made on an individual basis. You have to assess, perhaps in a brief few minutes, how someone feels about being wrinkled, or having a double chin, or a thinning hair line.

Most adults like to think of themselves as younger and more attractive than they really are, with an appearance that approximates to an 'ideal' defined by contemporary standards. Where possible, try two approaches – one showing the 'defect' in a straightforward way and the other suppressing it. If you use this method often enough you will gradually learn which approach is appreciated more. When you are short of time aim for the most flattering likeness. This is achieved by carefully controlling the lighting, camera angle and pose. As a general rule keep all those features that you want to suppress in shadow and further from the camera. These are the problems you are likely to encounter most frequently:

Dominant jawline. To make a broad face appear thinner use frontal lighting with the main light as high as possible (beware of casting deep shadows over the eyes). This style forms shadows over the lower cheeks making them less prominent. Use the minimum amount of fill-in light to keep the shadows fairly dense. Ensure that any hair or rim lighting is kept well away from the lower jaw.

Direct your sitter so that the head is turned to avoid a full-face pose.

Double chin. Use a similar lighting style and choose a high viewpoint.

Long or broken nose. Choose frontal or three-quarter lighting with a strong fill-in (ratio 2:1). A

full-face pose is best with the camera slightly below eye level.

Wrinkles. Use soft frontal or three-quarter lighting with a strong fill-in (ratio 2:1). Consider using a soft focus screen over your camera lens to reduce the clarity of fine image details.

Baldness. Minimise the amount of light falling on the scalp, although you can use a hair/rim light to highlight any hair at the side of the head. Do not use any form of lighting on the background which draws attention to the top of the head – scalp and background should be similar in tone. Choose a low viewpoint.

Deep set eyes. Use your main light at, or just above, eye level. Frontal lighting is preferable, although three-quarter lighting and side lighting are satisfactory when used with a strong fill-in (ratio 2:1). Select a low viewpoint or direct your sitter to raise his head.

Prominent ears. You must avoid any hair/rim light falling on the ears. A three-quarter or side lighting style is best for the main source, with one ear in shadow and the other receiving the minimum amount of light. Use a flag or barn doors to control the distribution of light on the fully lit side of the face. Do not light the background in any way which will emphasise the ears. Avoid a full-face pose: a profile is the best solution, if this is acceptable.

Unattractive teeth. Watch out for these and avoid a broad smile. Raising the main light casts a shadow of the upper lip over the top teeth. Use the minimum amount of fill-in to keep the shadow dense. Choose a high viewpoint. The best all round solution is to direct your sitter to keep his mouth closed!

Combination problems. It is likely that at some stage you will encounter a subject who presents you with more than one lighting problem simultaneously. In the most difficult cases taking corrective action to minimise one feature may aggravate another, eg. using hard side lighting to avoid reflections in spectacles actually emphasises wrinkles or skin blemishes. Conversely, ideal lighting for poor skin texture causes unacceptable glare in spectacle lenses.

Try to determine which problem is the more severe and correct for that as far as possible without unduly exaggerating other awkward features that the subject may have.

With difficult cases anticipate a degree of compromise and the possibility of some minor print retouching being necessary.

More advanced styles: Three-quarter face and profile

Although the full face pose is an excellent starting point, other attitudes of the head are generally more interesting. Ask your model to turn slowly away from the camera towards the light and observe carefully how the lighting effect changes. Two positions of the head are usually identified – *three-quarter face* when your model has turned through about 45 degrees, and *profile* which occurs with a 90 degree turn, leaving only one side of the head visible.

An infinite number of intermediate positions are possible and further subtlety is added by inclining the head.

Frontal lighting works well with a three-quarter face but gives a rather flat, featureless effect in combination with a profile. Three-quarter lighting gives a very similar result to a frontal approach, although you will notice less shadow on the far side of the face in the three-quarter position.

Side lighting is generally more successful. Used with a three-quarter face it produces the style usually known as 'Rembrandt' lighting. The far side of the face is fully lit with a small amount of light spilling on to the shadow half to form a characteristic inverted triangle of highlight on the cheekbone. Do not use too much fill-in light or the large area of shadow nearest to the camera may be too dominant.

In combination with a profile, side lighting produces a most pleasing effect with a band of highlight defining the facial contours and a graduation of tone across the cheek and jaw. A style similar to 'Rembrandt' lighting is produced by moving the light a few degrees further round, away from the camera, to form a narrow backlit rim of light on the forehead, nose and chin, complete with a typical highlight on the near cheek. Carefully control the intensity of your fill-in light to avoid creating a shadow area which is too light. This pose and lighting style together result in a distinctive, rather dramatic approach – do not dilute the drama with large flat uninteresting shadow.

A dark background is essential with these techniques.

Alternative compositions

In addition to the basic head and shoulders portrait you can compose a single figure in the following different ways – tight head, half length, three-quarter length and full length. They may be seated or standing poses.

The *tight head shot* fills the frame with the face.

59, 60, 61 'Rembrandt' lighting uses a three-quarter lighting in combination with a three-quarter view of the face. It is often employed with male subjects as the basis of a low-key lighting arrangement.

59 Four lights were used for this shot – main light, background, fill-in and hair/rim light. Identical monobloc flash units were chosen but the fill-in, background and hair/rim lights were set to quarter-power. The main light was fitted with a 50cm (20in) diffuser unit which, at a distance of 2m (6ft), gave a fairly hard shadow quality. Fill-in lighting (10:1) was produced by a 1m (3ft) diffuser unit, background illumination from a general purpose reflector dish, and the hair/rim light was fitted with a snoot.

60 With some subjects a tight crop is effective in emphasising their most striking features. This is a sectional enlargement of **59**.

Little, if any, background is visible and even the hair and upper forehead may be cropped off. Consequently, the main and fill-in lights are the only ones which make a significant contribution. Avoid using a hair or rim light if all it does is to introduce a distracting highlight at the edge of the picture. For optimum technical quality you should fill the viewfinder with a close approximation to the final composition. At such close focusing range depth of field is shallow, so focus on the eyes or, with a three-quarter facial view, the nearest eye. Use as small an aperture as possible, bearing in mind that with tungsten light you must also select a shutter speed which will avoid camera shake and freeze subject movement.

A *half length* portrait introduces those most awkward features – arms and hands. In many ways this composition is the most difficult to handle as there is a limited space in which to organise the limbs. One solution is to fold the arms loosely in front. Another useful trick is to ask your model to hold an undistracting object like a plain, dark toned book. One hand can be brought up to support the head, but this has to be done in a very sensitive way to avoid an impression of artificiality.

Pay particular attention to the clothes. Side lighting shows up creases and wrinkles very clearly – defects of this nature can ruin an otherwise well conceived picture. As a rough guide, a half length shot works best if you include a little of the body below the waist. If you crop above the waist it tends to look like a rather weak head and shoulders.

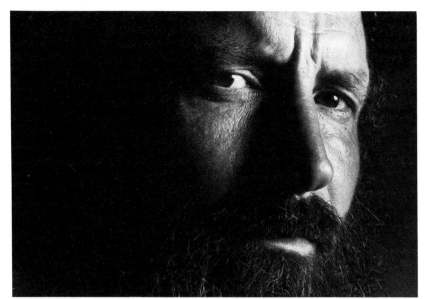

61 A lower viewpoint, tighter cropping and absence of fill-in light creates a less friendly, indeed almost hostile, expression. Experiment with subtle changes in lighting and perspective to explore nuances of mood.

59, 60, 61 A 6 x 7cm SLR fitted with a 135mm lens was used for these pictures. Exposure on ISO 100/21° (ASA 100/21 DIN) film was *f*/16.

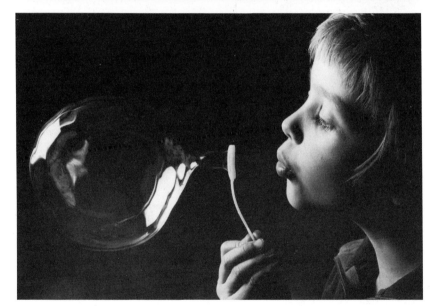

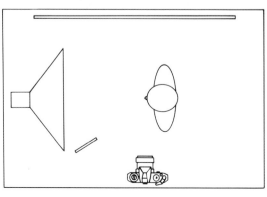

62, 63 The most effective lighting for profile portraits comes from the side to form a gradation of tone across the cheek and jaw. A 1m (3ft) diffuser fitted to a 120J monobloc flash unit was located at about 1.5m (5ft) from the subject. The camera was a 35mm SLR fitted with a 90mm lens. Exposure on ISO 100/21° (ASA 100/21 DIN) film was *f*/11.

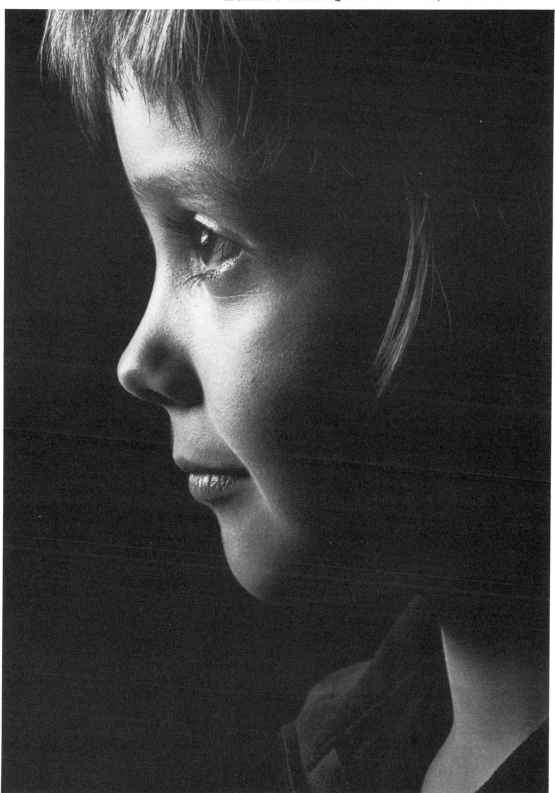

64 An ordinary flash gun is perfectly suitable for subtle and controllable lighting effects if it is equipped with a supplementary modelling lamp. For this tight head shot a fairly powerful gun – GN 30/100 (m/ft) for ISO 100/21° (ASA 100/21 DIN) – was fired into a white umbrella. A 60W domestic lamp in a clip-on reflector, positioned close to the flash gun, gave an accurate preview of the effect of the flash. No other lighting was used. The subject was close enough to the dark brown paper background for one light to illuminate subject and background. Camera was a 35mm rangefinder model fitted with a reflex housing and a 65mm lens. Exposure was *f*/11 on ISO 400/27° (ASA 400/27 DIN) film.

A *three-quarter* length portrait includes more of the figure, and is cropped just above the knee. More space is available for the arms and hands and so they can now be placed further from the body, perhaps bent at the elbow with the hands on the hips or head.

A *full-length* figure is completely uncropped. A useful basic (standing) pose to adopt is, in effect, a three-quarter face, but applied to the whole body so that one leg is placed in front, with the feet slightly apart and pointing away from each other. If your model than takes most of the body weight on the rear leg the posture is comfortable, stable and dignified. Check to see that dress, skirt or trousers are free from distracting folds or creases.

The background plays an increasingly important role as more of the figure is shown. In the case of a full length portrait you have also revealed for the first time some of the foreground. A seamless material such as background paper or fabric is ideal for pictures where all the emphasis is placed on the subject.

If you normally use a plain wall as your background, a full length shot will obviously include the floor. Remove patterned carpets and avoid including domestic fittings such as electrical sockets.

Lighting for half, three-quarter and full length portraits broadly follows the basic guidelines for a head-and-shoulders composition. But the lights, of necessity, have to be further from the subject. The hair or rim light in particular is difficult to locate, though a long boom fitted to a tall lighting stand solves most problems. Backlighting the hair to produce a halo effect at first appears to be impossible with a full length shot. It would seem that the light must be placed directly behind your model's head so the stand and power cable inevitably appear in the picture. However, this need not

happen.

By cutting a small hole in a paper background you can shine light on to the hair from a light source hidden behind the paper. A similar ploy involves placing a sturdy stand behind the paper. To this is attached a lightweight metal tube, which projects through a small hole in the background towards your model. A light is then fitted to the end of the tube and the power cable returned through the hole. A slave-synchronised battery flash gun is very convenient to use when flash is the source for general illumination. A variation of this technique replaces the light with a mirror which is angled at 45 degrees to reflect light from a source placed at one side. Metallised plastic film makes an ideal mirror which can be trimmed to exactly the shape and size required. If necessary, the metal tube is counterweighted to ensure stability.

In a full length picture you will inevitably include the shadow of your subject. Do not worry about this. The presence of such a shadow appears natural and often aids the composition by providing an undistracting dark tone at the base of the picture. If you want to minimise the shadow use a large main source and a strong fill-in light. It is possible to produce virtually shadowless lighting by using very soft light sources. The easiest way to achieve this is to bounce light from large white reflector boards (about 1.3 x 2m/4 x 6ft) or one board and a white wall. Two such reflectors located in front of the subject at angles of approximately 45 degrees provide a very soft quality of light and create no significant shadow. Each reflector is lit with a source of roughly the same power.

When using this approach you must ensure that the tones or colours of your subject and background provide sufficient inherent contrast.

A standing figure presents a rather long thin

65, 66 In a head-and-shoulders or half-length portrait, dealing with the hands and arms can be a considerable problem.

65 If you bring a hand up to support the face try to achieve a pose which is not too awkward or unnatural. Although obviously posed, this arrangement is still

quite elegant. An almost frontal main light is used which provides good highlight and shadow detail on the hand as well as the face.

66 There is little space in this tightly cropped half-length shot so the arms have been 'lost' by wrapping them round the torso.

shape which is difficult to compose within the normal confines of a picture format that complies with the usual 'standard' shapes whose sides have the ratios 2:3, 3:4 or 4:5 (eg. 35mm format is 24 x 36mm or a ratio of 2:3). Try an unconventional crop to make a narrow picture with the minimum of background. If you want to maintain a traditional format consider using some interesting props in the background to break up the large area of featureless tone – a table, desk or display of

indoor plants are suitable. Do not choose items which are too colourful or are so unusual and fascinating that they draw interest away from the subject.

A seated pose reduces the height and effectively extends the width of your model while also introducing a more interesting posture. Use a characterful chair or stool, or a support which is quite featureless like a plain box. When your background is fabric you can easily drape the

67 Experience with portrait lighting is of vital importance in commercial and advertising photography. This shot was commissioned for the dust jacket of a hardback book. Two monobloc flash units were used (one fitted with a metallised umbrella) and, placed to the right, provided three-quarter main lighting. The second unit, equipped with a white umbrella, acted as a fill-in light to give a 3:1 lighting ratio. No background light was used and the dark area above the model's head was introduced at the printing stage by burning-in. The camera was a 35mm SLR fitted with a 50mm lens. Exposure on ISO 400/27° (ASA 400/27 DIN) film was *f*/16. The 'banknotes' were specially made black-and-white enlargements.

68 The published bookjacket.

69 A full-length shot inevitably produces a shadow from the figure. In this shot, taken for a book jacket, it was important to retain as much emphasis as possible on the girl and the title. A dense, sharp-edged shadow at the base of the picture would have been too distracting. The lighting was arranged to create a soft effect, while still forming some shadows on the face and clothing. Main lighting was provided by a 1m (3ft) diffuser unit on the right while a 3:1 fill-in illumination was set up close to the camera by reflecting two lights from a 1 x 2m (3 x 6ft) reflector board. All lights were flash heads powered from a studio console. The camera was a 4 x 5in flatbed technical model fitted with a 150mm lens. Exposure on ISO 50/18° (ASA 50/18 DIN) daylight-balanced transparency film was *f*/11.

material over a box to disguise it. Watch out for your model becoming too relaxed and starting to slide comfortably down in a chair – this pose rarely looks good in a photograph.

High-key lighting

The purpose of a high-key lighting is to produce a picture with a very light, delicate atmosphere. This is achieved by using a limited range of pale tones with, perhaps, the exception of the pupil in the eye or some other very small area which might be black (though no other tone even approaches it).

Your model must be carefully chosen: this technique is best suited to pale complexions and subjects with blonde or light coloured hair. Because of its frequent use by Hollywood publicity photographers the high-key style is mainly associated with glamorous female subjects, though it is equally suitable for children. High-key lighting is not normally used for portraits of men (other than the exceptional theatre, movie or music industry publicity shot) probably because of this strong association. You may care to ignore such a traditional approach. Clothing and background must also be light in tone. A white background is usually the best choice to begin with.

Your main light must produce as little shadow as possible. A soft source located in the frontal position is ideal. Three quarter lighting is also suitable provided that you take steps to avoid lighting the side of the face in such a way that it becomes similar in tone to the background and so merges with it.

This is a particular problem when working in black-and-white. Frontal lighting offers the significant advantage that it casts shadows down the sides of the cheeks and lower jaw and in this way creates adequate separation from the background. A strong fill-in light is needed, with a lighting ratio of about 2:1. Pay special attention to shadows under the chin.

Do not use a rim light as it will destroy separation between the subject and background. However, a hair light is sometimes useful in lifting the tone of the hair which would otherwise appear too dark in the final picture. Position the hair light carefully to avoid forming a highlight at the edge of the hair. You need up to *five* lights for a high key portrait – main, fill-in, hair light and two for the white background.

Expose and process your picture very carefully

to preserve the delicate tonal qualities. A reflected light or TTL meter reading does not indicate an accurate exposure so in this case adopt the incident light reading technique. Take precautions to minimise flare by using an efficient lens hood (sunshade) and the minimum of white background area.

Low-key lighting

The low-key style can be regarded as the opposite of high key. Most of the tones in the final picture are dark or black with only the minimum of highlight area. Low-key lighting creates a sombre, romantic or malevolent mood depending on the subject, pose and facial expression. It is equally suitable for men and women but rarely for

70 This low key portrait was taken using only ambient daylight from a window. The soft-focus effect was produced by shooting with a simple magnifying glass taped to the front of a bellows unit – no conventional camera lens was employed. The camera was a 35mm SLR. Exposure on ISO 400/27° (ASA 400/27 DIN) film was 1/60 sec at an estimated aperture of *f*/3.5.

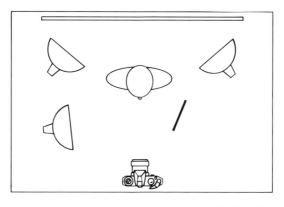

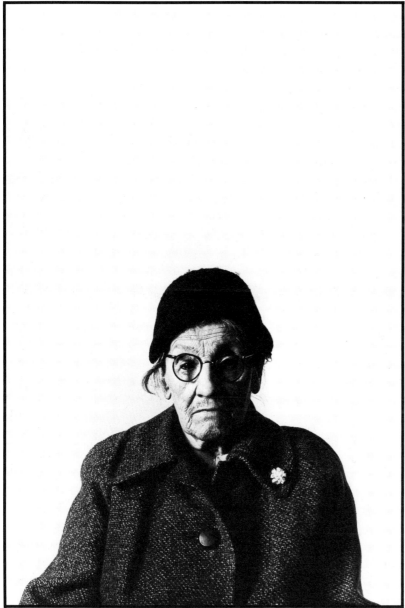

71 A large empty expanse of white background was chosen to imply isolation and loneliness which is the common experience of many old people. The 500W tungsten floodlights were directed at the background to ensure that a pure white was achieved. One light, fitted with an identical reflector, was used as the main source. A 1 x 2m (3 x 6ft) reflector board placed to the right side provided a 6:1 fill-in effect. The camera was a 35mm SLR equipped with a 50mm lens. Exposure was 1/125 sec at f/5.6 on ISO 400/27° (ASA 400/27 DIN) film up-rated to ISO 800/30° (ASA 800/30 DIN).

children. Subject tones are unimportant as the style is almost entirely controlled by the quality and distribution of the lighting.

Both hard and soft sources are used as the main light. The clearly defined, dense shadows formed by a hard light, such as a spotlight, tend to give the picture an aggressive atmosphere. Softer lighting provided by large sources conveys a more subdued impression. Three-quarter or side lighting is normally used in order to create the essential areas of shadow. Fill-in is either not required or is kept to a minimum.

The background in a low key shot is dark overall, but some areas of lighter tone can be formed to provide tonal interchange with the subject. A hair or rim light is used to further separate subject from background. You must control light distribution carefully to prevent any unwanted reflections acting as accidental fill-in lighting. Use a snoot, barn doors or flags to limit the spread of light. Matt black boards placed opposite light sources help absorb excess light. They are especially useful if you are shooting in a small room decorated in white or pastel shades.

A reflected light or TTL meter reading is unlikely to give accurate exposure so use the incident method.

In addition to portraiture the terms high-key and low-key are applied to other branches of photography.

Lighting for silhouettes

A silhouette is a simple type of portrait which reveals shape alone. The model is seen only as a dark mass set against a lighter background. Form, texture and colour are absent. Lighting for silhouettes is restricted to the background; you do not light the subject at all. There are two methods, depending on the nature of the background material:

Using paper or a painted wall you arrange two similar light sources equidistant from the background at an angle of 45 degrees or more from the lens axis. These sources must be capable of illuminating the necessary area at an even intensity.

An alternative method uses translucent material, such as acrylic sheet, tracing paper or drafting film. Fix the tracing paper or film to a wooden frame to stretch it taut. The translucent surface acts like a screen and is lit from behind by transmitted light (transillumination) with two sources arranged as before, but located on the other side

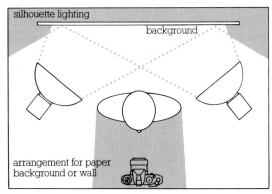

silhouette lighting

background

arrangement for paper background or wall

6.1 For silhouettes, you light the background only. With white material, two identical lights are located equidistant from the background, at an angle of 45° or greater to the lens axis.

of the background.

Place your model in front of the background in such a way that no light reaches her directly from the sources; use barn doors or flags if necessary. Limit the effective area of background to the minimum required to fill your field of view. You can do this by masking it with black card or paper.

The classic silhouette is a solid black profile head and shoulders portrait set against a white background. However, you can expand on this narrow interpretation to include other poses and a range of background effects such as graduated tones or projected patterns. But you must bear in mind that only the outer subject contours will be normally visible and that there should be no confusion between subject and background. Hands and arms should be clearly visible or hidden completely.

Interesting props with easily recognisable shapes add extra appeal to most silhouettes. If your model holds something, make sure both object and hand can be easily seen as outlines and are sharp at the taking aperture. Translucent or transparent props, such as a glass of wine, also work well in silhouette, adding a local spot of tone and colour.

Exposure measurement is best made from the background alone. For a classic white background, take a reflected light or TTL reading and increase it by a factor of 8x. With other backgrounds having an overall average tone, use the reading unmodified.

72 For a silhouette you only have to light the background. Two identical monobloc flash units fitted with general purpose reflector dishes were directed at the white paper background. Only a narrow roll of paper, 1.5m (5ft) wide was available – just enough to lie behind the outline of the subject. Extra white background was created at the printing stage by masking the negative with opaque tape. The camera was a 6 x 6cm SLR with a 75mm lens. Exposure on ISO 125/22° (ASA 125/22 DIN) film was *f*/16.

Strictly speaking, the term silhouette applies only to portraits although it is now widely accepted as a description for any subject lit in a similar manner.

Experimental lighting

Once you have become familiar with basic lighting and its more advanced variations, you may want to explore some less conventional styles. In many ways experimental lighting techniques tend to depersonalise your model so your picture might in this way become a photograph with a person as the subject, rather than a portrait of that person. This is not a criticism and it does not always occur but you should be aware of the strong possibility that it will happen.

You must think of your own experiments in lighting – to follow detailed guidelines in a book is in no way experimental! However, you may care to consider one of these ideas as a starting point for your own explorations.

Lighting direction. Try on-axis or near axial lighting with a ring flash or a flash gun placed very close to the lens. The very flat lighting quality is normally unsuitable for portraits but can be effective when combined with a tight crop and a distinctive facial expression or unusual make up. With the light very close to the lens you are at risk of producing the effect known as 'red-eye' or 'pink-eye' – a reflection from the retina. This can be exploited to produce an unreal gaze especially with black-and-white infra-red film (see page 147).

Lighting from below gives the face a grotesque appearance, particularly with a hard source. Soft lighting is more subtle, producing a quality which is slightly disturbing without being obviously theatrical.

Local lighting. Restrict your main lighting to narrow strips, squares or circles of light striking the face and body. Use a spotlight projector, slide projector or barn doors to create the shaped beams of light. A fill-in or background light allows the complete face or figure to be seen. Used alone with a black background the main light picks out only isolated details. An alternative technique uses a powerful backlight placed behind the model's head. Small mirrors or strips of metallised plastic film then reflect beams of light back to the face and body.

Image projection. Use one or more slide projectors to project images directly on to the model – simple patterns and geometric shapes work well. The same projected image can also cover the background to produce a subtle effect where model and background practically merge.

Mixed lighting. Combine tungsten and flash making no attempt to filter either source to match the colour temperatures. With daylight-balanced colour film the areas lit by tungsten are yellow. If you use tungsten-balanced film parts of the subject lit by flash are blue. A powerful tungsten light used to backlight hair gives a rich yellow halo when the main lighting is flash. Vary the effective brightness of the backlighting by changing shutter speed.

Filtration. The principle of mixed lighting can be further extended by adding various coloured filters to your lights.

Exposure. Certain types of lighting give quite different results as you increase exposure. In most cases deliberately overexposing merely produces a dense negative or a transparency which is too light and unacceptable. However, with silhouette lighting increasing the exposure beyond the minimum level required for a white background introduces flare. This has the effect of degrading the image and allows detail to be seen in those areas which would normally record as solid black.

A high-key portrait can also be deliberately overexposed to burn out all but the darkest tones. Provided that you have taken steps to minimise flare the pupil remains black. This technique leaves a face which comprises only the major features of eyes, nostrils and mouth. All skin tone and texture is absent. With a suitable subject try using dark lipstick and eye make-up to partially offset the effects of extra exposure.

Deliberately overexposing is a technique which works better in colour – the limited range of tones tends to look rather flat and lifeless in black-and-white.

Experiment with various combinations of these lighting methods and also try involving aspects of a more basic approach. Something as simple as low key lighting on the face combined with a *white* background makes a striking picture.

Group photography

Photographing a number of people is more difficult than dealing with an individual. It becomes even more awkward as the numbers increase – or the ages decrease!

Finding a background that is large enough and arranging the group in front of it are the major problems. A large plain wall offers the simplest solution. Seamless background paper in the standard width of 2.7m (9ft) is suitable for about three to five people photographed full length. Wider rolls are available but you can unroll a 2.7m width sideways. If necessary two sections can be lap-joined with doublesided adhesive tape to make a

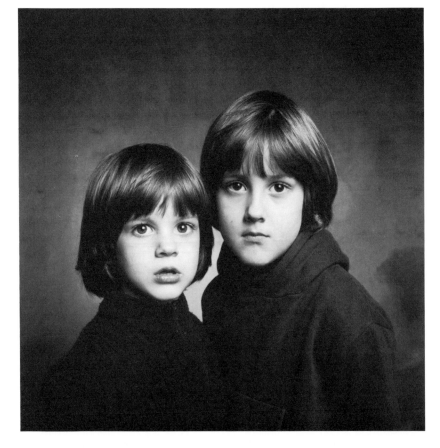

73 Start shooting group portraits by working with two people. Keep your lighting simple and not too dependent on an exact pose. Avoid lights that need critical positioning such as hair or rim lights. Lighting for this shot used only two monobloc flash units. The frontal main light was fitted with a 1m (3ft) metallised umbrella, while the background was lit by a second unit equipped with a snoot. The background light was positioned low down on a low-level mounting bracket. To bring the boys' heads close together the child on the left had to stand on a pile of telephone directories. The camera was a 6 x 6cm SLR fitted with a 75mm lens. Exposure on ISO 400/27° (ASA 400/27 DIN) film was *f*/16.

seamless background about 6m (20ft) wide by 5.4m (18ft) deep. Make the join horizontal.

Group the people together to create a pleasing shape. The heads should be quite close together and each face must be clearly visible. With a large group you need to arrange chairs, benches or raised planks in order to produce a series of stepped rows. A simple set up for three rows is to have the first row sitting, the second standing and the third standing on a bench or raised planks. A crescent shaped arrangement is preferable to one in straight lines. If possible organise a central figure to act as a focus of attention. In a family group this might be a parent or grandparent, with a sports team the captain, and so on.

Your lighting has to show each individual clearly, so all shadows must fall away from the faces. In addition, each person should be lit with the same intensity of illumination. These two considerations dictate a frontal main light located well above the camera to cast shadows downwards. Hard or soft sources are suitable but bear in mind

that you need to use an aperture which will ensure sufficient depth of field to record every member of the group sharply. Only a very powerful source can supply enough light to provide soft lighting of the required intensity. If you have only a limited amount of power at your disposal raise the camera until the film plane aligns approximately with the imaginary inclined plane of the rows of heads. From this position you need much less depth of field to ensure that each face is sharp. A camera or lens equipped with 'movements' provides a more elegant solution by allowing you to align the image and film planes. Front tilt, rear tilt or a combination of tilts is used.

Fill-in and background lighting can be handled in the normal way. Rim lighting is also easily arranged for small groups of around three to five people but becomes increasingly difficult as groups get larger.

A further difficulty in group shots is that of making sure you end up with at least one picture in which everybody has an appropriate expres-

74 Larger groups present more problems – the major difficulty is in getting every person's expression right at the same moment. Lighting and viewpoint must be chosen carefully so that each face is clearly visible. A high main light ensures that shadows are cast down and away from the faces of those individuals at the rear of the group. A 1m (3ft) metallised umbrella fitted to the flash head of a small 1000J console flash unit was the only light needed for this group. It was located slightly to the right of the camera at a height of about 2.5m (8ft). The camera was a 35mm SLR fitted with a 35mm lens. Exposure on ISO 400/27° (ASA 400/27 DIN) film was *f*/16. Taken on location, this picture had an unsuitable background which was removed at the production stage.

sion. There is always one member who blinks or looks bored or will not smile! Make sure that you let everyone know when you are taking the shot and shoot enough film to feel confident that you have succeeded in this awkward task.

Nude photography

Lighting for the figure closely follows the basic principles suggested for portraiture. Three-quarter and side lighting are the most useful techniques to adopt for your first session. As the face is not usually of prime importance the main light is lowered from the position above eye level recommended for a portrait.

Many photographers prefer to keep the face in shadow, crop to a torso or select poses which in other ways reduce emphasis on the head and face. Attention is thereby concentrated on the figure itself, and the contours, forms, textures and colours it exhibits. Depending on your own tastes a nude shot is a portrait of a naked person, an abstract composition exploiting shape and texture, or something between these extremes.

Both hard and soft sources are used as a main light. Soft lighting with adequate shadow areas conveys a subtle impression of three dimensions. Hard side lighting is excellent for revealing texture and bone structure. Lighting from the top or below, with light skimming the surface of the skin has a similar effect. The shadows this style creates on the figure do not look grotesque, as they tend to on the face.

Posing and cropping are important aspects of nude photography. The pose should be distinctive – elegant, erotic, aggressive, active, passive, relaxed, taut. If the face is shown, then the expression must complement the body posture. Look out for limbs at awkward angles or muscles compressed, especially in a seated position. When this occurs direct your model to shift most of the weight on to the thigh furthest from the camera. When organising a date and time for the session request that your model does not wear any tight fitting clothes or underwear since they leave creases in the flesh which are ugly and take a long time to disappear.

Photographing pets

Common domestic pets, such as dogs and cats, present few lighting problems. When the animal can be controlled and will obey simple instructions normal portrait lighting is perfectly appropriate. Ask the owner to stand behind you and

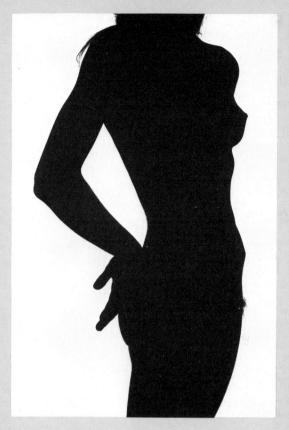

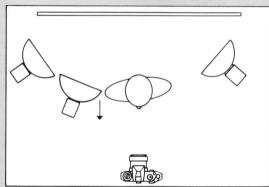

75 The full or partial silhouette is a particularly attractive lighting technique to use with nude studies. Make sure that the figure's contours are not distorted by arms or hands only partly in view. For this shot the further arm was carefully placed out of sight behind the torso – normally positioned, it appeared to thicken the waist and destroy the delicate outline of the lower rib-cage. Three lights were used, each directed on to the white paper background to illuminate it evenly. The lights were identical monobloc flash units each fitted with a general purpose reflector. Two units were arranged to give 'copy lighting' to the main area behind the model. The third light was placed low down to ensure even illumination where the seamless paper curved down towards the studio floor.

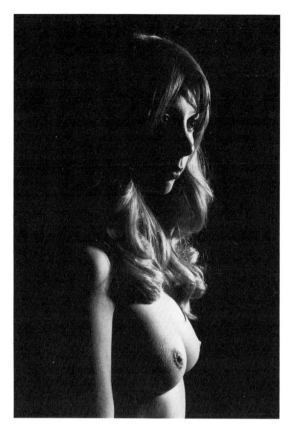

make a noise to attract the creature's attention. In this way you should obtain a well positioned head and an alert, interesting expression. If the animal is of pedigree breed and is entered for competitions, discover what particular features are noteworthy. Try to find a viewpoint which shows them to their best advantage.

Animals which are less likely to cooperate and adopt poses present more of a challenge. One simple way of exerting control is to ask the owner to hold his pet. You can then use portrait lighting. An animal which is uncontrollable may still behave in predictable fashion – it will come to a certain spot to feed or run along a known path inside its enclosure. Small mammals such as mice, hamsters and guinea pigs come within this category.

Set up your equipment to light the area and wait. You can arrange your lighting with a substitute, such as a ball of wool, to judge the effect of the various sources.

Animals sometimes have acquired skills or natural behaviour patterns which are worthy of special attention. If these activities are likely to occupy a large area, light the whole space to an intensity that is as even as possible.

Flash is the best light source for photographing animals. Few creatures seem disturbed by it and many ignore it completely.

Equipment and accessories

For a reportage or unposed approach, a 35mm

76 Hard lighting from a small flash gun gave this stark quality of illumination. An instant-picture test shot was needed to evaluate the lighting effect and the position of the gun carefully adjusted so the eye nearest the camera would be clearly visible. The 35mm SLR camera was fitted with a 50mm lens. Exposure on ISO 32/16° (ASA 32/16 DIN) film was f/11.

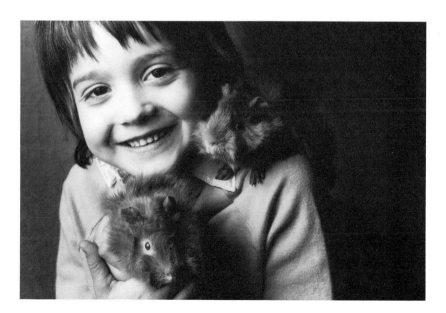

77 An effective way of photographing small pets, such as these guinea pigs, is to ask their owner to hold them. In addition to limiting their movements, this ploy also gives some idea of the size of the creatures and adds a measure of 'human interest'. Lighting was from a flash gun bounced into a metallised umbrella fitted to a small light stand. The camera was a 35mm SLR with a 90mm lens. Exposure on ISO 400/27° (ASA 400/27 DIN) film was f/11.

camera is the best choice. In low light conditions many photographers prefer the bright viewfinder and positive focusing characteristics of a range-finder or compact camera. Lenses of between 28mm and 85mm in focal length are the most useful.

A more formal portrait is best shot with an SLR camera as the ground glass viewfinder allows you to judge the exact effect of depth of field, soft focus screens and so on. A medium telephoto lens is generally recommended as giving the optimum blend of image size and working distance – an 85mm, 100mm, or 135mm lens would be ideal for 35mm cameras. For medium format cameras focal lengths of 135mm, 150mm, and 180mm give a similar effect. When buying such a lens look very carefully at the minimum focusing distance – some lenses do not focus closely enough to allow you to shoot a tightly cropped head shot.

Few camera accessories are necessary but you may need to amass a collection of assorted background materials and props.

Camera accessories
Tripod
Cable release
Filters
Exposure meter and 18 per cent grey card
Background materials
Seamless paper
Artist's canvas
Hessian
Velvet
Felt
Props
Interesting chair, stool, box
Toys, bubble liquid for child
Lighting control
White card or paper
Metallised card
Aluminium foil or metallised plastic
Tracing paper or drafting film
Black card or paper
General accessories, tools
Stands, clamps, clips
Scissors
Craft knife, scalpel
Staple gun
Adhesive tapes
Pins
General woodwork tools
Special effects
Soft focus screens

Petroleum jelly (to give soft focus effect when smeared on filter)
Fan or large sheet of laminate to blow hair (wave laminate up and down to make 'wind')
Room heater for nude model
Foodstuffs for pets

Portrait guidelines: working with a model

1 Choose your model carefully – self confident, extrovert personalities are best to begin with. A friend of a friend is often better than a close associate or relative.

2 Make sure that all arrangements between you and your model are clearly understood – use of photographs, fees, supply of prints and so on. When working with a minor always ask permission from the parent or guardian. Obtain a signed model release form, especially if you intend to publish the pictures.

3 Suggest that your model brings a few changes of clothing. For a head-and-shoulders shot only 'tops' are needed – shirt, jacket, sweater. Avoid patterned fabrics and vivid colours – plain light or dark materials are most suitable. A child might like to bring a favourite toy.

4 Provide a private room or place for changing clothing, applying make-up. The room needs bright lighting, large mirror, washing facilities.

5 Look for minor 'defects' in appearance – untidy hair, badly applied make-up, distracting jewellery, clothing creased or in disarray.

6 Adjust the height of a seated model to ensure a comfortable position for the camera.

7 Only use equipment with which you are fully familiar.

8 Do not be too ambitious – keep the first session fairly short. One hour is long enough for an inexperienced adult, much less for a child.

9 Begin with your model looking directly at the camera, or at something which is included in the shot. Gazing off-camera towards something unseen often produces a rather vacant expression.

10 Focus on the eyes. With an oblique viewpoint focus on the eye nearest the camera.

11 Avoid too many catchlights in the eyes. Try not to place a large catchlight so that it coincides with the pupil. If unavoidable, you can retouch the print.

12 Watch out for blinking. A nervous model will blink more often than normal. Bright lighting may also cause an increase in the usual rate. If you are using an SLR camera the finder image blacks out

78 As for **54** but a fill-in ratio of 2:1. The camera was a 6 x 7cm SLR with 135mm lens. Exposure on ISO 64/19° (ASA 64/19 DIN) film was f/8+1/2.

79 Lighting for this fairly high-key portrait involved the use of five identical monobloc flash units – main light, fill-in, two background lights and a backlight on the veil. Main and fill-in lights were fitted with diffuser units and the fill-in unit adjusted to a fractional power output to give a 2:1 ratio. The background lights used general-purpose reflector dishes to illuminate the white seamless paper evenly. The fifth unit was fitted with a snoot and directed on to the veil from behind to ensure adequate tonal separation from the background. The camera was a 6 x 7cm SLR with a 135mm lens. Exposure on ISO 100/21° (ASA 100/21 DIN) film was f/16.

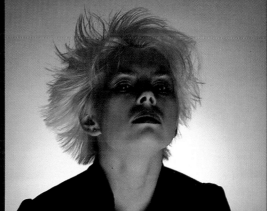

80 Lighting the subject from below usually produces a sinister or macabre effect. However, with a soft source a more subtle and only faintly disturbing quality is introduced. The main light was a 1m (3ft) diffuser unit fitted to a monobloc flash unit and placed on the floor with the diffusing surface pointing upwards. Background lighting was provided by a second unit equipped with a general purpose reflector dish and mounted on a stand with a low-level bracket. The camera was a 6 x 7cm SLR with a 135mm lens. Exposure on ISO 64/19° (ASA 64/19 DIN) film was f/11+1/2.

81 By deliberately underexposing, the mood, already slightly disturbing, becomes much more menacing. The camera was a 35mm SLR with a 90mm lens. Exposure on ISO 64/19° (ASA 64/19 DIN) film was f/16+1/2.

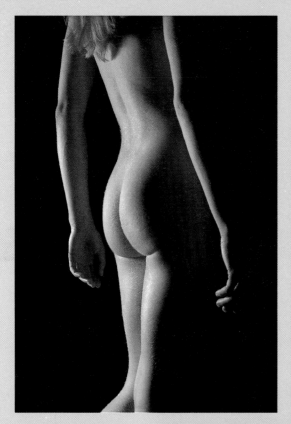

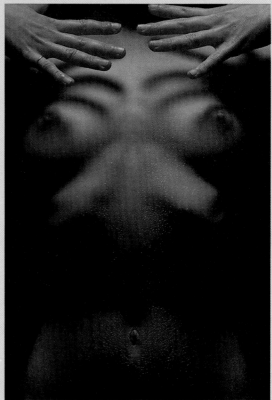

82 As in **11.** A flash head fitted with a 50cm (20in) diffuser unit was used, with no fill-in lighting. Exposure on ISO 64/19° (ASA 64/19 DIN) film was *f*/16.

82 6 x 7cm SLR with 135mm lens.

83 Similar to **82.**

84 A 1m (3ft) diffuser fitted to a monobloc flash unit was the only light source for this portrait. The diffuser was placed directly on the floor in front of the model. A 6 x 6cm SLR was fitted with a magnifying glass lens. Exposure on ISO 64/19° (ASA 64/19 DIN) film was *f*/11 with a ND 0.9 neutral density filter over the lens to reduce the original aperture of *f*/4 to an effective value of *f*/11.

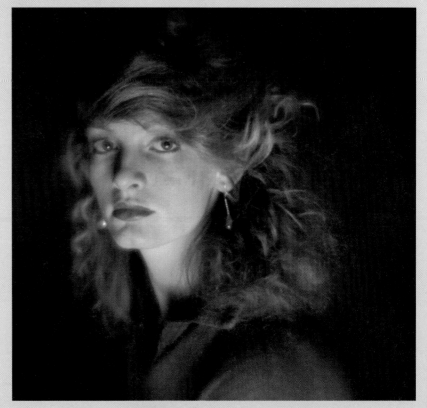

at the instant of exposure, so you cannot be certain whether or not your model blinks as you shoot. With a formal pose, use a tripod, focus and compose as normal but do not look through the viewfinder as you press the shutter release. By looking at the model directly you can see the expression as the photograph is taken, even with flash.

13 Avoid a 'straight-on' pose with your model facing the camera directly. Instead, angle the shoulders slightly even when the head is then turned back to present a full face.

14 Always give your model some of the best pictures.

Setting up and lighting

1 Choose the most appropriate equipment.

2 Assemble all cameras, lenses, lights and accessories and check their functions. Carry enough spares – fuses, lamps, sync lead and some simple tools.

3 If possible, use a stand-in model to roughly assess lighting style, background choice and provisional exposure.

4 Working alone, consider using a mirror – about 60 x 90cm (2ft x 3ft) at the camera position with yourself acting as the stand-in. Alternatively, shoot an instant-picture test shot of yourself.

5 Never set up from scratch with your model on the set. It is boring for the model and highly stressful for the photographer.

6 Always start out with enough space – about 3 x 4m (10 x 13ft) is adequate for a head-and-shoulders shot, though more room than this is desirable.

7 It is especially important to have sufficient space between model and background in order to position background, hair or rim lights, or for light to be kept off the background.

8 It is easy to reduce the shooting distance once you have set up. Trying to find more space is at best disruptive, and at worst impossible.

9 Check to see what each light does individually.

10 With flash, confirm that each unit fires every time.

11 Once your model is in front of the camera, make final adjustments to the lighting and check the exposure.

7 LIGHTING TECHNIQUES: STILL LIFE

A still life photograph uses a conscious arrangement of largely inanimate objects. You can begin with a single item or a small group of suitable subjects but a better starting point is provided by a concept or theme. Aim to create a visually exciting picture which expresses mood, atmosphere or period flavour. Sometimes the idea of still life can be extended to include some form of action, such as flowing liquid, or hands which set the main subject in a human context and show its scale.

Professional photographers frequently employ a still life approach for catalogue illustrations and advertisements. For the enthusiast it is an ideal medium for creative and technical experimentation. Working in a totally controlled way with easily arranged subjects you learn a great deal about composition, photographic technique, material characteristics and the behaviour of light.

Lighting style is of the utmost importance. Only by careful control can you form the essential qualities of highlights, shadows, textures and colours necessary to create the desired impression.

Choosing the light source
In selecting the most appropriate light source you should consider the following technical requirements and subject qualities:

1 Whether you have to work at any time other than the hours of daylight.
2 The need for a particular direction, quality or distribution of light.
3 The nature of the subjects eg. delicate or robust.
4 Whether there is likely to be any kind of subject movement.
5 Depth of field requirements, and the area you have to light.

Excellent pictures can be made using ambient tungsten illumination or daylight. However, such sources are often not bright enough or sufficiently controllable to satisfy the demands of the critical still life photographer. Consequently most of the work in this field is undertaken with studio lighting.

If the subject is delicate, likely to dry out, wilt or show unwanted movement, flash is the best light source. Modelling lamps or instant picture test shots are essential to judge the lighting effect.

Where maximum depth of field is needed, tungsten lighting provides the simplest solution. The small apertures you need to use are easily coped with by giving long exposure times. The high level of subject illumination provides adequate brightness on your camera screen, even with the lens stopped down to the taking aperture. This allows you to judge visually if the zone of sharp focus is sufficient.

For a subject which is both delicate and requires maximum depth of field, only a powerful studio flash unit can deliver the necessary output. However, with this arrangement the modelling lamp is unlikely to provide you with a screen image bright enough to assess properly at the taking aperture. You would have to take an instant-picture test shot or temporarily add a bright tungsten 'viewing' light. Use a short term substitute if there is any risk of damage to the subject.

The various possibilities are summarised in the following chart.

Lighting style
A basic approach with main, fill-in, rim and background lights is often used in still life work to establish the style and mood of the photograph. But these techniques normally need to be broadened and modified to cope with the highly diverse nature of the subject matter, in particular for the wide variety of materials and surfaces you are likely to encounter.

Some objects possess distinctive textures, while others may have a mirror-like finish. Brightly coloured, matt-surfaced materials require a very different lighting approach from the method you would employ with transparent items like bottles and glasses. These qualities have to be revealed, emphasised or subdued according to their importance and the overall 'feel' of the picture.

Revealing texture
Materials such as wood, leather, stone and fabric have characteristic textures. By revealing or emphasising these surfaces you add a realistic, three-dimensional impression to your photograph.

Light must strike the subject at a shallow angle,

Light source		Basic nature		Portrayal of movement ①		Depth of field required ②		Typical exposure and film speed
		Delicate	Robust	Blur	Frozen	Shallow	Deep	
	Daylight indoors	●●●○○	●●●○○	●●●●○	○○○○○	●●●○○	●●○○○	¼ sec f/16 ISO 400/27°
	Tungsten	●○○○○	●●○○○	●●●○○	○○○○○	●●●○○	●○○○○	1 sec f/16 ISO 400/27°
	Fluorescent	●○○○○	●●○○○	●●●○○	○○○○○	●●●○○	●○○○○	1 sec f/16 ISO 400/27°
	Low power 275W x 4	○○○○○	●●●●●	●●●●●	●○○○○	●●●○○	●●●○○	⅛ sec f/16 ISO 100/21°
	High power 500Wx3 – 1000Wx1	○○○○○	●●●●●	●●●●●	●●○○○	●●●○○	●●●●●	1/30 sec f/16 ISO 100/21°
	Flash gun/flashbulb GN 30/100	●●●●○	●●●●○	○○○○○	●●●●●	●●●○○	●●●○○	f/16 ③ ISO 100/21°
	Flash units x 4 GN 50/160	●●●●●	●●●●●	○○○○○	●●●●○	●●●○○	●●●●○	f/16 ISO 100/21°

Key: ● ● ● ● ● = most suitable
　　 ○ ○ ○ ○ ○ = least suitable

GN is quoted in m/ft for ISO 100/21° film
① Movement in a still life appears a contradiction but can occur on a small scale, eg. rising steam, flowing liquid, hand holding product, etc.
② Depth of field assumes camera movements cannot be used.
③ Exposure assumes direct lighting.

from the side, rear, top or below. The 'grazing angle' of the light creates a highlight and shadow on every element of the surface, so showing in stark contrast the nature of the material. Maximum emphasis is produced by creating very dense shadows with clearly defined edges. A small light source placed 2m or 3m from the subject provides lighting of this form. You can use a naked lamp, spotlight, slide projector, flash gun or a flash unit equipped with a small reflector dish.

As you lighten the shadows or soften their edges, so the texture becomes less dramatic. A fill-in light or reflector can be used to lighten shadows. Use a larger area light source such as a diffused floodlight to soften shadow quality.

You can subdue texture by using frontal lighting, or by using two similar lights, one either side of the subject (as with copy lighting).

In showing texture you must bear in mind the effect you want to create. Does the slice of bread have to appear appetising or do you want it to look like craters on the moon? Remember that eye and film respond differently to contrast. If you do not take this into account you are likely to over-dramatise textures. To produce a realistic appearance, light the surface so that it looks correct, then add some fill-in. The amount of fill-in you need depends on many factors including the quality and angle of the main light source.

As a rough guide use a lighting ratio of 3:1 with colour film and up to 8:1 with black-and-white.

Dealing with polished metal
Luxury goods such as cigarette lighters, expensive cutlery and trophies often have highly polished metallic surfaces. When included in a still life shot they suggest richness and quality.

They need to be lit with extreme care in order to show the nature of the smooth, mirror-like material. A conventional approach, requiring relatively small light sources, leaves the surface dark with tiny, harsh specular reflections of the lights and brighter surroundings. It is not uncommon for these reflections to include the disappointed expression on the photographer's face, peering over his camera and tripod!

With this type of surface you must employ a number of comparatively large light sources, which, when reflected, reveal both the nature of the surface and the subject contours. The best way to produce large area sources is to position a series of reflectors or diffusers close to the subject. Using this technique, a sheet of white card 20cm (8in) high at a distance of 30cm (12in) gives almost the same quality of reflection as a primary light source 2m (6ft) high located 3m (10ft) away.

A group of reflectors and/or diffusers all around

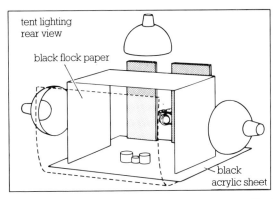

tent lighting
rear view

black flock paper

black
acrylic sheet

the subject is called a *tent*. It is usually easier to make a tent by using diffusers. With a reflector tent you have to ensure that the lights illuminating the reflectors are not placed directly between the subject and the sheets of white card. Locate them below or to one side of the reflectors, or you will create unwanted silhouette reflections of the lighting units themselves in the surface of your subjects. A tent for small items can easily be made

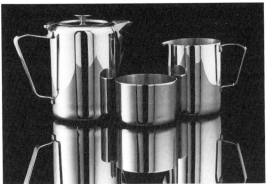

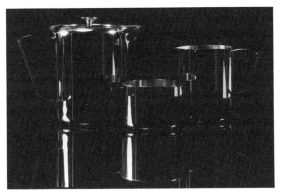

85 For shiny metal surfaces tent lighting is ideal. The tent used for this picture comprised three 60 x 90cm diffusers – at the left, top and right – and two 30 x 60cm (1 x 3ft) reflector boards at the front. The back was left open to reveal the background of black

flock paper; the foreground material was black acrylic sheet. A manufacturer of tableware may not care for such distinctive reflections, but the repeated pattern of black vertical lines was chosen in this instance for its graphic effect. The wide central line was formed by

the essential gap between the reflectors through which the picture was taken. Narrower lines on either side represent the deliberate spaces left between reflectors and diffusers. Three 500W floodlights illuminated the diffuser panels.

86 Identical lighting was used for this picture but the tent was removed.

85, 86 The camera was a 35mm SLR with a 90mm lens. Exposure on ISO 100/21° film was 1/4 sec at *f*/16.

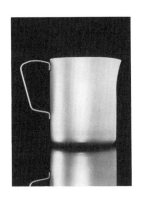

87, 88 A quick alternative to tent lighting is provided by dulling spray. This technique clearly reveals the shape and form, but makes the shiny surface dead matt. Dulling spray is most useful for local control of reflections.

87 Tent lighting with the addition of a naked 275W photoflood and a 'starburst' effect screen over the lens to add a sparkling highlight.

88 With the tent removed, but the surface coated in dulling spray.

by bending a sheet of translucent diffusing material into the shape of an open-ended cone.

The camera, tripod and photographer can be hidden from view by shooting from behind a sheet of suitable material through a small hole. This material may itself be a reflector or diffuser. In this case you will often notice a small black reflection caused by the hole, though this can sometimes be avoided by positioning the subject carefully or changing the viewpoint. If the black patch cannot be avoided and proves distracting, a local application of dulling spray will at least diffuse its hard edges. Alternatively, use a matt black card over the camera to deliberately form a larger clean-edged black reflection.

Controlling the reflections

You can change the appearance of a reflection in a polished surface by modifying the reflector or diffuser. Adding strips of black paper breaks up each reflection into two or more smaller areas. If

you make the strips into a cross shape the reflection looks as if it comes from a window.

Strips or small sheets of coloured paper placed close to the subject add local splashes of colour.

You can graduate the reflector or diffuser so that one part is effectively brighter than another. Do this by varying the lighting intensity, adding a pigment such as a black spray paint, or by curving a reflector round into a cylindrical shape. If you light a curved reflector from one side it has a naturally graduated brightness.

All your reflectors and diffusers should have blemish-free surfaces and clean edges. Any marks or creases will also be reflected. However, you may not see these defects with the lens set to its widest aperture, as you are focused on the object and not on the reflections. But as you stop down the camera lens these reflections, complete with their unwanted faults, come into sharper focus. It is vital to check the screen image at the taking aperture or shoot an instant-picture test.

Other components in a still life set, close to the polished surface, are also reflected in it. You can use their reflections as additional descriptive elements which are helpful in interpreting the nature of the surface. If you feel that such reflections are distracting, rearrange the composition, change viewpoint or apply the special dulling spray made for the purpose. Note, however, that a local patch sprayed in this way may not harmonise with the rest of the surface.

Try to make the reflections fully describe the object you are photographing. If the whole surface simply reflects a uniform tone, you will not create the impression of brightly polished metal. It is often a good idea to introduce one small, bright specular highlight from a light 2–3m (6–10ft) away, to add a hint of sparkle.

Objects made from dark shiny materials can be treated in the same way as polished metal. Note that dulling spray can permanently damage some kinds of plastic so first test it on a spare item, or the base. If you are in any doubt about its suitability for a valuable object do not use a dulling spray.

Using a pola screen

A pola screen has little effect on normal reflections from a metal surface. However, in addition to using a pola screen on the camera lens it is possible to achieve a considerable degree of control by fitting sheets of plastic pola screen material over your lights. Light must pass through the plastic sheet and then reach the subject *directly*

without being reflected or diffused. Placing the pola screen material on top of a diffuser is the easiest way to arrange this. Rotate the pola screens on the lights and lens to control the brightness of the reflections. Large sheets of pola screen material are unfortunately very expensive.

Photographing glassware

Most transparent objects have shiny surfaces. In order to illustrate both characteristics you must use transmitted *and* reflected light. However, the form and surface qualities of many bottles, glasses and vases can be interpreted well enough from the shapes and colours revealed by transmitted light alone.

Where all the subjects in a still life are transparent a lighting style similar to that used in shooting a silhouette portrait gives a most effective and

89 The contents of glassware are best revealed by placing small reflectors behind the vessels. These must be located at a small distance from the containers and angled to pick up the correct amount of light. Wine glasses on stems present the greatest problem as, with these, the reflector must be supported on a small wire. Lighting for this shot was with a single diffused flash unit. The surface of the 1m (3ft) diffuser panel was crossed with strips of black card to simulate the glazing bars of a window.

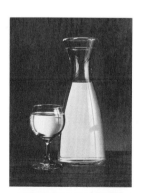

90 The same shot with the reflectors removed. Note how the shape of the reflectors is only approximately similar to the glass and carafe – the process of refraction through the vessel and liquid disguises the exact shapes.

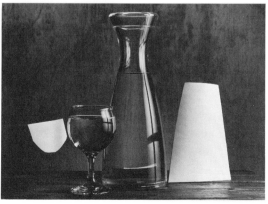

striking image. Direct the light on to a white or pale coloured background. Then position your subjects at some distance in front of the background, making sure that no light reaches them directly.

An alternative method gives similar results but uses a sheet of translucent acrylic plastic lit from the rear. This type of lighting is known as transillumination. If a sheet of identical material is used for your subjects to stand on, you can light this from below. A large piece of acrylic sheet can be curved, rather like seamless paper, to make a continuous background free from any horizon.

The structure of the glassware is shown in terms of light and dark areas according to the shape and thickness of the glass. By keeping the size of the background to a minimum you can produce dramatic silhouette effects. Experiment with changes in subject-to-background separation to create subtle variations in the quality of the silhouette. With this technique you can clearly see the colour of the glass and any transparent contents.

Adding some reflected highlights lends form to the subject and illustrates the smooth surface, producing a better impression of the real quality of the subject. You can add highlights by using a further light, coupled with a reflector or diffuser to effectively extend the size of the source and control its brightness. This light is normally positioned to provide front, three-quarter or side lighting.

But a highlight will only show up against a darker tone, such as a deeply coloured bottle, or one containing a dark liquid. But if you adjust the light on the background to form a graduated range of tones you can also take advantage of highlights on glass that is pale or colourless. You should align the highlight with a dark part of the background as seen through the glass. A pola screen is often effective in controlling reflections.

Glass on a dark background

High quality glassware looks very attractive when it is shot against a dark or black background. Use reflected or diffused side and rim lighting to create highlights similar to those needed for polished metal. Transmitted light can also be employed, introduced through a hole in the background.

Any liquid contained in a bottle or glass is easily illuminated with a small reflector. This can be made from white card, paper, smooth aluminium foil or a fragment of mirror. Locate the reflector a few centimetres behind the glassware pointing it towards a light source. Adjust its angle so that it reflects the required brightness. The liquid refracts the light in such a way that the precise outline of the reflector cannot be seen, though creases and marks are visible through smooth unpatterned glass containers. If necessary, you can graduate a white card or paper reflector by adding soft pencil shading or, ideally, with an airbrush.

Exploiting colour

Colour is a vital component in many still life photographs. Used in a direct, simple manner it adds emotional qualities of vivacity and appeal to many types of subject – in particular, food, flowers and consumer goods.

You can also use colour in more subtle ways such as to help create atmosphere, or reinforce a period flavour. For example, an overall blue implies cold, aloofness and exclusivity, while you would use warm brown and yellow shades to recall a 19th Century harvest scene. For this type of still life the addition of colour completes the descriptive process. But colour can also be exploited as the most dominant feature by adopting a more abstract approach. Concentrate your attention on just a part of the subject to emphasise its colours and graphic shapes.

Colour saturation

Colour is desaturated by reflections and made less vivid by shadows. A reflection 'dilutes' the colour with white light to form a highlight area of pale tone. Texture lighting produces a pattern of minute highlights and shadows across the whole surface and so desaturates colour and makes it less brilliant.

A bold use of colour requires frontal lighting from a small light source to avoid reflections and minimise shadows. But for most still life photography you have to adopt a lighting style which gives sufficient highlight and shadow detail to indicate form and texture, while preserving enough saturated mid-tones to reveal colour. The best compromise is provided by using side or three-quarter lighting from medium sized light sources.

A main light coming from the top or back is best avoided. Tent lighting is also unsuitable as it forms too many desaturated highlights. Reflectors and diffusers must be positioned with care. Sometimes even a light toned foreground can create un-

wanted reflections.

A small change in composition or viewpoint will often remove an awkward highlight. For subtle control of reflections a pola screen is particularly useful. Among its applications are those of revealing grain in polished wood, clarifying detail such as lettering on printed paper or cans and removing slight surface glare from background materials.

However a pola screen must be used with great care – if you remove all reflections your picture will look quite 'dead'.

Surround your still life set with black paper to avoid unwanted colour casts and reflections from the walls, floor or ceiling. Professional photographers who specialise in still life and product photography often paint their whole studios matt black.

Lighting problems

A typical still life set-up features a variety of surface qualities. This is even true for some single items which are made from a range of different materials. So a subject such as a radio cassette recorder with grain textured panels, bright chrome trim, a transparent tape compartment and coloured control buttons offers you a real challenge.

Lighting style is determined by the overall effect you require, or the most dominant surface. Deal with other smaller areas by using local lighting of the appropriate quality for each one. Extra lights are often needed, though the careful use of reflectors is sometimes sufficient. Fine control over light intensity and positioning of the lighting units and reflectors is most important.

In some circumstances you have to achieve the best possible compromise, for example, by accepting a slight loss of texture in exchange for more saturated colour.

Local texture

Use a spotlight or flash unit equipped with a snoot or barn doors. When positioned to one side or to the rear of the subject, light from this source grazes the surface to reveal its texture. The snoot or barn doors restrict the effect to the area which requires that treatment. You can create more precise lighting by placing a sheet of opaque card part-way between light source and subject. The purpose of this is to cast a carefully controlled shadow over those areas which do not need local lighting.

91 A naked 500W spotlight lamp was the sole source of illumination for this dramatic interpretation of fingers reading braille. The lamp was placed behind the subject and its height adjusted to cast the long dense shadows over the surface of the paper. The camera was a 4 x 5in monorail fitted with a 90mm wide-angle lens. Front and rear tilt camera movements were needed to give uniform sharpness over the paper surface. Exposure on ISO 400/27° (ASA 400/27 DIN) film was 1/4 sec at *f*/22.

Polished metal

This surface is often used as a decorative trim and for name plates and model identifications on consumer goods. Proper lighting for these important features is essential. Position a sheet of white card or paper so that it is reflected by the metal surface. With a subject that contains a long strip of polished trim, your reflector needs to be surprisingly large – up to 2m (6ft) in length is not uncommon.

You will occasionally find that in order to pick up the required reflection, your card or paper must be placed actually within the still life set-up. You can sometimes do this by hiding it from view behind part of the subject. If this is not possible use a local application of dulling spray on the metal, and light it directly, restricting the coverage with a snoot, barn doors or flags.

Transparent objects

You can usually light objects such as bottles by creating a local patch of brightness on the background to align with the bottle and the camera. Use a spotlight or flash unit, again, fitted with a snoot or barn doors. The local lighting must be in keeping with the main, overall style, otherwise undue emphasis may be placed on the glassware. A softly graduated increase in brightness is much less obvious than a distinct, hard edged spot of light.

Bottles and glasses containing clear liquid are easier to deal with. Small reflectors placed at a short distance behind the vessels will usually reflect sufficient light to reveal the nature of the contents. When photographing a long-stemmed wine glass locate the reflector on top of a thin stiff wire which is hidden by the stem.

If you cannot position a reflector to receive enough light from the main source, you must light it separately. This is not easy to do without introducing extra unwanted lighting, as it is difficult to restrict light coverage to the reflector alone. The normal controlling devices – snoot, barn doors and flags – do not offer sufficiently fine control, although a snoot temporarily elongated with a cone of black paper can work well.

A more elegant solution is offered by the slide projector. The precise shape of the light beam is formed by using a slide mount containing a mask cut from opaque card. The hole in the mask matches the shape of the reflector, so the focused light beam does not spread beyond its edges.

An alternative approach is to use a low power light source behind the glassware, shining through an appropriately shaped diffuser. You have to cut a hole in the background material in order to align light, diffuser, bottle and camera. If this is impractical, consider using a small tungsten lamp, naked flashbulb, or a slave-synchronised flash gun actually in the set, again located behind a suitable diffuser.

A cable may be carefully hidden behind some objects in the set or introduced through a small hole in the background.

Light output can be effectively reduced if necessary by using neutral density (ND) filters between source and diffuser, or extra layers of diffusing material. If, on the other hand, the brightness is too low use a double exposure technique. After making an exposure based on the normal lighting, turn off all sources so that the room is totally dark. Now give a further exposure for the small tungsten bulb or several flashes with the flash gun, firing it manually via an extension sync lead.

Exposure for this method is best determined by an instant picture test shot.

White on white

White and very pale coloured subjects can be successfully photographed against a white background if you use the correct technique. Use a light close to the camera to produce frontal illumination. This gives a dark edge all round the subject, separating it from the background.

If you use side or three-quarter lighting a strong shadow is formed down one edge but the highlight side will tend to merge with the background. You can prevent this from happening by carefully applying dark pigment to the extreme edges of the highlight side. In the case of smooth opaque objects smear on a little soft pencil lead.

The technique is equally suitable for glassware, but in this case draw a fine line with a felt pen or wax pencil.

Black, light-absorbing card placed close to shiny surfaces and glassware also helps to give a dark edge.

Black on black

Photographing a black object against a black background is not as difficult as you may think.

Textured or matt black surfaces need only simple back lighting to reveal their contours. Shiny black material must be lit with a broad source, such as a diffused flood or a reflector. Often, it is only possible to create the desired lighting effect with the light or reflector so close to the object that it actually appears in the shot.

If your background is *totally* black you can still take a successful picture by masking out the light source with a strip of black card taped close to the lens. You must carefully examine the screen image at the taking aperture.

This technique is not suitable for a background which is merely very dark as the mask itself then becomes visible. In this case, spray the extreme edges of the shiny surface with dulling spray and use direct backlighting.

Component interaction

Components in a still life shot can sometimes interact to cause unwanted reflections and local colour casts. For example, a blue vase placed next to an orange may reflect blue light into a

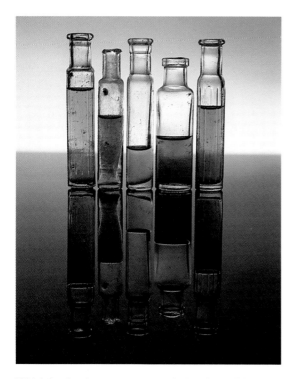

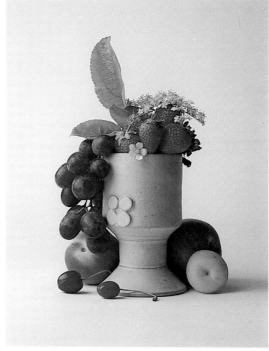

92 Lighting for glassware against a white background is the same as for a silhouette. You should direct your light only on to the background. One general purpose reflector fitted to a monobloc flash unit was located behind the subject. The light was placed on the floor pointing up at the white paper background to give a gradation of tone. Black, light-absorbing cards were placed at the sides of the old medicine vials to control the effective width of the background. Foreground material was black acrylic sheet. The camera was a 6 x 7cm SLR with a 135mm lens. Exposure on ISO 64/19° (ASA 64/19 DIN) film was $f/11+\frac{1}{2}$.

93 A centrally placed stone goblet was the starting point for this composition. The various items of fruit and foliage were then added to make an asymmetrical shape. The strawberries were placed on top of a wad of paper and held in place with needles. Lighting was with a single diffused monobloc flash unit placed to the left side. The right side of the set was surrounded with black paper to control the shadow density. The camera was a 6 x 7cm SLR with a 135mm lens. Exposure on ISO 100/21° (ASA 100/21 DIN) film was $f/16$.

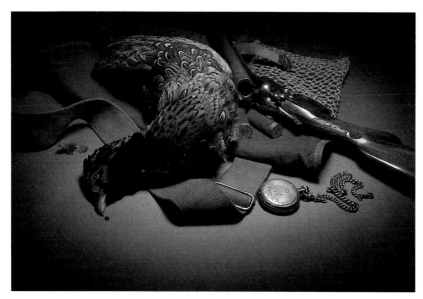

94 A 'pool' of light was needed for this composition – rapidly fading into total darkness. One flash head from a 1000J console unit was used, fitted with a general-purpose reflector dish and an improvised diffuser made from tracing paper. The spread of light was limited by encircling the reflector with a cylinder of black card to create the 'pool' effect. The camera was a 6 x 6cm SLR fitted with a 50mm lens. Exposure on ISO 32/16° (ASA 32/16 DIN) film was $f/11$.

95 When the subject is complex simple lighting is usually best. Only one 500W floodlight was used, arranged above the specially constructed acrylic box on a boom. Careful positioning was needed to ensure that the light illuminated both the white paper background and some of the protruding items in the foreground. The camera was a 4 x 5in flatbed model fitted with a 150mm lens. Exposure on ISO 50/18° (ASA 50/18 DIN) tungsten balanced film was 1/2 sec at *f*/32.

96 The theme for this picture was based on the items you would buy for a children's party. Various sweets and small toys were chosen then fitted to a background comprising metal pastry cutters glued to a sheet of glass. The glass was taped vertically between two light stands. Lighting was with one diffused monobloc flash unit carefully arranged high above the camera to avoid forming reflections in the glass or creating shadows on the white paper background. The whole area in front of the glass was covered in black card to prevent reflections. The camera was a 6 x 7cm SLR with a 135mm lens. Exposure on ISO 100/21° (ASA 100/21 DIN) film was *f*/11. A long shutter speed of 1/8 sec was chosen to record the candle flame at the correct intensity.

97 Experiment with different lighting directions to transform the appearance of everyday objects. For this picture the acrylic white background material is both the subject support and the light source. A monobloc flash unit placed underneath was the primary light source. The camera was a 6 x 7cm SLR with a 135mm lens. Exposure on ISO 64/19° (ASA 64/19 DIN) film was *f*/16.

shadow area. Light bouncing from a white coffee pot can form unexpected highlights in the adjacent milk jug.

You can usually solve these problems by altering the light direction or rearranging part of the set-up. A change of camera-to-subject distance coupled with the appropriate choice of lens also helps.

Food photography

You can photograph food to look realistic or to

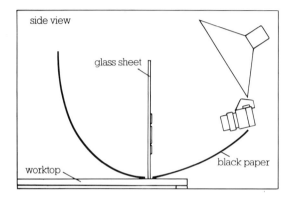

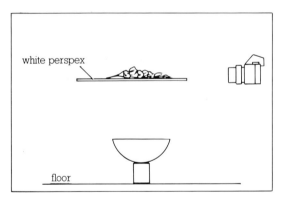

explore its graphic qualities. With the 'graphic' approach food is looked at in a more abstract way; attention is given to its qualities of shape, form, texture and colour. Just think of the marvellous shape of an egg, the structure of celery, or the rich colour of a ripe strawberry. Decayed and shrivelled pieces of fruit are not exactly appetising but exhibit subtle textures which can be exploited with hard side lighting. Many vegetables have a fascinating complex internal structure which is revealed when they are cut open or thinly sliced and then lit from behind.

The main aim of 'realistic' food photography is to make the subject appear as fresh, colourful and

mouthwatering as possible. Lighting style has to create a sense of environment and time of day as well as clearly illuminating colours and textures.

Soft but directional light from a large, diffuse source is normally employed to simulate natural daylight coming through a window. A floodlight or flash unit diffused through translucent material about 1m (3ft) square makes an excellent light source. Top lighting slightly from the rear is a good basic style to adopt for food laid out on a table. Fill-in light can be provided by a large, low power source or a reflector board placed near the camera. Your viewpoint is usually oblique in order to duplicate the eye level of a seated person about to enjoy a meal.

You can use side lighting in conjunction with appropriate foodstuffs to indicate a morning or evening setting. Add to the effect by introducing interesting shadows and warm coloured filtration. High-key lighting implies morning, whereas an evening atmosphere is better created with an overall low-key style. Experiment with soft focus for a 'romantic' feel.

Tricks of the trade

Professional photographers use a number of techniques to make their jobs easier and quicker and to make food appear more attractive. Some of these ruses involve downright fakes while others rely on less dramatic deceptions.

Fakes include plastic bubbles and acrylic ice cubes, which do not melt even under the hottest tungsten lighting. Expensive drinks are simulated with soda water and a few drops of food colouring. Cigarette smoke and dry ice vapour stand in for steam. You can even buy a wide variety of moulded plastic replicas ranging from a scoop of ice cream to a full-sized roast turkey. Acrylic ice cubes and replica foodstuffs are very expensive and are often hired for a particular shot.

Other techniques employ a more cosmetic treatment, such as painting pastry with food dye to create even, rich colour. If you coat vegetables and fruit with a thin layer of oil or glycerin, spray with water, and add a little back lighting, you have a fresh texture of sparkling droplets. By diluting deeply coloured drinks, such as red wine, with water you can match the colour of wine in a bottle with wine in a glass. The thicker bottle holds a greater depth of liquid and so transmits less light. Without dilution, this makes the wine look too dark.

Meat and vegetables are normally under-

cooked, and, for a stew or casserole, are added to the very surface of the dish just before the photograph is taken.

The basket brimming with out-of-season fruit actually contains a wad of paper, or a lump of modelling clay, with the minimum number of perfect specimens fixed in place with needles. The drink being poured so neatly in fact comes from a funnel, via a tube, through a bottomless bottle clamped in place. And that delicious pie? Well it is only a golden crust supported on crumpled kitchen foil.

Equipment and accessories

Most professional photographers specialising in still life shoot on large format – 4 x 5in and 8 x 10in. These cameras are chosen because they offer superlative quality, and fine control over image shape and depth of field by virtue of camera movements.

However, any camera with ground glass focusing is suitable, particularly medium format and 35mm SLRs. A depth of field preview control is essential for serious work. The ability to take test shots with an instant-picture camera is also highly desirable.

Your camera lens must be able to focus at close range – many still life subjects are quite small, so it should be possible to fill the frame with an area of about 20 x 30cm (8–12in). Any focal length of lens can be used but a medium telephoto offers the best balance between working distance and image size.

Although you can take still life pictures with no equipment other than a camera and one light, a large number of simple accessories is needed for a more committed approach. Many of these accessories can probably be found around the home, and some may be improvised from waste materials. Most of the other items may be purchased at a supermarket, craft shop or hardware store.

Camera accessories
Tripod
Cable release
Filters
Pola screen – optical grade
Exposure meter and 18 per cent grey card
Subject support
Table or sheet of 1 x 1.3m (3 x 4ft) blockboard
 which can be supported at any height from
 floor level upwards. Normal tables are always
 too high or too low

Wood blocks, shelves and planks
Glass sheet
Cardboard boxes
Modelling clay
Adhesive putty
Adhesive foam pads
'Invisible' thread (fine nylon monofilament)
Rubber bands
Stiff wire
Needles and pins
Adhesive tapes – double-sided and masking tape
Rapid setting epoxy resin adhesive
Lighting control
White card or paper
Metallised card
Aluminium foil or metallised plastic
Mirrors
Coloured card or paper
Tracing paper or drafting film
Black card or paper
Pola screen material – non-optical grade
Background materials
Seamless paper
Flock paper
Velvet
Felt
Laminate
Acrylic sheet; opal, black and colours
Wood
Cork
Leather
Slate
Brick
Tile
Stone
Pebbles
Sand
General accessories
Stands, clamps and clips
Water spray
Cleaning cloths
Cleaning materials – polish and solvents
Waste card or paper
Soft lead pencil, black wax pencil and black felt
 pen
Tools
Scissors
Craft knife and scalpel
Rule
Staple gun
General woodwork tools
Special effects
Glycerin

98 Camera movements often allow you to create massive depth of field without the necessity of using an extremely small aperture. Front and rear tilts provided complete sharpness at *f*/16, when *f*/64 or *f*/90 would have been needed with the movements in 'neutral'. The camera was a 6 x 7cm SLR fitted with a 100mm enlarger lens in a special home-made cradle which permitted a limited range of movements. Exposure on ISO 25/15° (ASA 25/15 DIN) film was *f*/16 with two diffused monobloc flash units.

Oil
Dulling spray
Cigarettes
Dry ice
Warning: dry ice can cause frostbite – always handle it with tongs

Set-building guidelines
1 Select the most appropriate type of lighting.
2 Assemble all equipment and accessories – check functions.
3 Collect together all potential subject matter, props and background materials. With delicate items, such as food and flowers, always purchase at least three times the amount you are likely to use, so that you can pick the best specimens.
4 Set up *roughly* at first, starting with the main subject, background and one light.
5 Choose the best working height for subject and camera. Use your camera on a tripod.
6 Leave enough space all around your set for lights, reflectors, diffusers and so on. A subject plus background occupying an area of 1 x 1.3m (about 3 x 4ft) needs a total space of around 3 x 4m (roughly 10 x 13ft).
7 Never set up fully, only to discover that you have to dismantle the set in order to relocate it just slightly lower or further from the wall.

8 Add other items, one at a time, so that they enhance the composition. An interesting prop often adds atmosphere and makes the purpose of the picture clearer.
9 Use suitable materials to support parts of the subject, reflectors and background firmly. An unstable set is a source of constant frustration.
10 Be prepared to discard anything which does not make a positive contribution.
11 Never begin with everything on the set, moving it all around until it looks 'right'.
12 If the composition is not working, remove everything and start again.
13 Make adjustments to the lighting as your composition evolves.
14 Use additional lights only when you clearly identify a need for them.
15 Keep your first still life pictures simple.
16 If your picture contains delicate items which are likely to be damaged or dry out during setting up, begin with substitutes. Replace them with the best specimens immediately before exposure.
17 Always assess the camera screen image at the taking aperture or take an instant-picture test shot for this purpose.
18 When working with long exposure times use a cable release or the self-timer mechanism to prevent camera shake.
19 If possible, process the film *before* breaking up the set.
20 Always be on the lookout for suitable subjects, props and background materials that might serve for other pictures.

8 LIGHTING TECHNIQUES: CLOSE-UP

Close-up photography reveals a wealth of fascinating detail invisible to the unaided eye. And as it forms a permanent record you can study the most delicate specimens and transient events at your leisure.

Almost anything can be photographed in close-up to create unusual and dramatic pictures. You can explore the fascinating shapes and colours of flowers, the forms and amazing details of insect life and the intricate structures of precision machinery. Even the most humble scrap of waste paper, discarded plastic or fragment of stone can yield a variety of striking images when photographed with the right combination of close-up technique and controlled lighting.

As a professional tool the close-up is frequently used in medical, scientific, forensic and advertising photography.

Image magnification
The whole field of close-up photography is divided into three areas, according to image magnification (the ratio of image size to object size).

1 Close-up: a general term usually considered to cover image sizes from about 1:10 to 1:1 (one tenth life size to life size).
2 Macrophotography (photomacrography): strictly speaking, the term macro should only be applied to images in the range 1:1 to 10:1 (ten times life size).
3 Photomicrography: magnifications greater than 10:1, produced with a microscope.

Choosing the light source
Your choice of the most appropriate light source is influenced by the following factors:

1 The need for a particular direction, quality or distribution of light.
2 The nature of the subject eg. delicate or robust.
3 Whether the subject is likely to move, and the nature of the movement.
4 Image magnification.
5 Depth of field requirements.
6 The need for special equipment or techniques.

When the subject is unlikely to move or be damaged by heat, a wide range of sources, including ambient light, can be used. Pictures of small creatures and flowers are best lit by flash. If they are photographed in their natural environment a flash gun is the most suitable source. Pay particular attention to the well-being of your subjects and avoid frightening them or damaging their habitat. It is especially important not to disturb mammals and birds with young. If in doubt do not take the photograph, or shoot from a distance using ambient light alone.

A high degree of magnification creates very shallow depth of field, low image brightness and a high risk of camera shake. A bright modelling lamp is essential if you are using flash as the exposing source. Even with a powerful tungsten lamp such as a 1kW spotlight, your exposure times can be quite long. A firm camera support is vital. Use your lights close to the subject but beware of heat damage to your camera, reflectors and diffusers, as well as the subject itself.

A further difficulty posed by high magnification is the lack of space between lens and subject, restricting the control you have over positioning the lights. Special equipment is used to solve this problem.

The following chart gives a breakdown of subject types and a guide to suitable light sources.

Lighting style and techniques
The style of lighting needed for close-ups is often similar to the lighting employed for portraits and still life photography. This is particularly true for pictures of small animals, flowers and precision machinery. But some subjects demand an unusual approach or a piece of special equipment to overcome lighting difficulties, or clearly show internal structures and fine detail.

Small animals
Insects, amphibians, reptiles, birds and small mammals all make marvellous subjects for a close-up picture. You can photograph them in their natural environment or in captivity.

Working outdoors, you become a hunter armed with lightweight mobile equipment. A flash gun makes you independent of AC power, dull daylight and shadows. Automatic exposure control ensures correctly exposed photographs. The short flash duration guarantees a picture free from camera shake and subject movement. In bright sunshine you can use flash as a fill-in light to

Subject characteristics and image magnification

Light source		Delicate – static ①		Delicate – active ②		Robust ③		Typical exposure
		M = 0.5	M = 2	M = 0.5	M = 2	M = 0.5	M = 2	
	Daylight indoors	●●●○○	●●○○○	○○○○○	○○○○○	●●●●○	●●●○○	⅛ sec f/8 ④ ½ sec f/8 ⑤
	Tungsten	●○○○○	○○○○○	○○○○○	○○○○○	●●○○○	●○○○○	¼ sec f/5.6 ④ 1 sec f/5.6 ⑤
	Fluorescent	●○○○○	○○○○○	○○○○○	○○○○○	●●○○○	●○○○○	¼ sec f/5.6 ④ 1 sec f/5.6 ⑤
	Low power 275W x 4	○○○○○	○○○○○	○○○○○	○○○○○	●●●●○	●●●●○	1/15 sec f/8 ⑥ ¼ sec f/8 ⑦
	High power 500Wx3 – 1000Wx1	○○○○○	○○○○○	○○○○○	○○○○○	●●●●●	●●●●●	1/60 sec f/8 ⑥ 1/15 sec f/8 ⑦
	Flash gun/flashbulb GN 30/100	●●●●○	●●●●○	●●●●○	●●●●○	●●●●○	●●●●○	f/16 ⑥ f/8 ⑦
	Flash units x 4 GN 50/160	●●●●●	●●●●●	●●●●●	●●●●●	●●●●●	●●●●●	f/22 ⑥ f/11 ⑦

Key: ●●●●● = most suitable
○○○○○ = least suitable

GN is quoted in m/ft for ISO 100/21° film
① Delicate subject, eg. flower
② Delicate subject, eg. insect
③ Robust subject, eg. coin
④ Exposure on ISO 400/27° (ASA 400/27 DIN) film with image M = 0.5
⑤ Exposure on ISO 400/27° (ASA 400/27 DIN) film with image M = 2
⑥ Exposure on ISO 100/21° (ASA 100/21 DIN) film with image M = 0.5
⑦ Exposure on ISO 100/21° (ASA 100/21 DIN) film with image M = 2

prevent shadows blocking up.

If you do not learn something about your subject's life cycle and favoured territory you could spend more time hunting than taking photographs! A long focal length lens provides a large image while allowing you to keep a reasonable distance from timid creatures.

Special adjustable clamps are available to fix a flash gun to the camera or lens, and allow it to be angled to provide a variety of lighting effects. Two or more flash guns plus reflectors can be used in this way, synchronised together to give main, fill-in, backlight, rim lighting and so on. In effect, you have assembled a tiny mobile lighting set to illuminate a small space just in front of the lens. This camera/clamp/flash gun assembly forms a single unit which can be hand-held to follow a moving subject. Shoot a test film, or a series of instant-picture shots to establish the most suitable positions for the flash guns and to determine exposure and depth of field characteristics. Test the equipment at home to ensure that it will all work smoothly and with the utmost reliability when used on location.

This approach is equally suitable for photo-graphs of flowers.

With a very shy animal, especially a bird, it is often best to set up your camera and flash guns on a tripod. Pre-focus the lens on an area where the creature has made its home or is likely to feed, then operate your camera by remote control from a distant vantage point. Observe the subject area through binoculars.

Photographing a captive animal is much simpler, provided that it is kept in a suitable enclosure. A glass tank is ideal for a variety of small mammals, amphibians and reptiles. It is easily possible to simulate a natural environment by making a floor of sand, stones, earth, plants and adding a small water pool and branches. Use a background of blue paper to represent the sky.

As a tank has four transparent sides, plus the top, you can use a wide variety of lighting directions. A small light source located over the top of the tank gives an effect closely resembling sunshine in its quality and direction. Fill-in, background and rim lights can be added through the side panels. Frontal lighting is a little more difficult to arrange because a light pointed straight at the tank will cause a brilliant glaring reflection from

99 Young housemartins emerging from the nest had to be lit with a fairly powerful flash gun because the nest was in constant deep shade. The camera was a 35mm SLR with a 300mm lens. Exposure was f/22 on ISO 400/27° (ASA 400/27 DIN) film and was calculated from the guide number as the surrounding light-coloured paintwork would have 'fooled' the automatic sensor into underexposing. Image magnification on the negative was about 0.2.

bright lights. Once again an outline knowledge of the creature's natural behaviour patterns will help. You are unlikely to produce a satisfactory action picture of a nocturnal (night active) mammal if you shine a 500W lamp in its face. Flash units with built-in or improvised modelling lamps provide an ideal answer. Set up with the modelling lamps switched on to judge the lighting effect and arrange the units to avoid reflections.

Pre-focus your camera on an area where the animal is likely to pass or come to feed. Switch off the modelling lamps and shoot the pictures using light from the flash units alone. You have to work in a darkened room with only sufficient ambient light available to judge when the animal is within your field of view. Shoot test pictures with a substitute as you may only get one chance to photograph a timid animal. For black-and-white pictures when accurate tonal qualities are unimportant experiment with black-and-white infra-red film (see page 147).

Frontal lighting

At the high degrees of magnification found in macrophotography there is little space between lens and subject. This makes frontal lighting very difficult to arrange. Three-quarter and side-lighting are unsuitable for subjects with complex recessed detail or shiny surfaces, where soft frontal lighting is essential. Two special techniques are used to provide this quality – ring flash and on-axis 'reflex' lighting.

Ring flash

Ring flash, as its name indicates, is produced by a flash unit with a circular flash tube. It may be a self-contained flash gun or a special 'head' operated from a studio flash console. Some ring flash units have miniature modelling lamps built in.

The unit is designed to fit on to the front of a camera lens so that the flash tube completely encircles it. In this position the tube occupies the minimum amount of space and creates a very even, soft lighting quality. The minimum of shadow is formed so texture is completely suppressed. A characteristic ring-shaped reflection is seen on surfaces which produce specular highlights.

A close-up photograph taken with ring-flash is usually excellent from the point of view of containing clear information. However, the very flat lighting can make your pictures appear rather lifeless if form and texture are important qualities in the

the front glass panel. To avoid this, place your light in direct contact with the front of the tank. It is best to do this with flash gun or studio flash unit equipped with a low-power modelling lamp. The heat from a powerful tungsten lamp at such very close range will crack the glass and may in any case cause your subject to behave unnaturally.

You also need to take steps to avoid other minor reflections which will spoil your pictures. Shoot through a hole, made in a matt black card, to prevent reflections from the camera area. Position your background paper *inside* the tank to avoid tell-tale reflections from the rear.

With a large tank you can temporarily restrict the movements of an animal by inserting sheets of glass to ensure that it remains within your field of view and focusing zone. Use the same techniques for fish in aquaria.

For really tiny creatures, such as small species of insect, you can improvise a 'tank' using a clear, colourless plastic container. Replace the lid with a sheet of good quality glass or a UV-absorbing filter.

In all cases your first concern must be for the well-being of your subjects. Do not be in a hurry to take your pictures – this kind of photography requires concentration and anticipation but above all patience.

The nature of the light source is largely dictated by the likelihood of rapid subject movement and the possibility of the animal being disturbed by

subject.

Ring-flash is frequently used in medical and scientific photography where an accurate detailed record of deeply recessed and inaccessible details is important and pictorial aspects are secondary.

On-axis 'reflex' lighting
This technique produces frontal lighting with the

direction coinciding exactly with the optical axis of your camera lens.

It requires a sheet of high quality plain glass (or a UV-absorbing resin filter) located in front of the lens at an angle of 45 degrees. The glass sheet acts as a partially reflecting mirror or beamsplitter. Your light source is placed to one side so that incoming light is reflected through 90 degrees from the beamsplitter on to the subject.

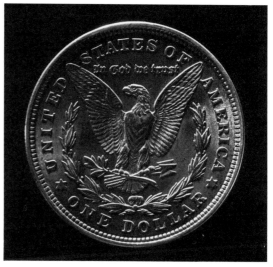

101 With the beamsplitter removed and the light from the floodlight being allowed to reach the coin directly, the design is shown in relief. Black card placed around the coin prevented any unwanted reflection of light from the surroundings.

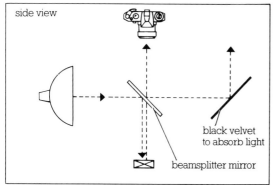

100 On-axis reflex lighting via a beamsplitter provides shadow-free lighting which is perfect for shiny surfaces and small, intricate machines. A 500W floodlight was placed about 60cm (2ft) from the beamsplitter. As well as any exposure allowance you need to make for extra lens extension, you must also take into account the effect of the beamsplitter. A semi-silvered mirror was used which required a factor of 4x to be applied to an incident meter reading. The camera used was a 35mm SLR with a 90mm lens. Exposure on ISO 100/21° (ASA 100/21 DIN) film was 1/2 sec at *f*/16. Image magnification on the negative was 0.5.

The on-axis method is normally used with diffused lighting for subjects which have shiny metal surfaces and detail in low relief. Coins and medals are typical examples. As the photograph is taken through the glass, its surface must be spotlessly clean.

Only about 5 per cent of the light is reflected from the beamsplitter – the remainder is transmitted. You must prevent this light from reaching objects close to the set and so causing reflections from the rear of the glass and back into the lens.

A small piece of black velvet or flock paper placed close to the glass, at an angle of 90 degrees, absorbs most of the light and reflects the rest harmlessly away.

A semi-silvered mirror, with a coating that allows 50 per cent reflection (and 50 per cent transmission) makes the most efficient beamsplitter. Replacing the glass sheet with such a

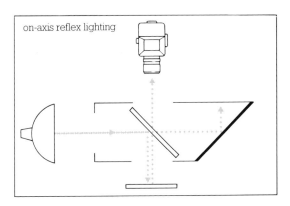

8.1 Lighting can be arranged to coincide exactly with the lens axis by reflecting it from a beamsplitter mirror located at 45° in front of the lens. Light which is initially transmitted must be absorbed to prevent unwanted reflections from the rear of the beamsplitter.

mirror increases the image brightness by a factor of approximately 5x.

Any type of light source is suitable for use with on-axis 'reflex' lighting although it must be reasonably powerful to compensate for the considerable light loss. A bright tungsten source, such as a spotlight or slide projector, is ideal as it produces a bright screen image for focusing and composition. Use an improvised flag to prevent the subject from being lit directly.

The individual components of this assembly can be held in place by clamps and adhesive tape. For regular use, a simple box assembled from cardboard or thin plywood is easily made to hold the beamsplitter, light-absorbing velvet and diffuser conveniently in their correct positions. A vertical arrangement of camera, beamsplitter and subject is usually the easiest to work with.

Transillumination
Transillumination is a type of backlighting used for subjects which are transparent, translucent or have an open, skeleton-like structure, eg. an insect's wing.

This style of lighting normally uses a diffuser illuminated from the rear by one or more light sources – either tungsten or flash. Your subject is placed in front of the diffuser and lit by transmitted light. Direct back lighting, without the diffuser, is also sometimes used.

Transillumination is a particularly suitable technique to adopt for close-up and macrophotography because the camera, subject, diffuser and light source are arranged in a line. This

means the subject can approach the lens very closely yet still remain correctly lit.

You should mask the diffuser down to a minimum area in order to reduce lens flare. Use four strips of black paper, and place them on the diffuser until they are just visible at the very edges of the viewfinder with the lens stopped down to its taking aperture. Then move the strips out slightly and tape them in position.

A vertical arrangement of camera, subject and diffuser is very convenient to work with as you can use a rigid diffuser made from opal acrylic sheet as the actual subject support. However, this arrangement can create difficulties in locating the light source. A flash gun at close range may not

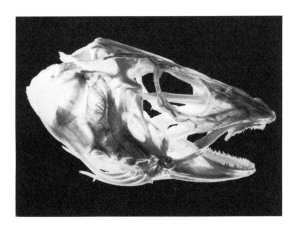

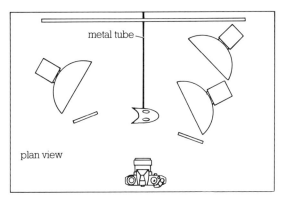

102 Three monobloc flash units were employed to transilluminate the fish skull. Each light was fitted with a general purpose reflector and flags were carefully arranged between lights and camera to minimise the likelihood of lens flare. The skull itself was supported on the end of a metal tube protruding through a hole in the background. The camera was a 35mm SLR with a 90mm lens. Exposure on ISO 100/21° (ASA 100/21 DIN) film was at f/22. Image magnification on the negative was 0.2.

103 A spectacular insect apparently caught in mid-flight was, in fact, perfectly stationary on the outside of a window. Lighting was with a medium power flash gun hand-held at an angle to the glass to avoid reflections. The automatic sensor was on a remote cord pointing at the subject from the camera position. A 35mm SLR camera was fitted with a 90mm lens and extension tubes. Exposure on ISO 100/21° (ASA 100/21 DIN) film was at *f*/11. Image magnification on the transparency, x1.

104 Including the fingers gives scale to this picture of a young lizard. One monobloc flash unit with a general purpose reflector was used. A small sheet of white paper under the hand acted as a reflector board. The camera was a 6 x 7cm SLR fitted with a 135mm lens and extension tubes. Exposure on ISO 50/18° (ASA 50/18 DIN) film was at *f*/16. Image magnification on the transparency was x1.

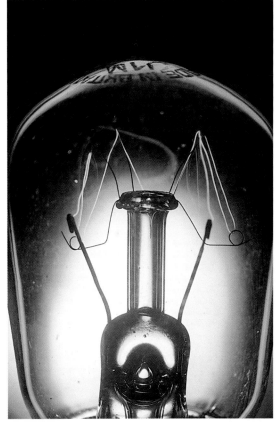

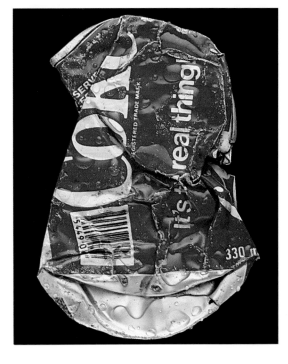

105 The simplest subjects can make effective close-ups when you choose suitable lighting. A flash gun was located above the pins, slightly to the rear. The sensor of the flash gun was attached to a remote cord and placed near the camera pointing towards the subject. The camera was a 6 x 9cm flatbed with a 105mm lens. Exposure on ISO 200/24° (ASA 200/24 DIN) film was at *f*/16. Image magnification on the transparency was x1.

106 A combination of electronic flash and light from the lamp was used for this picture. A small diffused flash gun was placed behind the lamp to transilluminate the filament support. Exposure estimation was based on a guide number. A 6 x 9cm

flatbed camera was used, fitted with a 105mm lens. Exposure was 1/2 sec at *f*/32 on ISO 200/24° (ASA 200/24 DIN) film. Image magnification on the transparency, x2.

107 Close-up photography reveals fascinating detail and textures, even in everyday rubbish. Isolated from its usual environment even a discarded soft drink can has attractive qualities. Lighting was provided by a 1m (3ft) diffuser on a monobloc flash unit. A white paper reflector added subtle highlights to the metal base. The camera was a 35mm SLR with a 90mm lens. Exposure on ISO 64/19° (ASA 64/19 DIN) film was *f*/11. Image magnification on the transparency was x0.2.

illuminate the diffuser evenly and a powerful tungsten light or slide projector must only be used with its lamp in the correct position – not tilted through 90 degrees.

You can solve these problems by making a simple reflex 'cube' from thick card or lightweight plywood. This open-sided box contains an ordinary mirror fixed at 45 degrees to reflect incoming light through 90 degrees up towards the diffuser placed across its open top. Using the cube means that your light can be positioned normally on a stand or table top and the distance easily adjusted to ensure even illumination at a controllable intensity. It is a good idea to keep the diffuser loose, or held in place with a strip of adhesive tape acting like a hinge. By temporarily removing the diffuser you can check that your light source is correctly aligned by focusing on its reflection in the mirror.

When the image is central in your viewfinder you have proper alignment.

If you want to graduate the light intensity, or add local areas of shadow or colour, experiment by placing scraps of black paper and filter foils below the diffuser.

Use a sheet of black card or paper as a flag positioned between the light source and the camera to prevent flare.

Dark-field lighting

This is a variation of the transillumination method which uses carefully controlled backlighting in conjunction with a black background. It provides an ideal way to reveal very fine detail which would not show clearly as a slightly darker tone against a normal white background.

The subject is suspended well forward of the background. A simple arrangement supports it on a sheet of glass with the camera arranged vertically above. You then direct your lighting on to the subject from behind (ie. with this set-up, underneath).

One method which gives a very uniform style of illumination has a ring flash as the light source. The flash tube is placed behind the subject and its central aperture covered with a small patch of black velvet to form the background.

An alternative method uses two small light sources, such as flash guns, placed opposite each other immediately below the glass sheet. Whatever light source you use make sure that it is carefully masked to prevent light entering the lens directly.

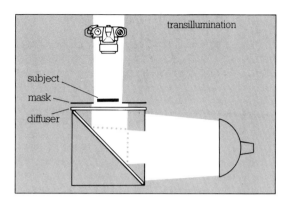

8.2 A convenient and controllable arrangement for transillumination uses an ordinary mirror set at 45°. Incoming light is reflected through 90° up towards a diffuser. This technique makes it possible to easily adjust the lamp-to-diffuser separation, so controlling the evenness and intensity of the lighting.

Equipment and accessories

You can shoot close-ups easily with any camera which has ground glass viewing and focusing. A medium format or 35mm SLR is ideal. There are numerous lenses and accessories which can be used to produce the necessary image magnification. These include the supplementary close-up lens, reversing ring, extension tubes, extension bellows unit, general purpose macro lens, close-focusing lens (usually a zoom), converter, special macro lens 'head' and the microscope (plus camera adaptor). Experiment with lenses from enlargers and movie cameras – they sometimes produce excellent results.

Your choice of lens must take into account the image magnification and the lens-to-subject distance you require and the need for automatic iris operation and data linkage between lens and camera body.

For high magnification choose a short focal length. This gives you a large image size with a conveniently small lens-to-film separation. A 50mm lens on a medium format camera gives a 1:1 (life-size) image with a separation of only 100mm. To produce the same size of image with a 150mm lens, the lens-to-film distance is 300mm. However, if you need a reasonable working distance between lens and subject the longer focal length allows more space within which to control your lighting. Continuing with the same example, both lens-to-film and lens-to-subject distances are identical with any lens producing a life-size image. So the 150mm lens allows you 300mm of

working space while the 50mm lens provides only 100mm.

If your subject is likely to move and/or you are hand-holding the camera, automatic iris operation is highly desirable. Aperture indexing is also essential for some automatic modes of exposure control.

Focusing the camera can be tricky. One of the best methods is to fix the lens-to-film separation and move the whole camera assembly towards the subject as a single unit. You can do this by hand, or with greater precision by using a focusing rack. This is a small platform which fits between camera and tripod and drives the camera back and forth with a rack and pinion mechanism. Some expensive bellows units have a focusing rack built in beneath the main rail.

You need a rigid camera support to prevent camera shake when using continuous light sources. It also acts as an aid to accurate composition and precise focusing whatever the light source. A copy stand is superior to a normal tripod when a vertical arrangement of camera and subject is called for. As there is only a single column supporting the camera it is much easier to organise the lighting. The legs of a tripod interfere with light stands and cast shadows. You can often temporarily convert the column and baseboard of an enlarger into an excellent copy stand and the appropriate fittings may be available for this purpose.

Greater detail on close-up photography and its techniques and equipment is to be found in *Close-Up Photography in Practice* by Axel Brück, a companion volume in this series.

Below is a brief summary of essential hardware and materials with which you may carry out the techniques previously discussed.

Camera accessories
Tripod or copy stand
Cable release
Filters
Pola screen
Focusing rack
Subject support and control
Glass tank
Clear, colourless plastic containers
UV-absorbing filter to fit above
Sheets of glass
Lighting control
Macro clamp for flash guns
Remote lead for flash sensor
Small sheet of high quality glass
Semi-silvered mirror
Ordinary mirror
Resin UV-absorbing filter
Black velvet or flock paper
Other items, as for still life
Background materials and tools
Miscellaneous accessories
Food to entice subjects
Binoculars
Remote control lead

108 Fascinating patterns occur on the surface of partly mixed 'silver' paint. Because of the highly mobile nature of the surface, lighting with flash is essential. One monobloc unit fitted with a snoot was used. The camera was a 6 x 6cm SLR fitted with a 50mm enlarger lens via a specially made adaptor ring. Exposure on ISO 400/27° (ASA 400/27 DIN) film was at f/11. Image magnification on the negative was x1.

109 Film developer made this amazing pattern as it dried and crystallised on the lid of a large developing tank. Lighting was provided by a 1kW spotlight placed to one side to avoid reflections from the plastic surface of the lid. The camera was a 35mm SLR fitted with a 50mm lens and an extension tube. Exposure on ISO 32/16° (ASA 32/16 DIN) film was 1/15 sec at f/11. Image magnification on the negative was x0.25.

9 LIGHTING TECHNIQUES: COPYING

Copying is a highly underestimated branch of photography and often involves a great deal more than merely producing an accurate duplicate of an original photograph or drawing. You can also use the copy process to make sophisticated typographic designs, internegatives from transparencies and 'master' negatives from retouched or montaged originals. Certain types of fading and damage can be corrected at the copy stage, colour can be improved and many creative effects introduced. Copying provides a number of professional photographers with a useful source of income. But, whatever copying you undertake, be careful not to infringe the laws of copyright.

Facsimile copies

The most common type of copying is where an accurate duplicate or facsimile is needed. If the original is a painting or drawing, a photographic copy is often required for reproduction or insurance purposes.

You may need to copy a photograph under the following circumstances:

1 The original negative is not available.
2 Your photograph is a transparency, instant print or photogram made without a negative.
3 The print is in some other way unique and could not be reprinted. You may have used one or more of these processes at the printing stage or in the finished print: extensive local exposure control (eg. burning-in); multiple exposure; tone separation; sabattier effect; extensive retouching or hand colouring; montage.

Modified copies

Minor technical modifications can sometimes mean that the copy is actually better than the original. Suitable techniques include:

1 Filtration to correct poor colour quality or increase contrast, eg. an old and faded black-and-white print which has yellowed with age can be greatly improved by copying via a blue filter.
2 Reduction in size of the whole or part of an original. Small copies are useful for reference and filing. 35mm slides made from larger originals are often used in audiovisual slide presentations.
3 Enlargement of the whole or part of an original; cropping may improve a picture by simplifying it.

4 Adding type: title slides for audiovisual work can be made by copying a sandwich comprising a normal slide and a high contrast line positive (black type on clear film). Another technique produces white type 'reversed out' of the image. For this effect you have to double expose – once for the photograph, and a second time for a line negative bearing clear type on a solid black background.

Image conversion

You can use the copying process to convert a photograph from one form into another. The main uses are to make:

1 Black-and-white and colour copy negatives (internegatives) from transparencies.
2 Slides from prints.
3 Black-and-white negatives from colour prints.
4 Line negatives from conventional photographs.

Creative copying

Many special effects can be introduced at the copy stage to modify an existing picture. These include:

1 Deliberately uneven lighting.
2 Filtration to completely alter original colours.
3 Filtration to add colour to a black-and-white photograph (copy on to colour film).
4 Soft focus and special effect filters, screens etc.
5 Blur – by movement of the original during the exposure. You can experiment with cut-out photographs.
6 Multiple exposure.
7 Distortion by using an overlay of textured glass or plastic, or by copying a distorted reflection via a curved mirror. Experiment with surface-aluminised plastic film to make a variety of distorting mirrors.

Choosing the light source

In selecting the most suitable light source you must consider the following:

1 The type of film required.
2 Whether the set-up is permanent or temporary.
3 The size of the originals.

Ambient light, especially diffuse daylight, is

suitable for large originals such as murals. Artificial ambient lighting tends to be too uneven to permit an accurate copy to be made. Most smaller scale copies, of originals up to 1 x 1.3m (3 x 4ft), are best tackled by using controlled artificial lighting – tungsten or flash.

Certain types of original produce the most accurate copies when photographed using special purpose films. A line drawing or piece of typesetting is best copied with a line or lith emulsion to preserve the pure black and white. Line and lith films are slow – ISO 6/9°–25/15° (ASA 6/9 DIN–ASA 25/15 DIN) – so you need quite powerful lights. Tungsten lights provide this kind of power in a convenient, inexpensive form. A pair of floodlights (200W–500W) is all you need for most line copy work. Colour internegative and some transparency duplicating emulsions are balanced for tungsten light sources.

If you are planning a permanent copying setup, either tungsten or flash lighting is suitable. You can even use a pair of small flash guns. In this case, to determine the correct exposure and the best positions for the lights you should expose and process a test film.

For a temporary arrangement you should use tungsten lights or flash units with built-in modelling lamps. Flash guns do not permit you to assess the lighting effect, unless instant-picture test shots are first made.

A large original (bigger than 1 x 1.3m/3 x 4ft) can be difficult to light evenly. You have to place your lights quite far away to ensure that the surface is uniformly illuminated. Powerful tungsten lights (500W–1000W) or studio flash units (250J–1000J) are needed.

The following chart summarises the suitability of the various light sources for a range of copying applications.

Arranging the lights

For most copy work one of two basic lighting arrangements is used. Which you choose depends on the nature of the original – whether it is normally viewed by reflected light, like a print, or by transmitted light, like a transparency.

Copying prints and drawings

This method is used for copying photographic prints, drawings, paintings, type and charts made on paper.

You need two suitable lights which are identical in terms of output, reflector characteristics and

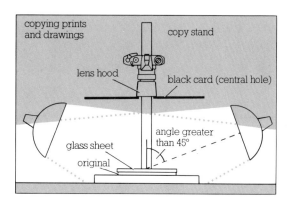

9.1 A vertical set-up is ideal for copying small drawings and photographs. Two identical lights equidistant, and at 45° or more from the lens axis provide even illumination. If the original is held flat under a sheet of glass, a black card beneath the camera prevents unwanted reflections.

colour temperature. It is possible to use two dissimilar sources but doing this introduces unnecessary complications.

Each reflector must produce a beam of light which illuminates a flat subject plane uniformly without a central 'hot-spot'.

The two lights are placed either side of the original at the same distance, and at an angle to the lens axis of between 45 and 60 degrees. This arrangement is termed *copy lighting* and is designed to illuminate the original uniformly and avoid glaring reflections from its surface.

Evenness of the lighting can be checked by covering the original with a matt white card and taking a number of reflected light readings from the centre, edges and corners. But you should take great care to avoid casting a shadow from the meter on to the card. A spot meter, reading from the camera position, is ideal.

When using studio flash units you should take both continuous light and flash meter readings to confirm that you have a perfectly 'proportional' relationship between modelling lamp and flash output. If one of the modelling lamps was nearing the end of its life and producing less light than the other you would not achieve an evenly lit area of flash illumination by judging the light intensity from the modelling lamps alone.

You can make a simple visual check on the lighting by holding a pencil in line with the camera lens axis, just touching the white card. The two shadows cast by the pencil should be equal in length and density when viewed from the camera position.

Lights that do not illuminate evenly but produce a distinct 'hot-spot' can still be used, provided that the 'hot-spot' covers the whole of the original. This situation occurs when copying a small print or when the lights are moved further away.

For highly critical copying where perfect evenness of illumination is needed *at the film plane,* you have to take into account the image forming characteristics of the camera lens. Most lenses exhibit a slight fall-off in image brightness at the edges and corners of the frame. To compensate for this natural variation in image illumination you must make the edges and corners of the original slightly brighter than the centre. An increase in brightness of 25 per cent is sufficient with most lenses.

The most sensitive and reliable check on the evenness of illumination is a photographic test. Shoot a picture of the white card using the type of film you intend to use normally. If the film is a negative emulsion, make a print, exposing the paper to produce a mid-grey tone. If the film is a transparency material intended for projection, expose to produce a mid-grey, then mount the slide and project it. Only assess the evenness of the final print or projected image (assuming that the transparency is intended for projection).

Copying large originals

Uniform brightness is difficult to achieve over a large area. Reflectors must be carefully chosen to ensure freedom from 'hot-spots'. In a small room you may not be able to move your lights far enough from the original.

The best method of lighting large areas is to use four lights instead of two. One light is placed near each corner at an angle of 45 to 60 degrees to the lens axis. As each light is only illuminating one quarter of the total area it can be placed quite close to the original.

An alternative technique uses only two lights which have their lamps in the form of long tubes. Tungsten-halogen linear filament lamps and studio flash consoles fitted with striplight flash tubes are suitable. Ordinary fluorescent tubes can be used for black-and-white photography. The long tubular light source when used with a suitable reflector produces a broad even 'wash' of light which is ideal for copy lighting.

Dealing with texture

With most originals it is not necessary or desirable to record the surface texture in addition to the

110, 111 Normally arranged copy lighting on this semi-abstract oil painting caused unwanted reflections at the sides. By fitting pola screens to the lights and the camera lens the reflections can be controlled and largely eliminated without moving the lights. Two 275W photofloods in general purpose reflectors were used.
110 Exposure on ISO 125/22° (ASA 125/22 DIN) film was 1 sec at f/16.
111 Exposure on ISO 125/22° (ASA 125/22 DIN) film was 15 sec at f/16.
112 In addition to standard copy lighting you can also use a third light to skim the paint surface and so indicate its texture or 'impasto'. This picture shows the effect of a 500W spotlight adjusted to just catch the thicker areas of paint. Exposure on ISO 125/22° (ASA 125/22 DIN) film was 1 sec at f/16.
110–112 The copy camera was a 35mm SLR with a 50mm lens.

image details. If the original has been made on rough-surfaced paper or fabric, lighting with large diffused sources will minimise its texture. You must take care in arranging such lighting to keep the angle between the lens axis and the *closest edge* of the reflector at 45 degrees or greater. Carelessly arranged lighting, with the lamps at too shallow an angle to the lens axis, often results in glaring reflections from the edges of the original which are nearest to the lights. You may not notice this defect immediately because the reflection comes not from the general surface but only from image details in ink or paint.

When copying oil paintings you can include some texture to indicate the quality of the brush strokes – the 'impasto'. This can be done by adjusting the positions of the normal copy lights or by adding a light to skim the surface and so create the necessary specular highlights.

If you need to suppress texture on an oil painting, large diffuse sources can be used. However, the irregular glossy surface often picks up unwanted reflections which desaturate the colours. To avoid this problem use pola screens over the copy lights and camera lens. The pola screens in front of the lights should align to polarise light in the same plane. Light reflected diffusely from the paint is depolarised and so is transmitted by the pola screen on the lens. Light reflected specularly remains polarised but can be eliminated by rotating the pola screen on the lens. This technique necessitates a considerable increase in exposure due to the combined absorption (filter factors) of the pola screens. Give between 8x and 16x the reading indicated by an incident hand meter.

Copying transparencies
The following techniques are used to duplicate slides and make internegatives from transparencies.

The simplest method is to use a form of diffuse transillumination. You need only one light source and a translucent diffuser. The diffuser must be completely free from scratches, dust and any form of grain or texture that is visible by transmitted light. Opal acrylic sheet material is ideal. The reflex cube arrangement described on page 105 is very suitable for transparency copying. Your light source lies behind the diffuser with the transparency in front. Any area of diffuser not covered by the transparency or its mount should be masked off with black paper.

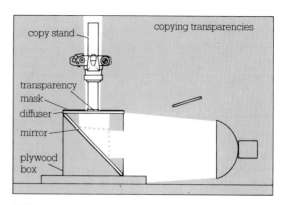

9.2 Transparencies are copied using diffuse transillumination. This arrangement comprises a single light source and a horizontal, texture-free diffuser. An ordinary mirror set at 45° reflects light through 90° and permits the lighting unit to be located at an appropriate distance to control brightness and uniformity.

For small format transparencies special slide mount holders with built in diffusers are made which fit on to the front of an extension bellows unit. Complete slide duplicators are also available which contain a lens, slide holder and diffuser pre-assembled in a single unit, ready to screw into the body of a 35mm SLR camera.

Professional slide duplicating machines use the same principle of diffuse transillumination but take the design a stage further by building in the light source and some of the following features: filters, modelling lamp (where the exposing source is flash), contrast control device, exposure meter. These machines also permit a range of

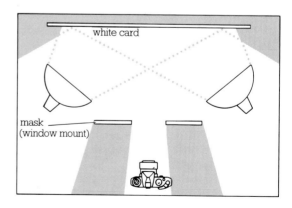

9.3 An alternative method of transillumination employs a white surface evenly illuminated by conventional copy lighting. The original transparency is positioned in front, supported in a black window mount. The white material must be perfectly clean, free from all creases and surface texture.

differently-sized originals to be copied by a variety of camera types. So a 4 x 5in transparency can be reduced to a 35mm slide, or a 6 x 7cm transparency enlarged to produce a 4 x 5in black-and-white internegative and so on. A similar unit permits the production of instant prints from 35mm slides.

Another type of transillumination is possible whereby the transparency is rigidly held some distance away from a sheet of smooth white card. The card is then lit with a copy lighting technique to produce even illumination. As with the diffuser arrangement the area surrounding the transparency must be masked off with black paper.

You can make a simple 'window' mount from black card which will have the dual function of support and mask.

This technique is useful when copying a large transparency if a sheet of opal acrylic material of the right size is not available.

Lighting must always be even. With a small diffuser the brightness levels at centre and edges are difficult to measure or judge by visual assessment. Run a photographic test, as before, to determine the evenness of illumination.

Contrast control

Transparencies are inherently high in contrast. A density range of 3 is common, which means that the lightest highlight is 1000x brighter than the darkest shadow. When a transparency is copied on to conventional film, detail is always lost on the resulting slide or print – highlights burn out, or shadows block up, or both.

For the best possible copies you should use special duplicating film which has a low contrast emulsion designed to cope with the high contrast original. This is made in 35mm cassettes, bulk rolls and large format sheet sizes. It is balanced for exposure to tungsten light and daylight or flash.

But acceptable duplicates can be made on conventional films by using a technique of contrast control. This method lowers the contrast by 'fogging' the film with a carefully adjusted amount of light. The technique is also known as 'flashing' or 'pre-fogging', irrespective of whether tungsten or flash lighting is used. The ratio of the 'fogging' exposure to that used to make the copy is best found by experiment but a value of 1:64 to 1:32 (1½ to 3 per cent) offers a good starting point for a series of tests.

A double exposure technique is used to expose the film, first to a uniform light of low intensity, then

for the image on the transparency. In practice, the fogging exposure is made by photographing the diffuser without the slide in place.

The most convenient method of achieving the essential low light level is to use a neutral density filter combined with a change in lens aperture.

If, for example, you were using flash and had determined the correct exposure for the copy to be f/8, then a fogging exposure of 1/64 that intensity is produced by using a 0.9 neutral density filter (filter factor = 3 stops or 8x) and closing the lens down to f/22. Using tungsten light you can manipulate both aperture and shutter speeds to achieve the necessary ratio.

Some professional slide duplicators offer a contrast control facility using the 'fogging' principle, but with a more convenient technique than double exposure. One method uses a beamsplitter below the lens, angled at 45 degrees to the vertically arranged lens axis. A low power diffuse flash unit is located at 90 degrees to the lens axis in such a way that light from it is reflected by the beamsplitter into the lens. The transparency is illuminated by a more powerful flash unit situated below a diffuser, in line with the camera. Both flash units fire together; the light reflected from the beamsplitter has the same effect as a fogging exposure. Each unit can be switched from full to fractional power so a wide range of fogging:copy-exposure ratios are possible.

Another technique uses a more sophisticated approach taking a small amount of light from the flash unit via a fibre optic bundle to a tiny diffuser situated at the rear of an extension bellows unit. As the flash fires, low intensity 'fogging' light simultaneously spreads across the film. The fogging: copy-exposure ratio is controlled by a stepped neutral density filter located between the flash tube and the fibre optic bundle.

You can make internegatives from transparencies using normal film. For black-and-white negatives use 'fogging' contrast control, or modify the processing. Try rating your film at *half* its normal speed, then reducing the recommended development time by 30 per cent. For optimum quality, colour internegatives should be made on special internegative film (tungsten balance). Conventional colour negative film produces high contrast results which may be adequate for non-critical use or as the basis of a reference or slide filing system. Contrast control by 'fogging' exposure or modified processing sometimes gives improved quality.

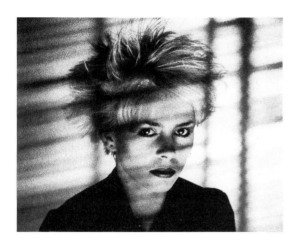

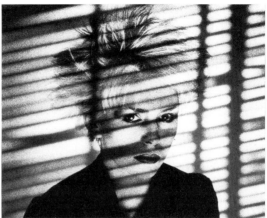

113, 114 In the original 6 x 7cm colour transparency the background is plain, though slightly graduated. These copies were made by holding the transparency in front of a bamboo window blind with sunlight casting shadows of the wooden strips on to the transparency sleeve. By adjusting the distance between the transparency and the blind, the shadows became softer and harder.

113 Distance from transparency to blind 50cm (20in).
114 Distance from transparency to blind 10cm (4in).
The grain-like texture is due to the frosted plastic diffuser material used to make the back of the sleeve. The copy camera was a 35mm SLR with a 90mm lens. Exposure on ISO 400/27° (ASA 400/27 DIN) film was 1/125 sec at *f*/8.

Colour accuracy

Copying is an unusual branch of photography in that it is quite a routine matter to be able to compare the photograph with the subject – copy with original.

You will often find that it is impossible to achieve an accurate match of all colours. This is an inevitable consequence of the photographic process, which uses only three basic dye layers to simulate the appearance of every colour. Not all pigments can be reproduced in this way.

If you undertake to copy any colour originals as a paid commission you should acquaint your client with this fact.

Equipment and accessories

In a permanent set-up any camera can be used provided that it can focus close enough and produce a sharp, undistorted image. Even a camera without ground glass focusing is usable as it can be fixed in place and the focusing and alignment carried out by reference to a ground glass screen temporarily positioned over the film plane.

The shutter is set to 'B' and locked open to provide the image. You then mark out the subject area. When shooting the pictures all you have to do is place the original within the indicated area.

For a more flexible approach you do need a camera which features ground glass viewing and focusing – large format cameras, medium format SLRs and 35mm SLRs are all suitable. A wide range of specialist emulsions is made in sheet film sizes and 35mm. Few such materials are available in roll film.

Your lens must be capable of focusing close enough to provide an image of a suitable size. For slide duplication this means it must be able to produce a 1:1 (life-size) image. Use a standard or long focal length lens of high quality which is free from curvilinear distortion. An enlarger or 'process' lens is recommended for slide duplication. In order to use the 'fogging' method of contrast control your camera must allow you to make double exposures with perfect registration.

A vertical arrangement of the camera and original is convenient to use for originals of up to approximately A3 (297 x 420mm) in size. Larger originals are best dealt with by fixing to a wall and copying with a horizontal arrangement. A copying easel made from flat blockboard or chipboard painted matt black makes a suitable support for the original.

Camera accessories
Tripod or copy stand
Cable release
Filters
Pola screen (optical quality)
Exposure meter, 18 per cent grey card
Subject support

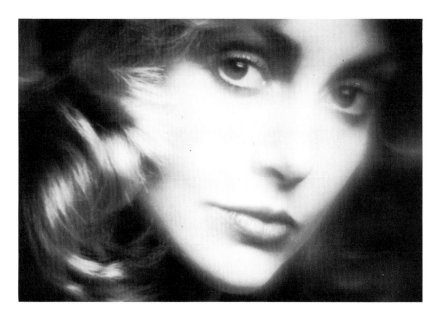

115 Copy with a soft focus screen over the camera lens.

Glass sheet
Adhesive tapes – double-sided, masking tape
Adhesive putty
Pins
Rubber bands
Wood blocks
Spirit level
Small mirror
Lighting control
White card/paper
Black card/paper
Black flock paper
Opal acrylic sheet
Non-optical grade pola screens
General accessories, tools
Stands, clamps, clips
Cleaning cloths
Scissors
Craft knife, scalpel
Rule

Copying guidelines

1 Choose the most suitable type of lighting.
2 Assemble all equipment and accessories and check functions.
3 Set up your camera exactly square on to the original. With a vertical arrangement use a spirit level to ensure that the copying easel and film plane are parallel. A small mirror placed at the exact centre of a large original helps alignment when using a horizontal arrangement. Focus on the reflection and when you see the reflection of the lens at the centre of the frame the camera is correctly aligned. A camera screen marked with a grid of lines helps you to judge when the image

is correct.
4 Hold the original perfectly flat. Use a sheet of clean, blemish-free glass to cover small un-mounted prints and drawings.
5 With an original on thin paper use a sheet of white paper behind. If there is 'show-through' from printed matter on the reverse, use black card or paper.
6 Remove transparencies from glass mounts and sleeves.
7 Take steps to prevent unwanted reflections from the original or the cover glass. Place a sheet of black card or flock paper in front of the camera (with a hole cut in it for the lens to look through), and arrange bellows or an improvised hood be-tween the lens and transparency. Turn off all over-head room lights.
8 Run a photographic test to determine the optimum aperture of your lens for the image magnifications you are most likely to use.
9 For critical copying with transparency film, take into account the 'safety factor' of the camera screen. Many 35mm SLRs show little more than 90 per cent of the image area in the viewfinder.
10 To copy pages from a book use a vertical arrangement. Hold the page to be copied flat with a sheet of glass and support the remaining pages upright with wooden blocks. Cover the facing page with black paper and hold it in place with rubber bands.
11 When using a tripod for vertical copying secure a heavy weight to the leg furthest from the camera to prevent the tripod from falling for-wards.

10 LIGHTING TECHNIQUES: INDOOR ACTION AND SPORT

Many activities which make exciting subjects for a photograph such as sports, games, concerts, and theatrical performances take place indoors, or outdoors at night. The most successful pictures of these events manage to capture the action at its peak, and communicate something of the original atmosphere.

Professional photographers shoot this kind of picture for editorial use in newspapers, magazines and books. Organisers and participants also require photographs for promotional purposes and as souvenirs.

Choosing the light source

When deciding on an appropriate light source you should consider the following:

1 Whether you are likely to be given permission to use your own lighting.
2 If your lighting would interfere with the performance.
3 The need to preserve atmosphere.
4 Brightness and colour quality of the ambient light.
5 The way in which you want to show movement – by 'freezing' it or creating blur.
6 How large an area needs to be illuminated.

7 The distance of your lights from the subject.
8 Depth of field requirements.

Existing light often makes a very important contribution to the atmosphere of an event. This is particularly true of concerts and theatrical performances. You must always seek permission from the organisers to take photographs and *never* use flash until everyone involved is aware that you are doing so.

Athletes, performers and audience can be seriously disturbed by flash being fired during a contest or performance. If flash is the only suitable light source, try to arrange a photographic session during a practice or rehearsal.

When shooting a large area or working from a considerable distance you need very powerful light: several 1000W tungsten lights or 1000J flash units are often required. Installing this kind of lighting is a major undertaking so working with existing light, and shooting with high speed lenses on fast film such as ISO 1000/31° (ASA 1000/31 DIN) or more may prove a more realistic proposition.

For photography by existing light see page 152.

The following chart summarises the suitability of the major forms of lighting for a range of typical subjects.

Action/sport

Lighting	Indoor sport ①		Rock concert	Theatre	Indoor games	Typical exposure and film speed ②
	Fast	Slow				
Arena – normal lighting	●○○○○	●●●○○	○○○○○	●●○○○	●●○○○	1/60 sec f/2 ISO 1600/33°
Arena – event lighting	●●●●○	●●●●●	●●●○○	———	●●●●○	1/125 sec f/2.8 ISO 1600/33°
Theatre	———	———	●○○○○	●●●●●	●●○○○	1/60 sec f/2.8 ISO 1600/33°
Rock concert – stage lighting	———	———	●●●●●	———	———	1/250 sec f/4 ISO 1600/33°
Flash gun/flashbulb GN 30/100	●●●●○	●●●●○	●○○○○	●○○○○	●●●○○	f/4 ② ISO 100/21°
Flash units x 4 GN 50/160	●●●●●	●●●●●	●●●○○	●●●○○	●●●●●	f/11 ISO 100/21°

Key: ●●●●● = most suitable
——— = not suitable
○○○○○ = least suitable

GN is quoted in m/ft for ISO 100/21° film
① Fast sport, eg. cycling, basketball: slow sport, eg. gymnastics (peak of action).
② Exposures assumes direct lighting.

Lighting for action

Once you have decided that some form of controlled lighting is needed, the choice between tungsten and flash is largely determined by how you want to record movement. You can use flash to 'freeze' the relatively slow movements you find in most sports and games. If you want to portray movement as a blur you have to use tungsten. For photographs showing a combination of sharp and blurred images both sources are used together.

Freezing movement

The most commonly used technique for showing action is to freeze it at a significant stage using flash lighting. A high shutter speed (1/500–1/4000 sec) used in continuous light produces an identical result. However, you are unlikely to come across existing light, or be able to arrange tungsten illumination of sufficient intensity to make such a shutter speed practicable.

To choose a stationary image that strongly suggests movement, it is vital that you find a point in the action which is impossible to hold in a static pose; eg. a leap in the air.

Where the peak of the action is difficult to identify, a motor-driven camera equipped with a rapidly recycling flash gun permits you to take a sequence of photographs, one or more of which should be suitable.

Flash guns and studio flash units are suitable, provided that a power supply is available for the latter. One point to consider, particularly when choosing a studio flash unit, is its flash duration. In some cases it may be as long as 1/200 sec, which is not sufficiently short to arrest rapid motion.

Most units can be switched from full to fractional power. This may shorten or lengthen the duration, or leave it unaltered, depending on the type of electronic circuit used.

Flash guns usually fire with shorter durations when set on fractional power or when operating automatically at less than full output.

Check with your instruction book for specific information about the equipment you are using.

When shooting with flash guns, or in a situation with an ambient light level high enough to overwhelm modelling lamps, only an instant-picture test shot will allow you to judge the lighting effect.

Using blur

Deliberate blur creates a strong impression of movement but it is very important to choose the correct amount. A small degree of blur can be mistaken for accidentally poor image quality whereas a large amount renders your subject unrecognisable, though this effect can often produce striking abstract shapes and patterns.

The amount of blur you produce depends on a number of factors:

1 Speed of movement.
2 Direction of movement relative to the camera.
3 Image size.
4 Shutter speed.

The greatest degree of blur occurs when the subject moves rapidly *across* the field of view (at 90 degrees to the lens axis) and is recorded as a large image and with a slow shutter speed.

A further influence can be exerted by moving the camera itself. Panning to follow the subject reduces the rate at which the image moves across the film during the exposure but it also blurs the background. This often heightens the impression of subject movement.

It is impossible to predict the exact appearance of the blur and the effect of any one shutter speed. If the action is repeatable, shoot a number of instant-picture test shots, or a series of conventional photographs at a variety of shutter speeds. Where you have only a single opportunity to take the photograph try to use a number of cameras set to different shutter speeds and fire the shutters simultaneously.

Blurred images usually work best when the subject is light in tone, or brightly coloured, and set against a dark background. With tungsten lighting you can easily ensure a dark background by illuminating only the subject area. The natural fall-off in light intensity, more or less quantified by the inverse square law (page 8) causes a distant background to receive far less light and so appear dark. Where there is a large space between subject and surrounding walls you can even produce a completely black background. You might use barn doors, snoots and flags to further limit the amount of light reaching the background.

The power of the lighting you need is largely dependent on the brightness of the ambient light. Where this is very low, a few 100W lamps are sufficient for most subjects. In brighter surroundings you need to be able to overpower the existing light with your controlled tungsten in order to subdue the background tone.

Where you need to use a very slow shutter speed (longer than about ½ sec) you can some-

times find it impossible to set the correct exposure because the lens cannot be stopped down sufficiently. Anticipate this problem by including a range of neutral density filters in your outfit.

For most blur shots it is convenient to work with your camera stationary and on a tripod. If background detail is included, even at a very subdued level it will be sharp. However, a *slightly* blurred background is distracting. With a tripod you can be sure to record only blur due to subject movement and not in combination with camera shake – generally the best option.

During long exposure times the viewfinder of an SLR camera is blacked out. Focus on the area you expect your subject to move into and take note of the limits of your field of view. When you are ready to make the exposure, observe your subject directly.

You can pan from a tripod or with a hand-held camera. An optical viewfinder fitted to the hot-shoe of an SLR camera allows you to follow the movement accurately, even while the normal viewfinder is blacked out.

Combination effects

An image which is partly sharp and partly blurred gives you the best of both worlds. The sharp component clearly shows the subject, while the blur describes its movement.

For this effect you often need to use flash and tungsten lighting together. The power and location of the tungsten lighting is related to the output of the flash. To find out how much power you need and how far your tungsten lighting must be from the subject you should follow this procedure:

1 Determine the *f*/number which gives correct exposure for the flash lighting.
2 Estimate what shutter speed you need to create the desired blur.
3 Select the power and distance for the tungsten lights which give correct exposure at the chosen shutter speed and predetermined aperture.

If your tungsten lighting is insufficient, reduce the output of the flash equipment by using a fractional power setting or a neutral density filter over the units. When the power of the tungsten lighting is too great, move it further away, change to lamps of lower wattage or use neutral density filters over the lights.

Once the basic lighting arrangement has been made, the most important decision is to determine

when the sharp image should be exposed in relation to the blurred component. If you synchronise your flash equipment in the normal way, the flash will fire at the beginning of the exposure, resulting in a sharp image followed by a blur. For many subjects this is quite appropriate but sometimes you might want the sharp image to fall part of the way through the blur, or at the end.

Provided that your exposure time is long enough (more than one second) you can judge the best time for the flash exposure and fire your equipment using the 'open flash' technique. With flash units located at some distance from the camera, you could short-circuit a sync lead or fire a small flash gun with its open flash button to trigger slave cells on the main lights. A dark or black background is essential.

If you are shooting on daylight-balanced colour film, your final result will consist of a sharp neutral image and a yellow blur. Where the images occupy a similar area of film this colour difference is useful. However, the two image components are already quite distinctly different (sharp and blurred) so any additional variation in colour could be considered unnecessary. If you want both components to have a neutral balance you must filter one of the light sources to match the colour temperature of the other.

There are two ways of doing this. Using daylight balanced film, fit a blue conversion filter over the tungsten lights (Wratten 80A for 3200K lamps, Wratten 80B for 3400K lamps). With tungsten balanced film and 3200K tungsten lighting, use an orange conversion filter over the flash units (Wratten 85B). If you are using photofloods (3400K) fit a Wratten 85 filter over the flash units and a Wratten 81A over the lens.

To make the sharp image more dominant consider deliberately underexposing the blurred components by between one half, and one full stop.

Other techniques for portraying and simulating movements in the studio are dealt with in Chapter 14.

Lighting style

You are likely to encounter a variety of working conditions in this field. At one extreme you are restricted to a single location, have no contact with the subject and are limited to using ambient light or a flash gun. You may also be rationed to a small number of pictures, or a brief period of time in which to take them.

At the other extreme you experience no restrictions and can use whatever space and equipment you find necessary.

Good photographs can be taken under any of these conditions, though you should be able to produce better and more varied results when you have greater freedom.

If you are forced to work under very restricted circumstances think carefully before you use flash. A flash gun used on or near the camera gives flat, frontal lighting. This style kills atmosphere – flash photographs taken in this way at concerts and plays are usually disappointing. Using the existing light and shooting with a wide aperture lens on fast film often provides a better solution. The effective film speed of many emulsions can be increased by extended processing. An increase of one stop, eg. making ISO 400/27° (ASA 400/27 DIN) effectively ISO 800/30° (ASA 800/30 DIN) can be achieved with a negligible change in emulsion characteristics. Extended processing to produce greater increases in effective speed are possible with some loss of image quality. An increase of between 2 and 3 stops, eg. making ISO 400/27° (ASA 400/27 DIN) effectively ISO 1600/33° (ASA 1600/33 DIN) and ISO 3200/36° (ASA 3200/36 DIN) can be regarded as the maximum which will produce an acceptable result on black-and-white and colour transparency materials. This technique is not recommended for colour negative films, though in practice a one stop increase is possible.

When the only possible light source is an on-camera flash gun you achieve the best result if your subject has some or all of these features:

1 Good colour or tonal contrast.
2 Occupies a single plane: is not spaced out at different distances from the camera.
3 Unimportant background.
4 Background contains no highly reflective surfaces eg. mirrors, gloss paint.

Make sure that the angle of coverage produced by the flash gun matches, or is greater than, the angle of view of your camera lens. If people are smoking take the photographs as early as possible before the air becomes too polluted. Shooting with on-camera flash through a smoke-filled atmosphere lowers contrast and desaturates colours. When you have no alternative but to shoot in such conditions, try to keep your flash-to-subject distance to the absolute minimum.

With a little more freedom to move you can use your flash gun away from the camera held on a lightweight stand, or by a clamp or an assistant. Coming from one side the light creates shadows and texture effects. It is a very useful style to adopt when your subject is spread out at different distances from the camera. By positioning your flash gun at about the same distance from each part of the subject you can ensure correct exposure over the whole area. A secondary advantage is that major shadows fall to the opposite side and are unlikely to obscure important details.

Unless you can shoot instant-picture test shots to assess the effect, estimate the best position for the flash gun, using experience you have gained from working with studio lighting.

Where considerable depth is involved you need two or more flash guns, one to light an area close to the camera, others for parts of the subject further away. With most subjects it does not matter if the space between these different areas is unevenly illuminated. Try to conduct a trial with a simulated subject before tackling an important assignment.

When more time is available and you have full co-operation from organisers and participants you can set up complex equipment, including a background, to achieve studio style lighting. Because greater distances are usually involved you need to make the most of what power you have. If your equipment can be fitted with interchangeable reflectors select those which give an adequate angle of coverage with the highest possible light intensity at the subject. Unless you are using very powerful equipment or lighting only a small area, you will not be able to use diffused or reflected light because of the large loss of light which these techniques involve.

Lighting style is based on an approach similar to that used for portraits. In particular, side lighting, rim, double rim and top lighting effects are most effective.

When action is unpredictable you have to light a large area, or one specific location where it is likely or certain that some activity will occur. A goal mouth is an example of a location where you would use this method. Try to arrange the lights so that they are well out of your field of view. If this is impossible, including some light sources in your shot can add sparkle and excitement to the composition, whether the lights are your own or part of the normal interior fitments. Where the light is

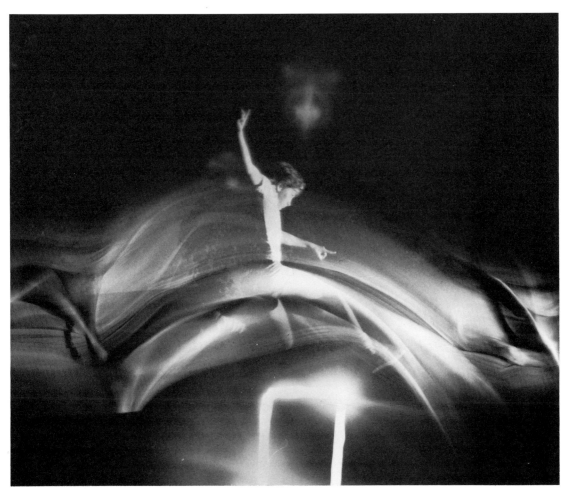

your own, attaching it by means of a clamp to an existing fixture (eg. wall bars in a gymnasium) avoids the distracting appearance of what is obviously a photographer's light stand.

Intense light sources included in the picture area influence exposure readings made by the reflected light method, TTL, automatic flash sensor and TTL controlled flash measurements. Unless a correction is applied, your photograph is likely to be underexposed.

Equipment and accessories

A medium format or 35mm SLR is the most suitable choice of camera. You may often have to operate at some distance from the subject so you will need a telephoto or zoom lens. A focal length of about 135mm on a 35mm camera is generally satisfactory. For photography with ambient light choose a lens with as wide an aperture as possible.

116 A combination of a blurred and sharp image shows both the direction and complexity of the movement as well as the person or object involved. Three different light sources were used – a 500W spotlight, a flash gun and an ordinary torch (flashlight). Both spotlight and flash gun were located at the right. The camera was fitted to a tripod and its shutter locked open on 'B' with a locking cable release. The spotlight was switched on and the runner instructed to 'go'. As he jumped over a black box the flash gun, fitted with a red filter, was fired by the open flash button. With the spotlight switched off, the outline of the box was then traced with the torch (flashlight). The picture was taken outdoors at night. Camera was a 6 x 6cm SLR with a 75mm lens. Exposure on ISO 64/19° (ASA 64/19 DIN) daylight-balanced transparency film was 'B' at f/4. The time for which the runner was in view was about 2 seconds. No filters were used over the spotlight, torch or camera lens.

11 LIGHTING TECHNIQUES: LOCATION LIGHTING

Provided that you have the time available and the energy it is possible to transport all the equipment and accessories you would normally use in a studio along to a location. For some assignments which require large amounts of flash power and involve many exposures, the only practical and economic solution is to take along your AC powered flash units. When you can be sure that the ambient light level is low, a tungsten outfit performs perfectly well on a factory floor, in an office or outside at night.

But there are other situations where a lack of time, money or AC power make it impossible to simply transfer studio facilities to the middle of nowhere!

It is tempting, when faced with difficult working conditions, to seek a convenient solution and accept its limitations. In the majority of cases this means a battery powered flash gun and the major disadvantage of not being able to pre-judge the lighting effect. However with some careful observation and a little improvisation it is possible to achieve the best of both worlds – convenience and control.

Duplicating atmosphere
Ambient light at a location is often very attractive. The intimate atmosphere of a restaurant, for example, is partly a product of the carefully arranged light fixtures and their low wattage lamps. Unfortunately, the light level at such a location seldom permits you to use an exposure which is appropriate for the subject. Even if you use a tripod, you still run the risk of subject movement when shooting pictures of people with exposures as long as ¼ sec.

Turning to a flash gun solves most of the technical problems but used in an unsubtle way it completely destroys the original atmospheric light quality. Fortunately, there is a simple way in which you can use the flash to more or less duplicate the ambient light.

The first stage is to look very carefully at where the light comes from and what its qualities are and analyse it in terms of colour and distribution. With a single flash gun you are unlikely to simulate lighting for a whole interior, so the next stage is to simplify the shot by selecting one area which is typical of the whole.

Finally, you position your flash gun close to the ambient light source. With the flash and continuous light coming from the same direction you can prejudge the lighting effect. If you need to soften its quality or introduce a colour, this is easily done by the usual methods of reflection, diffusion and filtration.

An umbrella makes an ideal reflector for location photography. You need a lightweight stand, or a clamp or assistant to hold it and the flash gun. Synchronisation is most easily maintained by using an extension sync lead but it can be a nuisance and in some instances quite difficult to keep out of the shot. A sensible alternative is to use a second gun on or near the camera and fit a slave cell to the more distant main light. The second gun is synchronised in the normal way and its output triggers the main flash. Adjust the output so that it has no significant effect on exposure or so it is powerful enough to fulfil a useful role, probably as a fill-in light.

Exposure can be determined by any of the normal methods but if your flash gun has a built-in sensor you must always ensure that it faces the subject.

With a little more time to spend you can arrange several flash guns in a similar way to light a larger area. If you find that the light intensity from a reflected flash gun is too low, consider firing two or more guns from the same place, eg. bounced into one umbrella. If you are planning to shoot only a small number of pictures, expendable flashbulbs are often a worthwhile alternative to electronic flash guns. If necessary you can mix lighting from both electronic and expendable flash sources.

For colour photography always use blue-coated flashbulbs.

When power light sources are included in the picture, choose a shutter speed which allows them to record at a 'realistic' brightness, say, 1/30 or 1/60 sec instead of 1/125 sec, to control the flash-to-ambient balance.

Shoot instant-picture test shots to judge the accuracy of your exposure, the authenticity of the atmosphere and the relationship between your controlled lighting and the existing sources. Look out for shadows coming *from* light fixtures – this is a telltale fault which immediately indicates that lighting has been added in the picture by the photographer.

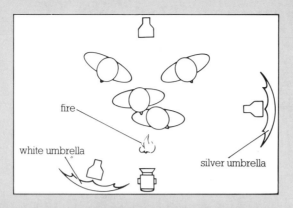

fire

white umbrella

silver umbrella

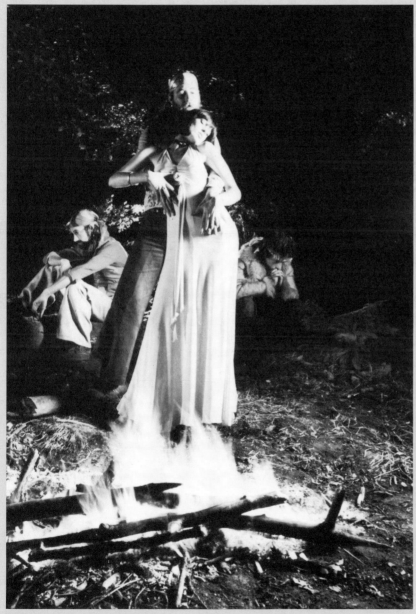

117 Taken at the dead of
night miles from an AC
source, this picture was
shot with three flash guns.
Focusing, composition and
organisation of the lighting
was achieved with the aid
of modelling lamps
operated from a small 300W
generator powered by a
petrol (gasoline) engine.
The main light was bounced
into a 1m (3ft) metallised
umbrella on the right. A
second flash gun was
bounced into a white
umbrella placed close to
the camera to act as a fill-in.
The third gun was used
behind the models as a rim
light. Slave cells were fitted
to the fill-in and rim lights.
The camera was a 6 x 6cm
SLR with a 50mm lens.
Exposure on ISO 200/24°
(ASA 200/24 DIN) film was
f/11. A long exposure time
of 1/4 sec was chosen to
record the firelight at a
realistic intensity. Even
with this long shutter speed,
the modelling lamps were
too weak to cause any
secondary exposure
problems.

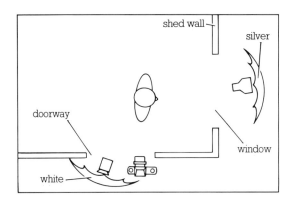

118 Two monobloc flash units were used to light the interior of this tiny outdoor workshop. The main light was fitted with a 1m (3ft) metallised umbrella and located just outside the window. A second unit equipped with a white umbrella, to act as a fill-in, was placed near the camera in the doorway. The camera was a 6 x 7cm SLR with a 55mm lens. Exposure on ISO 100/21° (ASA 100/21 DIN) film was $f/11$. A slow sync speed of 1/30 sec ensured that the bare lamp recorded at an appropriate intensity in order to create an impression of ambient light.

Adding a modelling lamp

The usefulness of a flash gun is greatly increased if you add a supplementary modelling lamp in the form of a clip-on attachment. In a situation where no AC supply is available suitable lamps can be operated from batteries, a car battery, accumulator or generator. A movie light run from an accumulator is useful in remote indoor locations or outside at night. An improvised modelling lamp is unlikely to match the angle of coverage of your flash gun, but it will show the approximate effect of lighting angles. When the light is used indirectly, for example, bounced into an umbrella, the difference between flash and modelling lamp illumination is usually very slight. Take care to separate or insulate your flash gun from the lamp: heat will damage the plastic case of most flash guns.

If you use a number of flash guns with different outputs to light one subject, choose lamps with appropriate wattages to provide proportional modelling. Alternatively run the lamps on dimmers to control their brightness. Calculate or measure the power of the flash guns, then measure the brightness of each modelling lamp using a standardised reading method and distance. Change wattages or calibrate the dimmers to maintain the correct flash-to-modelling-lamp relationship. Confirm your measurements with a photographic test, exposing with the flash, then the modelling lamps alone, with the necessary adjustment to exposure – the test pictures you have taken should be indistinguishable from one another.

12 EXPOSURE TECHNIQUES

To produce optimum quality you must first choose the most suitable film then expose it correctly, with an appropriate choice of shutter speed, aperture and, where necessary, filtration.

Film choice

Decide on the basic type of emulsion to use – black-and-white, colour negative or colour transparency. Next, consider the conditions you will be shooting in:

1 Type of lighting.
2 Power available and exposure required.
3 Possibility of long exposure time.

These factors enable you to further refine your decision and select the correct colour balance, emulsion speed and if necessary to choose a film specifically designed for long exposures. For photography in black-and-white only the film speed is relevant. The following chart summarises the availability of the various types of colour film.

Exposure in practice

Exposure is best assessed with the aid of an exposure meter, flash meter, or a TTL metering system. With an average subject a general reflected light or TTL reading gives accurate results. But a subject whose tones do not average out to give approximately 18 per cent reflectance, will be wrongly exposed. This occurs most frequently when the background is dark or light or where strong backlighting is introduced.

A dark background fools a meter into indicating too great an exposure. A light background or backlight has the opposite effect and causes underexposure. To minimise the likelihood of inaccurate exposure you can use a number of techniques.

With a hand-held exposure meter the easiest solution is to move in close and take a reflected light reading from the subject alone, cutting out the background. Make sure however, that you do not read from an area which includes a shadow of your hand or the meter itself. If you cannot approach the subject, a spot meter which accepts light only in the form of a narrow beam (acceptance angle about 2 degrees) allows you to take selective readings which ignore the background.

Colour transparency films

Colour balance		Recommended exposure range		Film speed		
Daylight 5500K	Tungsten 3200K	Short 1/1000– 1/10 sec	Long 1/10– 60 sec	Slow	Med.	Fast
●		●		●	●	●
	●	●		–	●	●
●			●	●	–	–

Colour negative films

●		●		–	●	●
	●		●	●	–	–

Key ● = film available
— = film not available

Film speed
Slow = ISO 25/15° – 80/20°
 (ASA 25/15 DIN – ASA 20/20 DIN)
Med. = ISO 100/21° – 200/24°
 (ASA 100/21 DIN – ASA 200/24 DIN)
Fast = ISO 400/27° (ASA 400/27 DIN) – upwards

An incident meter placed in the subject plane and reading the incoming (or 'incident') light is also a reliable way of dealing with awkward subject/background combinations. When the subject itself is light or dark this method is, again, very accurate. A reflected light reading made from an 18 per cent grey card placed to receive the same lighting as the subject is equally reliable.

When none of these techniques can be applied, make an estimated correction, note the general reading then give the equivalent of 1½ stops *less* exposure if the background is very dark and 1½ stops *more* if it is light.

Corrective techniques using a TTL meter follow a similar pattern. Move in close and lock the exposure, if your camera has this facility. If it does not feature an exposure lock control, note the reading and set it manually. Alternatively, manipulate the film speed or set an over-ride until the reading from the shooting position matches

the reading you took from close by. When it is difficult to move the camera use a longer focal length of lens to read from the subject only — a zoom lens is ideal for this purpose. To cope with light backgrounds and backlit subjects some cameras have a backlight button which automatically gives 1½ to 2 stops extra exposure. Do not use this control without checking that your shutter speed is still adequate. On an aperture priority automatic camera the correction will, for example, drop your speed from 1/250 sec to 1/60 sec with the attendant risk of camera shake and/or subject movement.

As with a hand meter, you can also estimate a correction and set this as an override to the film speed but you must also remember to cancel the override or re-set the correct film speed after the shot has been taken.

The best method of dealing with a problem caused by backlighting is to turn off that light while the exposure is being read.

Exposure for close-ups

Many close-up techniques achieve the necessary degree of image magnification by extending the lens-to-film separation. This has the secondary effect of significantly reducing image brightness. A TTL method of exposure determination takes this into account, but a hand meter reading must be modified.

You can use either of two simple formulae to calculate the essential correction:

1 Exposure factor $= (M + 1)^2$
M is the image magnification – the ratio of the image (I) and object (O) sizes: I/O. Measure the size of the image on the camera screen, then the size of the object you are photographing. For example, if the image is 20mm high and the object 50mm high, the magnification is 20/50 = 2/5 or 0.4. Applied to the formula the exposure factor for this magnification is. $(0.4 + 1)^2 = (1.4)^2 = 2x$, to the nearest whole number.

2 Exposure factor $=$
$$\left(\frac{\text{Total lens-to-film separation}}{\text{Focal length}}\right)^2$$

If you use extension tubes or a bellows unit the total lens-to-film separation is easily arrived at by adding together the length of tube or bellows extension and the focal length. For example, with an extension of 100mm and a 50mm lens the separation is 150mm. Applied to the formula this gives

an exposure factor of:
$$\left(\frac{150}{50}\right)^2 = (3)^2 = 9x$$
The magnification under these circumstances is x2 (the image is twice life-size).

Apply the exposure factor by increasing exposure time, opening the aperture, increasing the light intensity, choosing a faster emulsion, or any suitable combination of these adjustments.

This kind of correction also has to be used as a matter of routine in still life photography and copying. No correction is required for supplementary close-up lenses.

Reciprocity law failure

Your exposure must not only be correct in its total effect, it must also comprise a shutter speed and aperture which are appropriate for the subject. A basic reading can be manipulated to provide a number of combinations. Eg, with a basic reading of 1/125 sec at *f*/8 all these other settings give the same exposure:

1 1/15 sec at *f*/22
2 1/30 sec at *f*/16
3 1/60 sec at *f*/11
4 1/125 sec at *f*/8 (basic reading)
5 1/250 sec at *f*/5.6
6 1/500 sec at *f*/4
7 1/1000 sec at *f*/2.8

Settings 1 and 2 are used when great depth of field is needed and the subject is static. Combinations 6 and 7 are used to freeze action. Settings 3, 4 and 5 are compromises suitable for most average subjects.

Equivalent exposures such as these, are based on the principle that changes in time are exactly compensated for by alterations in image brightness. Hence going from 1/125 sec to 1/250 sec *halves* the time, while changing the aperture from *f*/8 to *f*/5.6 *doubles* the image brightness. This principle is called the *reciprocity law*.

Unfortunately the law does not hold true for every possible exposure time. Most black-and-white emulsions, colour materials with a daylight balance and some tungsten balanced colour films (particularly fast emulsions) are only designed to adhere to the law between exposure times of approximately 1/1000 – 1/10 sec. With significantly shorter or longer exposures these films suffer from *reciprocity law failure*.

In the vast majority of situations you will only experience reciprocity law failure with long

exposures. Correction for the failure is simply a matter of giving additional exposure. The extra amount cannot be calculated because each film has a different characteristic. In addition to the loss of effective emulsion speed, colour films often require filtration to maintain a neutral colour balance. For specific information you should contact your dealer or the film manufacturer. As an approximate guide however, the following exposure factors can be used:

Indicated exposure (sec)	Exposure factor
1	2x
10	2 – 4x
100	4 – 8x

Slow tungsten balanced colour films are usually designed for long exposures and require much less correction. A typical emulsion of this type needs no extra exposure at an indicated time of 1 sec, a factor of only 1.5x at 10 sec, and 3x at 100 sec.

Filter factors

Most filters absorb enough light to have a significant effect on exposure. The amount they absorb is expressed as a filter factor, eg a deep red filter intended for contrast control on black-and-white films has a filter factor of 8x, a Wratten 80A colour conversion filter has a factor of 4x. The factor for any one filter varies according to the type of film being used and the source of illumination. The filter factor for the same red filter varies in this way:

Light source/film	Filter factor
daylight	8x
tungsten	4 – 5x
infra-red film	1x (no extra exposure)
colour film	0.5 – 4x
(For special effect only – see page 147)	

TTL metering takes the normal filter factor into account, usually with acceptable results. With a hand-held meter the factor must be used to modify the indicated reading.

Using exposure factors

You may need to apply an exposure factor to compensate for extra lens extension, reciprocity law failure, a filter or any combination of these.

A single factor is applied by taking the exposure reading (usually from a hand meter) and then multiplying the exposure time by that factor.

For example, with a factor of 4x an indicated exposure of 1/125 sec at $f/11$ becomes 1/125 x 4 = 4/125 = 1/30 sec at $f/11$. Alternatively, the factor can be used to modify the aperture. In this case a factor of 4x necessitates the aperture being opened by two stops, as each stop has the effect of doubling image brightness. The exposure then becomes 1/125 at $f/5.6$. You could also compromise and split the factor between both shutter speed and aperture – increasing *both* by a factor of 2x to give an exposure of 1/60 sec at $f/8$.

When more than one factor is involved the individual factors are *multiplied*, eg, a factor of 2x and one of 4x together give a total exposure factor of 8x. This commonly occurs when a still life photograph is shot with low power tungsten lighting on daylight balance colour film. In this situation all three factors are likely to be involved, as in this example:

1 Indicated meter reading = 1 sec at $f/22$
2 Image magnification (M) = ½ or 0.5
Exposure factor is $(M + 1)^2 = (0.5 + 1)^2 = (1.5)^2 = 2.25x$
3 Filter factor for Wratten 80A = 4x
4 Total factor at this point = 2.25 x 4 = 9x
5 Applied to the reading, the exposure becomes 1 x 9 = 9 sec at $f/22$
6 Allow a factor of 2x for reciprocity law failure
7 Final exposure = 18 sec at $f/22$

The correction for reciprocity law failure is always applied last.

Where flash is the light source, factors are usually applied by opening the aperture. It is useful in this case to convert the factor into an exposure increase expressed in stops:

Exposure factor	Increase in exposure (in stops)
1	0
1.5	½
2	1
3	1½
4	2
6	2½
8	3
12	3½
16	4

Under some circumstances the factor can be used as a guide to increase the number of flashes (see page 141).

Bracketing and clip tests

Despite careful exposure measurements and the accurate application of any necessary correction factors, there are still many situations when the *exact* exposure needed is in doubt. In such circumstances the ideal procedure is to bracket your exposure. The technique involves making the best possible estimate of correct exposure, then shooting a series of pictures with exposures of less and more than this estimate. The number of frames required, and the difference between exposures, depends on the probable accuracy of your estimate and the type of film you are using. With black-and-white and colour negative emulsions bracket by one full stop under and over the estimated exposure (N) thus: -1, N, $+1$. If the conditions are particularly difficult, extend the series in this way: -2, -1, N, $+1$, $+2$. Colour transparency film needs more accurate exposure, so the series should take the form of ½-stop divisions, as here: $-½$, N, $+½$, or -1, $-½$, N, $+½$, $+1$ and so on depending on circumstances.

The principle of bracketing can only be applied to a static subject, or one which is fully controllable. Think carefully before bracketing shots involving people, especially groups. It is quite likely that the ideal exposure and the best expressions will be on different frames!

Other circumstances involve actions or events which cannot be repeated. Here you should shoot a bracketed test sequence of a similar subject lit in an identical fashion. Using 35mm film it is quite possible to shoot the test series and the actual pictures on the same roll. Shoot the test, then leave two blank frames. Complete the roll, shooting each picture at the *same* estimated exposure. The first part of the film can then be removed and processed. A piece of card cut to about 35cm (14in) in length acts as a template to judge where to cut the film.

This length is suggested as a guide for removing the first three frames. You will need to make your own measurements.

Assess the test exposures, then process the remainder of the film accordingly, increasing development ('push') for underexposure, and decreasing it ('cut' or 'pull') for overexposure. This method is suitable for black-and-white and most colour transparency films. For slide films, a 'push' of one stop and a half stop 'cut' should be regarded as the maximum modifications which will still, at the same time, retain most of the original qualities of the film.

A professional laboratory will process a short length of film if you ask for a *clip test* and indicate how much film to remove.

Consistent colour

Colour films, especially transparency emulsions, must be exposed with care to ensure consistent results. The following procedures are used by professional photographers.

Although it may not be possible for the enthusiast to follow the whole sequence, adopting some aspects of it will increase the likelihood of improved quality.

1 Buy a quantity of film all with the same batch number and store it under recommended refrigerated conditions. Professional films offer the advantage of quoting the exact film speed for that batch, which may be up to ⅓ stop slower or faster than the indicated 'box' speed, eg, a film described as ISO 200/24° (ASA 200/24 DIN) may be that speed, ISO 160/23° (ASA 160/23 DIN), or ISO 250/25° (ASA 250/25 DIN).

2 Obtain data sheets from the manufacturer – read and follow all recommendations.

3 Test the film by shooting a bracketed series of exposures under typical lighting conditions. Choose a subject which is similar to the type you normally photograph. A test subject containing subtle and saturated colours, white, black, neutral grey and flesh tone is ideal. Include exposure data within the picture area.

4 Use the kind of exposures which you are likely to experience during normal photography.

5 Process the film promptly.

6 Assess the test under standard illumination and repeat if necessary with corrective filtration. Retain all tests for comparison purposes.

7 Use identical processing procedures or a reliable laboratory for tests and normal shooting.

8 Avoid using the mail.

9 If you cannot process it promptly, return the exposed film to cold storage.

10 During normal photography take all precautions to minimise errors. On an important job repeat the shots if possible using a second camera. When shooting, bracket all exposures and/or clip test procedures. Process the film in at least two batches to avoid total loss if a processing fault occurs.

11 Standardise your film choice as far as possible. Test out new products by comparison with known materials.

Instant-picture tests

Testing with instant picture film is an extremely useful technique to adopt in many circumstances. A special film holder or camera 'back' which attaches to your normal camera is the best method of testing, though a separate camera can be used, provided that you have full manual control over its exposure settings.

The instant-picture 'back' confirms correct focus, composition, aperture and shutter functions. The latter is particularly important with flash where correct choice of shutter speed is often essential. Depth of field and the result of special lighting or exposure effects can also be assessed on the spot.

In addition both the camera 'back' and the separate instant-picture camera allow you to check on approximate lighting balance, lighting direction and, in many cases, accuracy of expo-sure. One especially valuable application is when flash is being used in conditions where its effect cannot be judged. This occurs with a flash gun and when ambient light is bright enough to overwhelm light from modelling lamps.

Try to use instant-picture material which is of the same speed as your conventional film. If this is not possible choose a faster material and lower its effective speed to match the film by shooting via a neutral density filter of the correct value.

Instant-picture material and conventional film respond in different ways to a given lighting contrast, ie to the strength of fill-in light, and may also exhibit different reciprocity law failure characteristics. Extensive testing or a gradual accumulation of experience is necessary before subtle relationships between test and final picture can be fully appreciated.

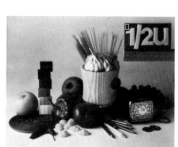

119–122 A suitable test subject contains a range of subtle and saturated colours, with white, black, grey and, if possible, a flesh tone. Always try to include data within the picture area – it is more reliable than making written notes on paper, which are easily lost. For these test exposures the data can be included in the form of plastic numbers and letters in the top right hand corner.
119 1/2 stop overexposed.
120 Normal exposure.
121 1/2 stop underexposed.
122 1 stop underexposed.

13 LIGHT AS THE SUBJECT

For most assignments light tends to be viewed as an essential but, nevertheless, utilitarian aspect of the photographic process. The subject is all-important, light merely illuminates it.

But there is another approach in which light itself is the subject matter. These pictures are largely abstract patterns of colour caused by motion or a variety of natural phenomena, such as interference or dispersion. You can also compromise and use a conventional subject in conjunction with an unusual light source or lighting technique.

Light trails

Light trails are photographs of actual light sources in which the images are blurred and expanded into lines and patterns. You need to move either the light, or the camera, or both, during a long exposure time in order to create the effect. One of the simplest, but least controllable ways of doing this is to shoot street lights from a moving vehicle. The sky must be dark or totally black to provide a contrasting background. If your local lighting is the common sodium vapour variety, shooting at twilight with just a hint of blue left in the sky is especially worthwhile. This combination produces a dramatic colour contrast of brilliant yellow trails against a blue background.

The technique for shooting these pictures is very simple. Support your camera on the car dashboard, pointing it towards the windscreen. Make sure that it is secure. Set the shutter to 'B', focus at a point just short of infinity and attach a long cable release. Exposures are not critical, but try 10 sec at $f/11$ with ISO 100/21° (ASA 100/21 DIN) film.

If your camera has an autowinder you can shoot several pictures during a journey. If you have to wind on manually, then *don't*. Limit yourself to one shot per journey. Operating a cable release and counting to ten is just as safe as tripping an indicator switch or any other activity associated with driving. Never attempt to look through the camera while driving. It is a better plan to travel as a passenger or to use public transport.

Controllable light trails can be shot indoors in a darkened room or outside at night. Any low power source is suitable – even a battery operated torch (flashlight) provides enough light. Your pattern of movement may be random or it can

follow a well designed route – tracing round subject contours is an effective technique. Add other lighting, such as a flash exposure to illuminate the subject details. An exposure time of several seconds is needed and you should ensure that the light faces the camera at all times – it is usually easier to keep the camera stationary and move the light only. As with street light trails your exposure is not critical – shoot a series of bracketed exposures based on this data:

Film speed	ISO 100/21° (ASA 100/21 DIN)
Aperture	$f/5.6$
Exposure time	30 sec
Light source	large torch (flashlight)
Distance light moves during exposure	2m (6ft)

Remember that on daylight balanced colour film a tungsten light will leave yellow trails. Try changing the focal length of a zoom lens during exposure to create radiating trails from either a stationary or a moving light.

Rainbow colours

Spectacular coloured patterns result when white light is broken up into its constituent 'rainbow' colours. Several natural phenomena are responsible for these displays.

Dispersion. This causes the colours you see in a real rainbow as the various wavelengths are refracted at different angles through the water droplets. It is not easy to re-create a rainbow under studio conditions but you can sometimes do it outdoors with a fine spray of water from a hose. Fortunately, other more convenient materials disperse light – glass and transparent plastic prisms and simple lenses show the effect clearly.

Exploit dispersion in the studio by passing narrow beams of light through thick bodies of glass and allowing the dispersed rays to fall on a light material or subject. You will usually need a close-up shot to show the colours at a reasonable image size.

Interference. This phenomenon is responsible for the swirling patterns of colour in thin 'films' such as soap bubbles or oil floating on water. You can easily organise these surfaces in the studio, though the oil-on-water effect is time-consuming to get right. A large light source is needed and it

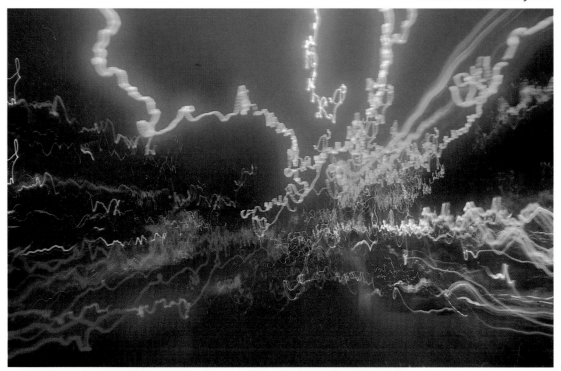

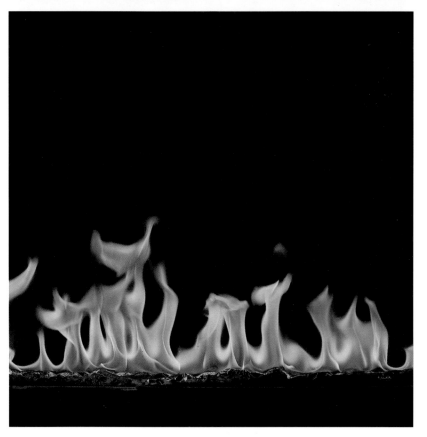

123 Shot from a moving car, street lights become a pattern of coloured lines. The camera was an old 6 x 9cm folding model. Exposure on ISO 200/24° (ASA 200/24 DIN) film was approximately 10 sec at *f*/16.

124 Flames move with surprising rapidity – you need quite a high shutter speed to arrest their movement. The camera was a 6 x 6cm TLR with a 105mm lens. Exposure on ISO 200/24° (ASA 200/24 DIN) film was 1/500 sec at *f*/5.6.

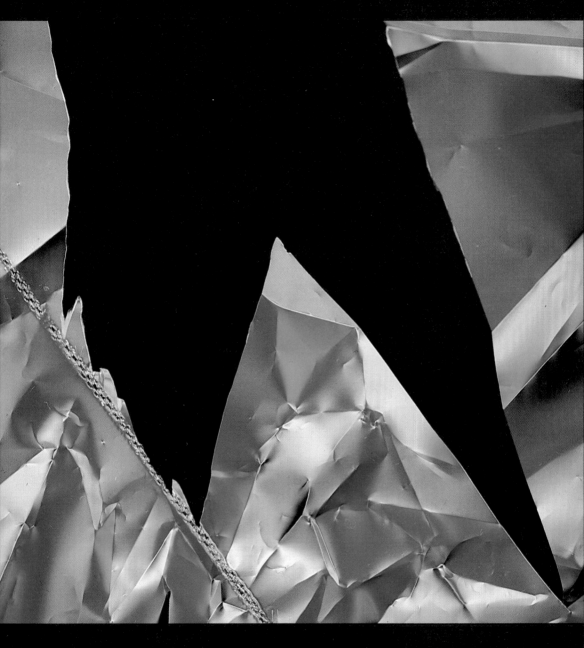

125 The colours and patterns in this torn and stretched polythene are due to the phenomenon of birefringence. A pola screen was used below the plastic with a second pola screen over the lens. Diffuse transillumination was used with a flash gun as the light source. The camera was a 6 x 7cm SLR fitted with a 135mm lens and extension tubes. Exposure on ISO 200/24° (ASA 200/24 DIN) film was f/16.

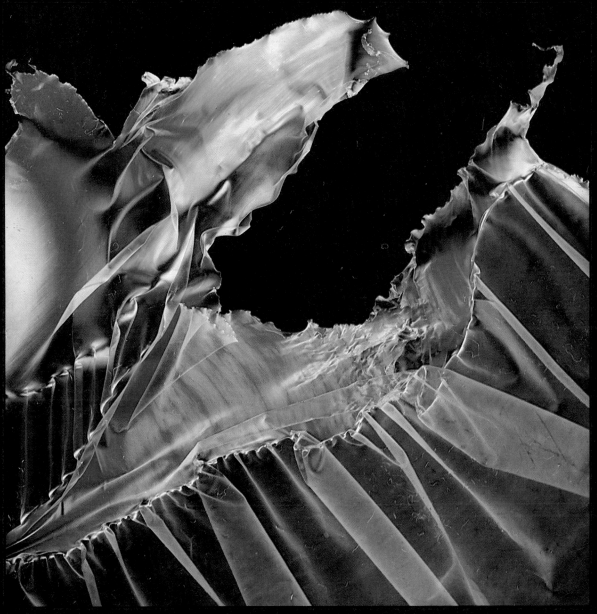

side view

pola screen

scrap of
polythene

mask

diffuser

mirror

plywood cube

126 Bubbles show a similar pattern of interference colours. A large diffuse light source is required to form the neccessary areas of reflections. As the patterns move quite quickly, a high shutter speed or electronic flash is needed. A monobloc flash unit fitted with a 1m (3ft) diffuser was used here. The camera was a 6 x 7cm SLR with a 135mm lens. Exposure on ISO 64/19° (ASA 64/19 DIN) film was f/16. This is a section from the original transparency.

must be powerful enough to allow an exposure that will freeze movement. Patterns in a soap film are constantly changing at a high rate. A flash unit bounced from a white reflector board or diffused through a panel of translucent material is ideal. With a normal spherical bubble you need the light very close to the surface to produce a large reflection in which the colours are revealed. Place a reflector board opposite the light source to create a second reflection on the other side.

Experiment with detergent solution suspended across wire frames to make bubble-like surfaces which are relatively flat.

Diffraction. This occurs with surfaces containing closely spaced grooves, such as records. Laser discs and some kinds of metallised plastic films intended for display purposes exhibit very intense patterns of colour which are due to diffraction.

Birefringence. Many transparent colourless materials have the ability to split the light passing through them into separate rays. This characteristic is known as double refraction or birefringence and is demonstrated by a number of crystals and common types of plastic. As different wavelengths may be affected by varying amounts so, under the right illumination conditions, a whole range of colours can be created.

Thin sheets of plastic, such as polythene and cellophane wrapping materials, when stretched or torn produce an almost magical array of colours. A modified transillumination technique is used to reveal these abstract colours and patterns. All you need add to the standard lighting set is a pair of pola screens.

127 Fine lines and grooves create colours by diffraction. These patterns were obtained by shooting a sheet of metallised plastic intended for display and experimental purposes. A soft focus lens was used to destroy the clean-edged pattern of the original design. Lighting was provided by a 500W spotlight. The camera was a 35mm SLR. Exposure on ISO 200/24° (ASA 200/24 DIN) film was 1/250 sec at about f/4. A Wratten 80A filter was used over the lens.

One pola screen fits on the camera lens while the other lies under the torn plastic but above the diffuser. By rotating the pola screen on the lens you can change the colours and the background tone. A 90 degree rotation transforms the colours into their exact complementaries (eg. blue into yellow) and turns a light background dark. You can make subtle alterations to the colours by rotating the plastic itself.

Exposures determined with TTL metering may not always be accurate as some systems contain components which further polarise the light, so giving a false reading.

Birefringence in some crystals is best revealed by photomicrography.

Fire and flames

Few light sources are as uncontrollable, dangerous and fascinating as a naked flame. In its simplest form – the candle – it helps create a romantic 'period' feel, or conjures up the atmosphere of a birthday party.

You can easily take photographs by the light of one or more candles, or by using any other source of flame such as a camp fire. Exposures need to be quite long – 1/15 sec at f/2 with ISO 400/27° (ASA 400/27 DIN) film is typical for a subject reasonably close to the flames. In taking a meter reading, exclude the light source and read from the subject alone. The colour temperature of normal flames is very low – about 1500K – so pictures shot on daylight balanced colour film exhibit a pronounced yellow/orange cast. In most cases this is not unpleasant and helps convey an appropriate impression of warmth.

Flames also make ideal subjects themselves. An ordinary garden or camp fire can produce some interesting patterns, but the best plan is to arrange a special long trough so that separate flames can be produced. Make a shallow dish from aluminium foil and fill it with cotton wool. Add a small quantity of paraffin (kerosene). *Under no circumstances use petrol (gasoline).*

Set fire to the paraffin to produce tall tongues of flame. You need a short shutter speed to arrest their rapid motion – 1/500 sec at f/8 with ISO 400/27° (ASA 400/27 DIN) film is easily possible.

Take extreme care when lighting the fuel. Place the tray in a stable position well away from any combustible material. Only do this outdoors at night. Keep cans of fuel tightly stoppered and well away from the flames.

128 A venetian blind created this pattern of lines in the swirling surface of water in a washroom sink. Exposure was a major problem because the reflection was highly mobile and needed a small aperture to secure a clear outline. The camera used was a 35mm SLR with a 28mm lens. Exposure on ISO 1000/31° (ASA 1000/31 DIN) film rated at ISO 4000/37° (ASA 4000/37 DIN) was 1/500 sec at *f*/16. The resulting negatives were underexposed and had to be printed on high contrast lith film to produce sufficient density. This final print is made from a sandwich of two identical lith film negatives.

14 SPECIAL LIGHTING TECHNIQUES

Special lighting techniques enable you to take better photographs of difficult subjects, to extend the usefulness of a limited amount of equipment or low power sources and to help you create 'special effects' in the camera. Many of these lighting methods are used in conjunction with a multiple exposure technique – a procedure which involves one frame of film receiving two or more images.

Multiple exposure methods

A surprising number of techniques is available, although some are only variations on a basic approach. One or two methods are specific to a certain type of camera, while others are universal. A major consideration in deciding on the most suitable technique to use is the accuracy of *registration* which that method allows. Registration in this context refers to the method and degree of exactness by which component images may be superimposed. For some special lighting techniques, eg. boosting effective flash output, perfect registration is essential.

Rewind button. This method is used with 35mm cameras that do not have a multiple exposure control. It works like this:

1 Take your first exposure.
2 Without touching the rewind button, turn the rewind crank in the direction of the arrow to tension the film. Maintain pressure on the crank.
3 Now press in the rewind button and *at the same time* operate the film transport lever to wind on.
4 Take your second exposure.
5 Repeat for third and subsequent exposures.

The frame counter is not disengaged: keep a written note of how many multiple exposures you make on a roll so that you can calculate how much film you are actually using. Registration is highly unlikely to be perfect.

Multiple exposure switch. Some 35mm and medium format cameras have multiple exposure switches or buttons. Once activated the switch allows you to expose the film two or more times. On most 35mm cameras the control is self-cancelling and must be activated for each multiple exposure. With many medium format cameras the switch stays in operation until manually cancelled – do not forget to do this after your last multiple

exposure or you will shoot each and every subsequent picture on that single frame of film. Used with a motor-drive this technique produces an almost stroboscopic image of a moving subject.

The multiple exposure switch disengages the frame counter. Registration is not always perfect.

Double and multiple loads. One of the simplest methods is to load your camera two or more times with the *same* film. You can do this easily with 35mm film, but a 120 roll is extremely difficult to rewind. When using a medium format camera choose 220 film.

1 Load the film normally.
2 Remove the camera lens. Set your shutter to 'B', fire and lock it open with a locking cable release.
3 With a felt tip pen draw a reference line directly on to the film or backing paper using the edge of the frame as a template. Wait for the ink to dry, then close the shutter.
4 Take your pictures. If only certain frames are to be multi-exposed, make a written note of those frame numbers.
5 Run the film off. With 35mm rewind leaving some leader protruding. In a darkroom or changing bag rewind your 220 back to the start.
6 Reload the camera in exactly the same way as before, checking that the reference line is in the same place.
7 Shoot the series of second images, paying careful attention to the written notes. Where a multiple exposure is not required, fire the shutter with a lens cap in place for that shot.
8 Repeat for the third and subsequent exposures.

Registration is never perfect so to determine the probable shift in image alignment you should run a test film.

Interchangeable magazines. If your camera has interchangeable film magazines or 'backs', you can use this method:

1 Take your first shot.
2 Remove the magazine.
3 Wind on the camera body.
4 Replace the magazine.
5 Shoot the second exposure.
6 Repeat for third and subsequent exposures.

Registration is unlikely to be perfect.

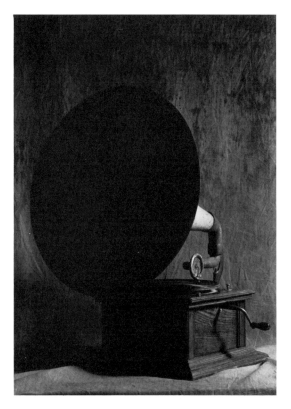

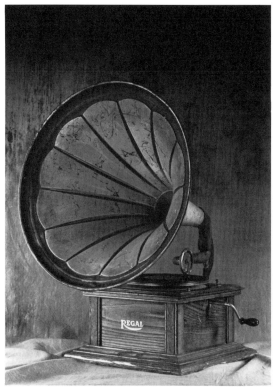

129, 130 By moving a light during a long exposure you can simulate the effect of several individual lights.
129 A general purpose floodlight fixed to a stand was used for this exposure of 2 sec at *f*/16.
130 By moving the light to the other side, then above and below, one light was made to do the job of three fixed lights. Exposure was 15 sec at *f*/16. The floodlight was fitted with a 200W domestic lamp. The camera used was a 35mm SLR fitted with a 50mm lens. Film was ISO 125/22° (ASA 125/22 DIN).

Single frame loads. A large format camera which takes film in the form of a single sheet is by far the most convenient and flexible to use for multiple exposure photography. However, with a little improvisation a 35mm or medium format camera can also be loaded with a single frame of film. This may be cut from a sheet or trimmed from a roll. Some medium format camera manufacturers make special single shot film holders.

Using 35mm film you can use a modification of the normal loading procedure:

1 In total darkness pull out sufficient leader to ensure that you have reached unexposed film.
2 Cut off the leader.
3 Load the camera so that the squared-off end of

film just fails to reach the sprockets. Hold it in place with a tiny patch of adhesive tape.
4 Shoot all your exposures on this one immobile frame of film.
5 Return to the darkroom, cut off and process the film or store it in a light-proof box. A professional laboratory will process a short length of 35mm film as a clip test.

The single frame technique works well in conjunction with a motor drive unit, producing a near-stroboscopic effect. Assuming that your camera does not move, registration will be perfect.
Supplementary shutter. As it is the interlock between shutter and film transport mechanism which makes multi-exposing an awkward procedure with 35mm and medium format cameras, one way round the problem is to add a second shutter which is independent of the interlock. This can be a separate shutter fitted to the front of the camera lens, or a complete lens/iris/shutter assembly used to replace the conventional lens. In either event the operating sequence involves setting the camera to 'B' and locking it open. The exposures are then made with the supplementary shutter, following this procedure.

1 Open front shutter on 'B' or 'T' setting.

2 Focus and compose your picture.

3 Pre-arrange all subject components and lighting.

4 Close the front shutter and set the shutter speed and aperture; the viewfinder of an SLR camera is now inoperative.

5 Set the camera shutter to 'B' and lock it open.

6 Fire the front shutter to expose the film.

7 Repeat this for second and subsequent exposures.

8 Close the camera shutter after the final multiple exposure.

Provided that the camera remains totally stationary registration is perfect.

Darkened room techniques. By working in a darkened room you can give any number of exposures, while your shutter is locked open on 'B'. So a flash gun can be fired several times or a tungsten light turned on and off. Using this technique it is the duration of the flash or the time for which the light is switched on, which effectively becomes the shutter speed. If you need to re-arrange the subjects for one image component, then the lens is capped and the room lights switched on. The viewfinder of an SLR camera is inoperative under these circumstances so all rearrangements must be carefully planned. For some non-critical compositions an optical viewfinder placed in the camera hot-shoe provides an adequate substitute. Alternatively, consider using a twin-lens reflex or rangefinder/compact camera. Remember to close the shutter after your last exposure. Registration is perfect.

Avoiding vibration

Although a number of multiple exposure techniques offer the *potential* of perfect registration you will only achieve it in practice if the camera and subject remain totally immobile. A firm tripod is essential, especially if you need to touch the camera. If you are working in a room with a wooden floor try not to move during or between exposures, since because even very slight movements can be transmitted through the floorboards. Use a flash gun off the camera, firing it with its open flash button, via a flash meter lead or a short-circuited sync lead.

Power boosting

One of the most common applications of multiple exposure technique, used to produce a special lighting effect, is the power boost. By giving several flashes instead of one this serves to increase the effective output of a flash unit. You can only use the power boost with a totally stationary subject, but this is no disadvantage because it is in the field of still life photography that you are most likely to need it. Consider this example:

You have arranged a group of objects and found that in order to achieve adequate depth of field an aperture of *f*/16 is needed. But a calculation or flash meter reading indicates that to give correct exposure *f*/8 is essential. The answer is to give a number of flashes using the 'darkened room' method of multiple exposure.

The number of flashes is easily calculated by first determining the difference, in stops, between the aperture you require and the one that you have estimated will provide correct exposure. In this example the difference between *f*/8 and *f*/16 is two stops. The next stage is to convert the difference in stops into an exposure factor. As each stop represents a change in exposure by a factor of 2x, the total exposure factor for two stops is 2 x 2 = 4x. Consequently, four flashes gives correct exposure at *f*/16. Allow adequate recycling time between flashes so that you produce full power each time. Other examples are given in the following table.

Difference between required and calculated/measured apertures – in stops	Number of flashes needed
1	2
2	4
3*	8*
4*	16*
5*	32*

* = not recommended without test exposures: as a guide – increase the number of flashes by a factor of 1.5x.

There is a limit to how much power boosting you can do. After a certain point the number of flashes you need for correct exposure exceeds the number shown in the chart. This is due to an emulsion characteristic, similar to reciprocity law failure, called the 'intermittency effect'. As well as additional flashes, with colour films you may also need to use filtration because the different emulsion layers do not necessarily exhibit identical intermittency characteristics.

An additional point worth considering is the extra wear to which you are subjecting your equipment – regularly giving 16 or more flashes for each shot will dramatically shorten the life of

any flash unit. However, the technique is very useful for gaining the equivalent of one or two stops in flash power.

Simulating a lighting set

One light can do the job of a main, fill-in, background and rim light when your subject is a still life. Using the 'darkened room' method of multiple exposure you simply move the source to various pre-arranged locations. You can combine this idea with the principle of power boosting. For example, two flashes from one side followed by a third from the camera position produces side lighting with a 3:1 fill-in effect.

The same basic idea can be used with tungsten lighting, provided that you can arrange your exposure times to be long enough to measure accurately with your wristwatch or an audible timer. An exposure comprising 10 sec illumination from the side and 5 sec from the front produces the same style as before. In estimating such long exposure times you must take into account reciprocity law failure (see page 128). Copy lighting can also be simulated by giving two or four identical exposures with the light source moved to appropriate positions.

In order to locate the light you can temporarily cap the lens and switch on room lighting or maintain a very low level of illumination throughout the exposing sequence. A light source with an output similar to a candle or darkroom safelight provides sufficient light to enable you to move without falling over the tripod. With a small aperture, eg. $f/11$ or $f/16$, such a low light level has no significant effect on slow or medium speed films, provided that the total time for which the shutter is open does not exceed roughly 60 secs. A hand-held torch provides a more easily controllable alternative. A firm tripod and solid floor are essential.

This technique is also suitable for large scale subjects such as architectural interiors or exteriors of buildings photographed at night.

Painting with light

Many still life subjects need to be lit with a broad light source to create the minimum of shadow. One way to achieve this style is to use a long exposure time, during which you move a tungsten light – a technique known as 'painting with light'. The pattern of movement effectively expands the size of the source, eg a 30cm (1ft) reflector moved to and fro through a distance of 60cm (2ft) produces

the same light quality as a source measuring 30 x 60cm (1 x 2ft). You can use much more complex movement, varying the time for which the light reaches each part of the subject. In this way you are simulating a lighting set as well as controlling the quality of the light.

The darkened room method of multiple exposure is used.

In the studio, painting with light is considered as a less time consuming alternative to setting up diffused lighting, though it is not usually successful with surfaces that tend to reflect specular highlights.

On location, painting is a standard method of lighting for architectural interiors.

Exposure determination is a matter of making measurements, then applying some intelligent estimation.

1 Fix the light in one place and take an incident meter reading, or reflected light reading from an average tone at a typical light-to-subject distance, eg. 2 sec at $f/16$.
2 Rehearse the pattern of movement and estimate how often the light illuminates each part of the subject at full intensity. Estimate this as a percentage of the total time for which the light is switched on, eg 25 per cent.
3 Calculate an exposure factor based on your estimate of the frequency of full intensity illumination. In this example the factor is $100/25 = 4x$.
4 Apply the factor to the meter reading, eg 2 sec at $f/16$ with a factor of $4x = 8$ sec at $f/16$, then make a further allowance for reciprocity law failure.

Your final exposure time must be long enough to be measured accurately with a wristwatch or audible timer. A time of about 15–60 sec is convenient to work with. Use neutral density filters or a lamp of lower wattage if your exposure time is too short.

Because of the factor of estimation, painting with light is best used with negative films, where any small error in exposure can be corrected at the printing stage. If you are shooting transparencies take test shots first to establish correct exposure and any requirement for filtration. An instant-picture test shot may not be much help unless you are fully familiar with the reciprocity law failure characteristics of both the instant-picture material and your conventional slide film.

Take all necessary precautions to avoid vibrating the camera or subject.

Background control

Even if your subject is lit in a straightforward fashion you may still have to apply a special lighting technique to the background.

White backgrounds. To produce a pure white background in the final photograph you must ensure that your background material receives adequate illumination. It is not always possible to organise this, especially when the background is large and you have only a limited amount of power available.

Provided that your subject is static you can split the exposure into two phases, exposing the subject correctly, then giving additional time or extra flashes with the background lights. Using an incident exposure meter, measure the light intensity at the subject plane and background. Consider a situation where tungsten lighting is used, allowing an exposure of 1 sec at $f/16$ for the subject and 2 sec at $f/16$ for the background (half the brightness). By giving the indicated exposure for the subject then a separate exposure of 2 sec at $f/16$ for the background you are effectively balancing up the light intensities. Further increasing the background exposure by a factor of 2x (to 4 sec at $f/16$ in this example) is helpful in burning out any small areas of tone caused by slightly uneven lighting. If your film is likely to suffer from reciprocity law failure at these exposure times make additional allowance for this.

The same principle is applied to flash lighting. Continuing with a similar example, imagine that the subject requires an aperture of $f/16$, while the background needs $f/11$. By giving one flash for the subject and two or four flashes with the background lights you achieve the same result. These examples assume that subject and background lights fulfil separate roles.

Colour from white. A useful variation of the two phase background exposure technique allows you to create deeply saturated coloured backgrounds without the expense of carrying a large stock of different seamless paper rolls or lengths of fabric.

All you have to do is split your exposure, as before, but then place a coloured filter over the camera lens for the background exposure. A contrast filter intended primarily for tonal control in black-and-white photography is ideal. The filter factor quoted for normal use does not apply with this technique. Calculate the exposure needed for a white background, then expose a series of test shots bracketing in half stops from two stops

under to two stops over this exposure, thus: -2, $-1\frac{1}{2}$, -1, $-\frac{1}{2}$, N, $+\frac{1}{2}$, $+1$, $+1\frac{1}{2}$, $+2$ (where N is the exposure for the white background). Repeat for other colours.

No one exposure is 'correct'. Keep the tests for future reference. You can use them as colour charts to decide what density of background colour is best for a particular shot.

Ghosted backgrounds. Some subjects need to be partially isolated from their surroundings but still seen against a detailed background. An approach is needed which de-emphasises the background while still preserving enough information to show the environment. You can do this by 'ghosting' the background. The technique involves splitting the exposure into two phases. The first exposure is for the subject and its normal background. You then place in front of the background a sheet of white card or black velvet and make the second exposure. The result is to leave the subject unaffected but to lighten or darken the background. White card desaturates colours and is usually more successful in creating a ghosted appearance.

You can split the total exposure into equal or unequal parts. By choosing to give more or less exposure with the background covered you control the degree of ghosting which occurs. With flash, an exposure of $f/11$, for example, can be divided into two phases, each of half-power giving a calculated or measured exposure of $f/8$. Greater flexibility is possible if you sub-divide this even further into four, quarter-power flashes – each flash indicating an exposure of $f/5.6$. In this case the background can be ghosted for one, two or three flashes. Shooting with tungsten an exposure of 1/30 sec at $f/11$ is split into two phases of 1/60 sec at $f/11$, four of 1/125 sec at $f/11$ and so on. With more than eight sub-divisions you are likely to have to make an allowance for the intermittency effect.

A multiple exposure method which permits perfect registration is essential.

Shadow free backgrounds. To produce this effect suspend your subject above or in front of the background. A sheet of glass makes a suitable support but often produces small tell-tale reflections which are impossible to avoid. Glass also limits the way in which you can organise your lighting, as certain locations for the lights result in glaring reflections.

A more sophisticated approach is offered by the 'stick shot' technique. This quaintly named method suspends the subject on the end of a

narrow metal tube – the 'stick'. The tube is supported vertically or in a roughly horizontal position, depending on the subject. In either case the tube is fed through a small hole in the background. By carefully aligning camera with subject the tube is completely hidden from view. When a horizontal arrangement is used the tube is clamped to a support or stand placed behind the background. If necessary the tube can be counter-weighted to increase stability. It may be necessary to build a small support platform in order to attach the subject firmly.

The background must be lit with diffused sources or a painting technique to avoid forming a shadow of the tube.

Projected backgrounds

A transparency projected on to a screen behind the subject often makes a most effective background. There are two simple methods of projection, the first on to a conventional white surface with the projector, camera and subject all in front of the screen. The second technique uses back projection where the projector is placed behind a translucent screen, so that the projector, screen, subject and camera are all aligned.

Choose your screen materials carefully. The white screen should be smooth matt paper or painted board. Proper projection screens are not always suitable because they frequently have a textured surface. You can make a back projection screen from tracing paper or drafting film and professional photographic suppliers market special types of translucent plastic film specifically for this purpose. Stretch the material over a wooden frame to make a smooth flat surface.

Neither projection system is perfect. The conventional method gives even illumination. But it is difficult to position the projector absolutely square-on to the screen and so the image is often slightly distorted (keystone effect) and may not be uniformly sharp. Back projection requires more space to set up, although it is a simple matter to produce an undistorted, sharp picture on the screen. However, image brightness is not always uniform and a central hot-spot is common.

On balance, the back projection method has fewer disadvantages and even these can be overcome if necessary. In a small room it is possible to reflect the beam of projected light from a *front-surfaced* mirror located at 45 degrees so condensing the total projector-to-screen distance. If the hot-spot is undesirable (and it can be quite

effective) shoot a bracketed series of black-and-white shots of the screen image without a slide in the projector. Fill the viewfinder with the image to record the light distribution in a negative form. After processing, select a thin negative and bind it together with a transparency. The denser central portion of the negative evens out the image brightness and prevents the hot-spot from forming.

Lighting for the subject must not reach the screen or it will desaturate the projected image. Use snoots, barn doors and flags to prevent this from occurring. For a realistic result, subject lighting should match the quality and direction of the lighting used for the projected image.

You can match the brightness of the subject lighting with the screen image so that the shot is taken with a single exposure. However, as the projected image tends to be low in intensity compared with most photographic light sources, a simple double exposure technique affords a more flexible way of combining incompatible light levels:

1 Set up the projector screen, subject, lighting and camera.
2 Cover the side of the screen near the camera with black velvet or flock-paper.
3 Expose for the subject.
4 Turn off the subject lights, remove the black velvet and switch on the projector.
5 Expose for the projected image.

The black velvet absorbs any small amount of light which would otherwise fall on the screen. If you are lighting the subject with flash you can shoot on daylight balanced colour film and filter the projected image exposure (Wratten 80A) or choose a tungsten balanced emulsion and filter the flash exposure (Wratten 85B). Although the latter technique appears the less logical of the two it does have significant advantages – the Wratten 85B has a fairly small filter factor of 1.5x, so little effective flash power is lost. Full emulsion speed is available for the projected image exposure and many tungsten balanced films are designed to cope with long exposure times without suffering from reciprocity law failure.

The filter can be located on the camera lens (Wratten 80A or 85B), on the projector lens (Wratten 80A) or over the flash units (Wratten 85B). Use the darkened room method of multiple exposure or the supplementary shutter technique

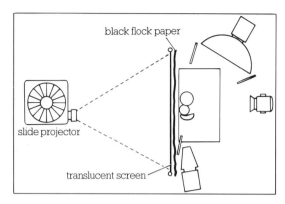

black flock paper

slide projector

translucent screen

131 Background projection allows you to create all kinds of effects in the comfortable and controllable conditions of a studio. This technique used a 35mm transparency, back-projected on to a small translucent screen made from drafting film taped to a rectangular wooden framework.
The final combination image. The 'darkened room' method of multiple exposure was used, with the lens capped between exposures. The camera was a 6 x 6cm SLR with a 135mm lens.

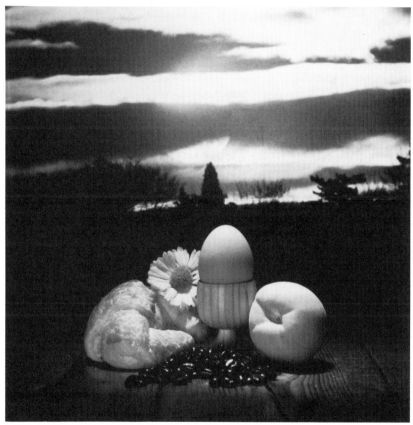

– registration must be perfect. If your projector will not focus close enough to produce an image size suitable for a small subject, tape a supplementary close-up lens in front of the projector lens.

Front projection

Front projection is a much more sophisticated version of the previous techniques. It works by projecting a transparency on to a screen in the normal way. But the screen has a very unusual surface containing countless minute glass beads. These reflect light back along the same path as the incoming projected image beam. When viewed on-axis the projected image is of great brilliance – about 1000x brighter than if a white screen had been used. Off-axis the image is almost invisible. In order to exploit this type of reflection the camera and projector lenses must share a common axis. A semi-silvered beam-

splitter mirror angled at 45 degrees is used to make the two axes coincide precisely. The camera is supported in a normal convenient position, while the projector is arranged at 90 degrees below or to one side of the beamsplitter. Although the transparency is also projected on to the subject, insufficient light is reflected to record an image. You light the subject in the usual way, taking precautions to prevent light from spilling on to the screen. The picture is taken with a single exposure.

Commercially built front projection systems use flash as the exposing source for the projector, with a modelling lamp built in to allow for compositional adjustments and focusing. As the modelling lamp tends not to be proportional in brightness to the subject lighting, exposure and lighting balance are best determined by test shots. Front projection systems of this kind are expensive items. Enthusiasts and professional photographers with only an occasional need for this technique usually hire a studio which has the equipment installed.

Beamsplitters

You can use a beamsplitter mirror to combine two images in a single exposure. All manner of special effects can be added in this way, including subtle touches such as sparkling highlights.

The beamsplitter is located in front of your camera lens at an angle of 45 degrees. You then combine two fields of view – one directly in front of the camera, transmitted by the mirror and another subject area at 90 degrees which is reflected from the inclined surface of the beamsplitter. It is usually best to arrange the main subject in front, with the secondary subject matter above, below or to one side of the camera within easy reach.

With a simple beamsplitter, each subject component has to be at a similar distance from the mirror if both images are to be equally sharp. Under certain circumstances this is not practicable, so you may need to use a close up lens between subject and beamsplitter. Filters and special effects screens can also be introduced at this point to affect only one component of the final picture. If your beamsplitter is a plain sheet of glass or a resin filter, neutral density filters are useful in achieving a balance between the intensities of the transmitted and reflected light beams. Place them in front of the beamsplitter.

A refinement of this technique adds a lens and

simple focusing mechanism which allows you to combine a real life subject with the image of a slide projected directly into the camera lens. By lighting the main subject with flash and the slide with a tungsten lamp an interesting blend of colours is produced.

Ghosting the subject

A solid object such as a box or a cooking pot can be made to apparently reveal its contents and so appear transparent by using appropriate lighting plus a double exposure.

Light the background normally but limit the lighting on the main subject to rim or top lighting. In this way the area nearest to the camera remains dark. Make your first exposure. The second exposure is for the contents which should be laid out in a realistic manner against a background of black velvet or flock-paper. Lighting for this component should be compatible, in terms of quality and direction, with the lighting for the first exposure.

To look convincing, a shot like this needs careful planning. You must be able to locate the second exposure accurately within the dark area created specially for it. A careful drawing, made directly on to the camera screen immediately after the first shot is made, enables you to do this. Choose a multiple exposure method which permits reasonably accurate registration and full use of the camera viewfinder.

If your 35mm SLR camera does not have a removable pentaprism you cannot make a drawing on the camera screen. Make an accurate sketch on paper, using the central focusing aid as a reference point.

Simulating movement

A static subject can be photographed in such a way that it appears to have moved. Use a multiple exposure, changing the position of the subject and/or camera to simulate a pattern of motion. A very dark or black background is needed which is large enough to fill the field of view even if the camera moves. Your lighting must be limited to the subject alone as stray light reaching the background quickly turns a rich black into a muddy grey when it is exposed a number of times. Use snoots, barn doors and flags to prevent this. Suspending small subjects in front of or above the background using the 'stick shot' technique is an excellent aid to achieving full lighting control.

Plan the location of each image, using a drawing on your camera screen if possible. Regular

movement is implied by designing evenly spaced images. Acceleration requires them to be closely spaced at first, then becoming further apart. Your multiple exposure technique should permit reasonably accurate registration and normal viewfinder function.

Stroboscopic flash

A stroboscopic flash unit is capable of repeated firing at a controllable rate. Such units are not usually sold by photographic stores but are available from scientific suppliers, theatrical lighting dealers and hi-fi retailers where they are sold as 'disco lights'. They need an AC supply.

Stroboscopic flash units are not very powerful when compared to a conventional flash gun – a small unit may have a power output of only 2J. In practical terms this results in a guide number of only about 18/60 (m/ft) for ISO 1000/31° (ASA 1000/31 DIN) film. The unit does not require synchronisation and is best used in a darkened room with your shutter locked open on 'B'.

Rapidly repeating flash is a perfect light source for capturing real life motion as a series of closely spaced sharp images. As with the similar but simulated effect, you need a black background carefully shielded from stray light. With such a low output you have to use a fairly wide aperture – f/5.6 at 3m using ISO 1000/31° (ASA 1000/31 DIN) film is a typical exposure for a small stroboscopic flash unit. Depth of field is limited at such apertures so arrange your subject to move in such a way that it remains within the zone of sharpness. For a person walking or dancing, a firing rate of about 8 to 20 flashes per second and an exposure of 1 or 2 seconds provides a good starting point for a series of experimental shots. Rehearse the movement in room light.

Warning: some susceptible individuals suffer nausea and in rare cases epileptic fits when working with stroboscopic flash.

Infra-red photography

Infra-red film is available in the form of a black-and-white negative material and a colour transparency emulsion. Both materials are sensitive to visible light and infra-red radiation. Consequently, both types of film require filtration to prevent unwanted blue light from reaching the emulsion. For the black-and-white film deep red (Wratten 29) and infra-red transmitting, visually opaque (Wratten 87, 87C, 88A) filters are recommended. The colour material is used with a deep

132 Lighting for ghosted subjects simply involves keeping light away from the area into which the second and subsequent images will be aligned. As an additional point, you must also ensure that the lighting quality and direction are compatible for each image component. The triple pan was lit in such a way that the front area remained dark. An accurate tracing was made on the camera screen. The ingredients were then laid out on black velvet and arranged to give an impression of three dimensions. The piece of velvet was large enough to cover the whole field of view of the lens. A second exposure was made with the foodstuffs carefully composed (according to the drawing on the screen) so that they appeared to be inside the three compartments of the pan. Monobloc flash units were used fitted with general purpose reflectors. The camera was a 4 x 5in monorail with a 150mm lens. Exposure on ISO 50/18° (ASA 50/18 DIN) film was at f/8.

yellow (Wratten 12) filter in daylight or with flash. Quoted film speeds take into account the effect of the basic filtration – do *not* apply a filter factor.

Lighting for the colour film broadly follows normal procedures, although soft styles with a strong fill-in are needed to avoid loss of shadow detail. This film was originally designed for aerial reconnaissance and has an inherently high contrast characteristic.

The black-and-white emulsion is much more interesting from a lighting viewpoint, largely due to the nature of the visually opaque filters. Instead of placing a filter over your lens, you can position it in front of the light source. Most common sources, including flash, are rich in infra-red rays so special lighting equipment is unnecessary.

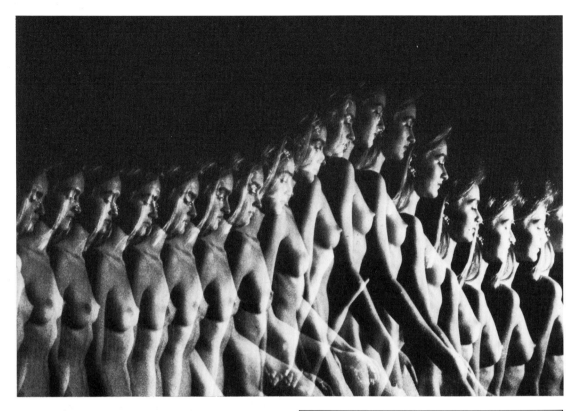

133 Stroboscopic flash records actual movement as a series of images. The power of each flash is low, so a fast film and a large aperture are frequently needed. Because the film is, effectively, exposed many times, light must be kept off the background. For this shot an improvised barn door of black card was used to limit the amount of light reaching the black painted wall which acted as the background. The action was rehearsed in room lighting and the picture was then taken in a darkened room with the shutter set to 'B'. The stroboscopic unit was set to fire at 10 flashes per second. The camera was a 35mm SLR with a 50mm lens. Exposure on ISO 1000/31° (ASA 1000/31 DIN) film was about 2 sec at *f*/5.6.

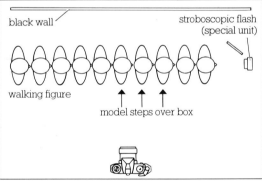

With the filter in place, your light is converted into an almost invisible source. Direct observation of a powerful compact tungsten lamp or a firing flash gun does reveal a dull red glow, but the output is otherwise undetectable.

With this arrangement you can photograph in darkness without alerting the subject to your presence. Because infra-red rays have a longer wavelength than visible light, a focusing correction is necessary – especially with long focal lengths and when working with wide apertures or subjects at close range. Most lenses for 35mm cameras carry a small dot, line or letter 'R', often marked in red, to one side of the normal focusing index. This is the infra-red index.

To apply the necessary correction, follow this procedure:

1 Focus normally, measure or estimate the subject distance.
2 When visual focusing is used, read off the distance against the normal index.
3 Set the subject distance against the infra-red index.

134 A sound-activated trigger fires a flash gun in response to noise detected by a microphone. An airgun was used to shatter a number of burnt-out lamps. Lighting was provided by a flash gun located behind and below the lamp. The automatic sensor on the flash gun was detached, fitted to a remote lead, and positioned close to the flash tube to receive direct illumination. With this arrangement an estimated flash duration of 1/15,000 sec

Some subjects are recorded on black-and-white infra-red film in much the same way as they appear on a panchromatic emulsion but others are totally transformed. Green foliage is rendered a silvery white, and the infra-red reflectivity of pale skin is such that normal tonal qualities become flattened out. In addition the lips all but disappear along with skin texture, most wrinkles and blemishes. The outer white part of the eye becomes unnaturally dark, while veins show up with great clarity. Infra-red film is very prone to halation – image spread caused by rays reflected from the film base.

Taken together, these characteristics make infra-red film a unique and fascinating material to work with.

Light and sound triggers

Subjects which are timid, or which move too quickly to be seen clearly can be made to photograph themselves. The same principle may be applied to an event in which noise accompanies a significant occurrence, such as the shattering of a bottle.

In the first case a light trigger is used. This device is a variation of the familiar burglar alarm which is activated when a beam of light (or infra-red radiation) is broken. The trigger consists of two parts – a source of light or infra-red rays and a receiver unit containing a photo cell which is connected to a flash unit. Light source and receiver are positioned so that the subject must pass between the two components. As it does so, the beam of light which is focused on the photo cell is broken.

The circuit then fires the flash unit.

A sound trigger works in a similar way, firing a flash unit in response to noise detected by a microphone.

Both types of accessory can be purchased as commercially made products. If the trigger fires only a flash unit and not the camera itself, this technique must be used in a darkened room or outdoors at night. This exposing sequence is as follows:

1 Set up the camera, lights, trigger device and test all functions.
2 Compose, focus and set the aperture for correct exposure.
3 Set the shutter to 'B', extinguish the lights and lock the shutter open.
4 Activate, or wait for the subject.
5 Close the shutter.

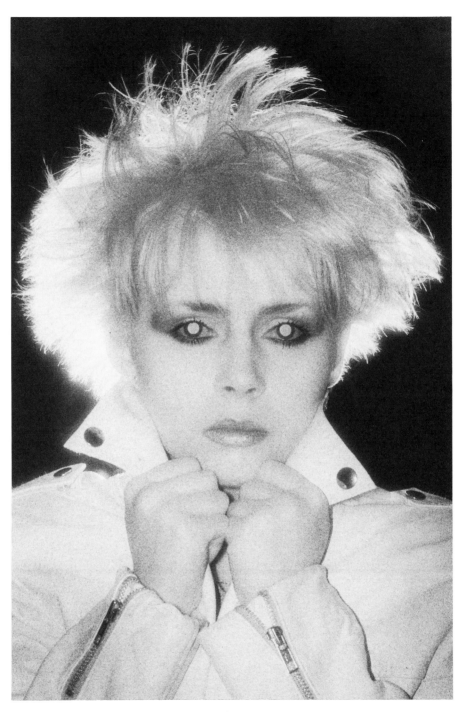

135 Portraits on black-and-white infra-red film exhibit several unusual and slightly surreal qualities.

Two lights were used for this portrait, a monobloc flash to backlight the hair and a flash gun as the main light. The flash gun was fitted with an opaque Wratten 87 filter and held close to the lens. In this position it produced a very pronounced version of the 'red-eye' or 'pink-eye' effect. Combined with the large diameter iris of the eye and the darkening effect which occurs with the outer white part of the eye, the result is a most disturbing gaze. The camera was a 35mm SLR with a 90mm lens. A red Wratten 29 filter was used over the lens to filter the light from the monobloc flash unit. Exposure at the recommended film speed of ISO 25/15° (ASA 25/15 DIN) was *f*/8 based on the guide number of the flash gun.

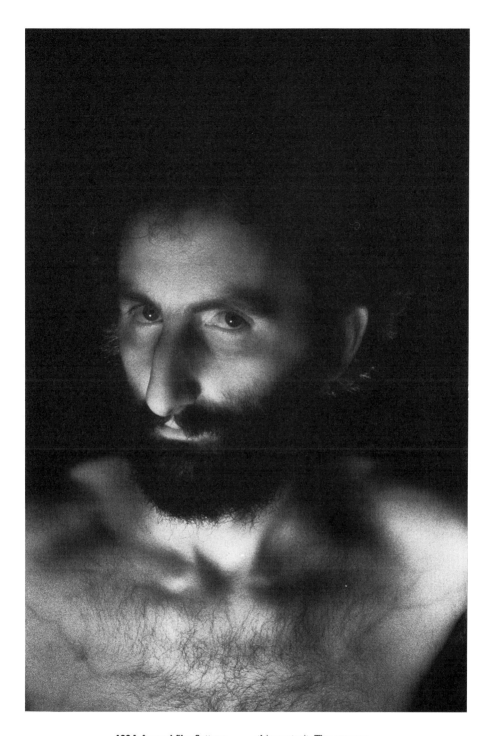

136 Infra-red film flattens skin tone, and minimises the appearance of texture; thus, the veins are emphasised. A diffused monobloc flash unit was placed at floor level to light this portrait. The camera was a 35mm SLR with a 90mm lens. A red Wratten 29 filter was used over the lens. Exposure at a rating of ISO 50/18° (ASA 50/18 DIN) was *f*/22.

15 AMBIENT LIGHT

Working in ambient or existing light can be difficult and challenging. However, with the right choice of equipment and materials the resulting pictures are often excellent. The technical quality cannot match the kind of colour accuracy, sharpness, depth of field and freedom from grain which you can achieve under controlled conditions. But technically inferior pictures shot in obviously 'awkward' situations are often more successful in evoking atmosphere. In some circumstances a compromise approach is possible using ambient light as the major source then adding a small amount of controlled lighting to brighten dark shadow areas.

Daylight indoors

Ambient daylight is one of the most attractive, subtle but surprisingly variable light sources with which to work. It is also often deceptively low in intensity. If you have been indoors for a long period your eyes adapt to the prevailing light level and an area near a window, which you may choose because of the quality and apparent intensity of the light, probably seems brighter than it really is. You must use your exposure meter or TTL system with care. Do not estimate or rely on previous experience – in these circumstances it is an unreliable technique.

An incident reading with a hand meter is usually the most accurate method of judging exposure. A TTL system is easily fooled if any of the window is included in the shot, or if the area behind your subject consists of anything other than an average mid-tone. Use an efficient lens hood to prevent lens flare.

The quality of light usually appears soft and even but in fact may fall off in intensity quite rapidly. Pay particular attention to the way shadows fall. If any important detail is included in these areas it will be recorded as a much darker tone than it appears to be. If you have control over your subject re-arrange it to minimise the area of shadow. In some circumstances it may also be possible to lighten the shadows using fill-in flash or light from a reflector board. When you have not properly prepared for an assignment, reflectors can usually be improvised from materials you find in the home or office – a sheet of newspaper, a white jacket or sweater, even a pocket handkerchief has some effect.

The colour of daylight is highly variable. Although a standard colour temperature of 5500K is quoted, this figure only applies to an average midday quality. At sunrise and sunset it may drop to 3500K, while light from a clear blue sky has a colour temperature of 12,000K or more. On transparency film these variations cause a change in colour quality overall. Shots taken early or late in the day are warm. A photograph illuminated by blue skylight not surprisingly exhibits a 'cold' overall blue cast.

Such deviations from a neutral balance can be corrected by filtration. For exposures made one hour after sunrise and one hour before sunset use Wratten 82A filters or a Wratten 80B. To reduce a blue cast try Wratten 81A plus Wratten 85C filters, or a Wratten 85.

But before filtering your pictures you should perhaps pause and consider if a neutral balance is indeed required. Changes in colour help mood and add to the atmosphere. Where time permits, shoot comparison pictures with and without corrective filtration and see which effect you prefer. Generally speaking, the warm cast is accepted as helping the mood but the blue cast is usually regarded as undesirable.

Room lighting

Compared with daylight entering the same room, domestic lighting normally provides a lower overall brightness and a greater variation in brightness level. Small light fittings, such as tungsten lamps in average-sized shades, give a hard light quality which rapidly falls off in intensity. Large shades, light reflected from ceilings or walls, and fluorescent strip tubes all give a softer effect and more even illumination.

As with daylight, shadows are likely to be much more dense in the final photograph than their appearance suggests. This is particularly true with shadows formed by a hard source. Your metering technique must take the location of the light into account. If the source is included in the shot an unmodified TTL reading will inevitably indicate underexposure. To avoid this, use a hand meter that reads incident light or read the reflected light from the subject alone, ignoring the source itself.

Exposures made with tungsten lighting on unfiltered daylight balanced transparency film

show a strong yellow/orange cast. Although this is technically incorrect, the warm colouration is usually regarded as conveying a comfortable, secure impression of a home environment. The combination has almost become a convention. If you need a more neutral colour balance, shoot on tungsten balanced film and for even greater accuracy use Wratten 82A, 82B or 82C filters.

With both daylight and tungsten room lighting the final colour of the light is influenced by decorations, furnishings and lampshades. Anticipate colour casts in the shadows and local changes of colour. Many of these 'defects' contribute to the sense of environment and heighten the impression of reality.

Equipment and film

With your camera on a tripod and a stationary subject low light levels present no significant problem. But hand holding requires a more carefully considered choice of equipment and technique. The difficulties involved are further compounded when you have an uncontrollable and highly mobile subject such as a group of young children.

A 35mm camera fitted with a lens of wide maximum aperture is the most suitable choice. To capture a shot of the general environment a 28mm or 35mm lens is ideal. For small groups and individuals 50mm, 85mm, 100mm and 135mm are all suitable lenses. A motor-drive or auto winder is useful for capturing a sequence of events, although you should be sensitive to the fact that its noise is sometimes obtrusive.

In dealing with a moving subject in poor light you have to balance three problems – camera shake, subject movement and focusing accuracy.

The longest shutter speed that you can successfully use with a hand-held camera and produce a sharp picture depends on a large number of factors:

1 Focal length.
2 Individual ability.
3 Posture/support.
4 Fatigue.

The longest workable shutter speed can be used when you have a wide angle lens and a very stable posture. Practise hand holding to improve your skill but anticipate the need for a shorter speed when you are tired or after carrying heavy equipment. Where possible, improve the stability

137 Soft lighting from a large open doorway provided an ideal quality of illumination for these shop display figures. By up-rating ISO 400/27° (ASA 400/27 DIN) film to ISO 800/30° (ASA 800/30 DIN), an exposure of 1/60 sec at f/5.6 was made possible. The combination provided a shutter speed fast enough to avoid camera shake with an aperture which produced adequate depth of field. The camera was a 35mm SLR with a 50mm lens.

of your camera by improvising a support – the back of a chair is ideal. Other supports such as monopods and bean bags are worth considering but can impair your speed of working. As a broad guide to the longest shutter speed which is likely to give you a majority of pictures free from camera shake, take the focal length and divide it into one to give a fraction. Use the shutter speed which is nearest to this value:

Focal length	1 / Focal length	Shutter speed
28mm	1/28	1/30
35mm	1/35	1/30
50mm	1/50	1/60
85mm	1/85	1/125
100mm	1/100	1/125
135mm	1/135	1/125

Freezing subject movement is more complex. The shutter speed you need depends on:

1 Speed of movement.
2 Direction of motion.
3 Image size.
4 Whether camera is stationary or panned.

Human movement indoors is relatively slow unless it involves a sporting activity. In the majority of situations a shutter speed which avoids camera shake also freezes most subject movement. If possible use *half* the suggested speed, eg 1/250 instead of 1/125 sec. Unlike camera shake, which causes an overall loss of sharpness, subject movement only creates a local blur. The effect is often quite pleasing and reinforces the impression of activity.

By giving choice of shutter speed priority over aperture you are normally forced to work with your lens set almost wide open. A typical exposure in ambient daylight is 1/125 sec at f/2.8 with ISO 400/27° (ASA 400/27 DIN) film. Depth of field is shallow at wide apertures, particularly with a lens of greater than 50mm focal length. Focus with extreme care and try to react quickly to capture the sharp image – mobile subjects move rapidly through shallow depth of field zones. One technique which is appropriate in these circumstances involves pre-setting your focus at a point where you have previously seen the subject several times. In the case of children playing, for example, it may be at a table or doorway. Using this approach all you have to do is judge when the subject is sharp and react accordingly.

Stage lighting

Whenever possible, try to photograph theatrical performances and concerts with the existing stage lighting. This is often quite spectacular and makes a major contribution to the visual effect. Most of the difficulties you experience in ordinary room lighting are found on stage as well but the illumination level is higher. Unfortunately, offsetting this advantage is the effect that the activity is almost certain to be more rapid, so you are still faced with problems relating to focusing accuracy and depth of field. Access to the stage is likely to be limited so for tightly composed pictures you normally need telephoto lenses. On a 35mm SLR camera 85mm, 100mm, 135mm and 180mm lenses are the most useful. All those focal lengths can be obtained in versions with a maximum aperture of

f/2.8 or faster.

Many concerts feature lighting which is constantly changing and so determining the exposure under these circumstances is especially difficult. A TTL reading may give an accurate measurement with one arrangement but drastically underexpose when overhead lights which point into the lens are switched on. It is worth spending some time simply watching the performance to judge the various lighting effects. In this way, you may be able to detect the occurrence of regular patterns. For example, when top lights are turned on, lighting from the sides may be switched off. Take a series of TTL readings and note the variations. Relate the visual effect of the lighting to the reading using experience gained in studio situations. Assess whether high readings are distorted by backlighting or if all readings are influenced by a dark backdrop. Make an override correction to the film speed setting if necessary.

A reliable alternative method is to take a reading from an average area which does not include a light source. A spot meter or camera fitted with a lens of long focal length (eg, 300mm) allows you to do this. On a professional assignment try to gain access to the stage during a lighting trial to make incident light readings. To confirm the accuracy of your exposure estimation it is always a good idea to shoot a few frames with bracketed exposures which you process as a clip test (see page 130). An exposure of 1/250 sec at f/4 with ISO 1600/33° (ASA 1600/33 DIN) film is typical for a well lit concert.

Fill-in flash

Light from a hard source creates dense sharp-edged shadows. You find this quality indoors with small tungsten lights, when sunshine streams in through a window and outdoors in bright sunlight. Pictures shot under such conditions contain featureless shadows which are often unattractive, particularly on a face.

Fill-in lighting brightens the shadows and recreates a more natural appearance. A small flash gun is the most convenient light source as it can be used on-camera. A reflector board allows you to judge the effect, but requires supporting in the most suitable position – often at head height.

The effect of the fill-in flash can be thought of as being a kind of deliberate underexposure, so that the shadows are lightened but not completely over-powered. By using the flash gun on or near

138 Brilliant sunshine is often an unflattering light source for portraits. Try turning your model so that she faces away from the sun. In this position the sun acts as a powerful backlight. You can create main frontal lighting with a soft quality by bouncing flash from an umbrella or reflector board placed close to the camera. For this picture a 1m (3ft) metallised umbrella was used. Exposure for the flash was calculated from the guide number and a factor of 2x applied to allow for light loss from the umbrella. The camera was a 6 x 6cm SLR with a 135mm lens. Exposure on ISO 50/18° (ASA 50/18 DIN) film was 1/40 sec (top X-sync speed) at *f*/5.6. A starburst screen was fitted over the lens to accentuate the backlit highlight on the model's bracelet.

the camera it produces flat lighting which does not introduce other significant shadows.

Two methods are used to calculate exposure. One applies to the situation where the fill-in light falls only on the shadows. The other technique is used when fill-in light also reaches the highlight areas.

Method A: fill-in for shadows only:

1 Take a meter reading of continuous light. Outdoors in sunshine a typical exposure is 1/125 sec at *f*/11 on ISO 100/21° (ASA 100/21 DIN) film.

2 Choose a small flash gun, and select a fractional

power setting or use a neutral density filter to produce an appropriate GN, in this case 16/52 (m/ft) for ISO 100/21° (ASA 100/21 DIN).

3 Decide on a suitable fill-in lighting ratio – eg 4:1.

4 Calculate from the GN the aperture and distance combination which would give correct exposure if the flash were the only exposing source, eg

> in m GN of 16 = *f*/8 at 2m
> in ft GN of 52 = *f*/8 at 6½ft

5 In order to create a 4:1 lighting ratio the flash must be 'underexposed' by 4x or 2 stops, which in this example is *f*/16.

6 The exposure now becomes 1/60 sec at *f*/16 (same effect as 1/125 sec at *f*/11) with the flash gun at a distance of 2m/6½ft.

Method B: fill-in reaching highlights and shadows:

Repeat stages **1** and **2** from Method A.

3 Decide on a suitable fill-in lighting ratio, eg 3:1.

4 Calculate from the GN the aperture and distance for correct exposure, as in Method A.

> GN of 16/52 = *f*/8 at 2m/6½ft.

5 With a basic exposure of 1/125 sec at *f*/11 set on

139 Deliberate use of the 'wrong' type of film sometimes produces effective results. This photograph was shot on daylight balanced film with a 15W tungsten lamp as the sole source of illumination. The resultant yellow cast helps in conveying an impression of warmth and security. Camera was a 35mm SLR with a 50mm lens. Exposure on ISO 64/19° (ASA 64/19 DIN) film was 1/2 sec at *f*/2.8.

the camera, the flash *apparently* gives a 2:1 fill-in lighting ratio. But this arrangement overexposes the highlight because the exposure is based on the sunlight alone and discounts the flash.

6 Taking into account the effect of the flash, adjust the aperture to between *f*/11 and *f*/16, closing it down by half a stop.

7 The exposure now becomes 1/125 sec at *f*/11 (+½) which is correct for the highlights and underexposes the flash by 1½ stops, so creating a 3:1 ratio.

In any manipulation of the basic exposure remember to keep within the range of shutter speeds which gives correct flash sync. A convenient method of reducing flash output to achieve the desired GN is to bounce it from a small reflector board or use a wide angle diffuser. If you do not own a neutral density filter which fits the flash gun, layers of white tissue will suffice.

INDEX